The Digital Plenitude

The Digital Plenitude

The Decline of Elite Culture and the Rise of Digital Media

Jay David Bolter

The MIT Press
Cambridge, Massachusetts
London, England

© 2019 Massachusetts Institute of Technology

This book was set in Stone Serif by Westchester Publishing Services. Printed and bound in the United States of America.

Library of Congress Cataloging-in-Publication Data is available.

ISBN: 978-0-262-03973-4

10 9 8 7 6 5 4 3 2 1

Contents

Preface

November 8, 2016, was a seismic event for the cultural elite in the United States. How could the country have elected as president a man who possessed no experience and not a single intellectual or moral qualification for the office? A man who embodied almost the precise opposite of every such qualification? I write "cultural elite" intentionally. If you belong to any of the groups constantly vilified by Trump and his followers (journalists, scientists, political activists, academics and intellectuals of all kinds), you have been defined by this election as a member of a cultural elite, whether you like it or not. In the past two decades, although right-wing politicians had been getting mileage out of attacks on the cultural elite, their voter base did not understand the "media bias" of the press and the "political correctness" of academics as threats to their way of life. Now they do. As *FiveThirtyEight* data journalist Nate Silver has noted, the single most important characteristic that determined the votes for or against Trump in the election was the voter's level of education. Even relatively wealthy people with less education went for Trump, just as relatively less affluent voters with higher education voted against him. The classic Trump voter—the hillbilly of J. D. Vance's *Hillbilly Elegy* (Vance 2016)—feels acutely the difference between those with higher education and those without. Trump's extraordinary success with this population of voters shows that, unlike their European counterparts, what the American working class resents above all is not the economic divide between itself and the wealthiest 1 percent (the division that the left in the United States and in Europe assumes should be the natural marker of political preference). Instead, the American (white) working class both sees and resents the chasm in outlook and status that separates it from the educated elite—above all, anyone in the media or the academic world, anyone who works with words as their profession or vocation.

Donald Trump has managed to fashion himself as a billionaire with a working-class persona, and that is why his followers can identify with him. Clinging to the American myth of mobility, they can imagine themselves rich. They cannot imagine themselves with an elite education, because, as they rightly understand, that education would rob them of their class identity. They can envision themselves in Trump Tower much more easily than in the Ivory Tower. Because of Trump, the idea of the cultural elite has emerged as a political issue for the United States, rivaling or even surpassing the issue of economic inequality.

How did we get here? How has our media culture developed in the past half century to bring us to this pivotal moment? I say "media culture" because our political culture *is* a media culture. We don't even think of it any other way—when we say "politics," we think of television ads, cable news coverage, email lists, and now especially tweets. Media constitute the political for us in the United States today. Just as there is now no universally recognized distinction between entertainment and art, so there is no firm distinction between entertainment and politics. Obviously the social and economic developments that led us to Donald Trump's presidency are numerous. In hindsight the Trump era could only have been possible because of a perfect storm of economic dislocations, social realignments, and changes in cultural assumptions. In this book I will be focusing on cultural assumptions specifically in the realm of the arts, entertainment, and to some extent the humanities—on the rise of what used to be called popular culture and on the relative decline of elite culture.

What has happened to our media culture is the breakdown of any broadly shared conviction in hierarchy. In 1950 we still accepted the notion that there was a significant difference between art and popular entertainment. We believed that novelists, poets, artists, composers, literary critics, art critics, and historians had access to a special cultural sphere, to Culture with a capital C; we believed that their novels, poems, essays, paintings, and music simply mattered in a way that romance novels, radio and television shows, and comic books did not. This shared cultural understanding came under assault in the following decades. The term "popular culture" gradually lost its negative connotation, while the term "elite" became pejorative. But while the hierarchies in art, language, and learning have broken down, they have not entirely disappeared. The resentment that so many in the American heartland feel for their more educated fellow citizens on

the coasts shows that there remains some suspicion that perhaps elite culture *is* more important. The hierarchies have fragmented, but the fragments are still floating around in our media culture. There is no single cultural center, but the remaining centers can still be felt, comforting some and threatening others. Most important, perhaps, the cultural hierarchies have become detached from the economic hierarchies. There is certainly still an economic elite in the United States, but that elite does not necessarily align itself with what remains of the cultural elite.

While Culture with a capital C was breaking down, new digital media were beginning to emerge. These new forms (video games, websites and web applications, social and mobile media) did not cause the breakdown of cultural hierarchies, but they turned out to be perfectly suited to spread and magnify the changes. In the aftermath of the 2016 election, the mainstream news media (that is, the newspapers and to some extent television networks that are branded "elite media" by the followers of Trump) have understandably focused on the overtly political digital media forms, such as Twitter, fake news websites and racist Facebook pages. These forms are indeed the most directly relevant examples of the breakdown of hierarchy. A few decades ago, newspapers such as the *New York Times* or the *Washington Post* and the nightly news broadcasts were regarded as gatekeepers, vetting sources and deciding for us what constituted newsworthy and reliable information. Today if you believe that the *New York Times* is a more reliable source than Fox News, or for that matter a fake news site compiled by Russian hackers, you are marking yourself as a member of the educated elite. But the breakdown in the hierarchy of what constitutes news is only one aspect of the larger breakdown that I will be discussing. And the rise of digital media forms in the delivering of news is only one part of the large digital matrix in which the fragments of our traditional culture have landed. Just as we no longer have Edward R. Murrow or Walter Cronkite to provide us news that we all accept, we no longer have Leonard Bernstein or Leopold Stokowski to provide us what is best in music. We no longer have Susan Sontag and Lionel Trilling to help us understand the latest novels and nonfiction. Or rather we do have authoritative figures in all these traditional elite areas (music, art, fiction, political reporting, and so on) and in all sorts of more popular areas (rap music, movies, video games). But they are authorities only within their communities of readers, listeners, or viewers. When Trump and his followers attacked elitism, what they meant above all

was training and experience in the traditionally accepted hierarchies. Much of his cabinet lacks the expected backgrounds for their posts—no history of positions in the federal government, little or no academic education in economics or science, no experience running large bureaucracies. Here as elsewhere, Trump's position is an absurd exaggeration of a larger cultural development.

Trump is a host of contradictions: he is a media illiterate yet a consummate user of Twitter, a pathetically ignorant graduate of an Ivy League institution. The reactions he provokes, the strong and yet strangely ambivalent support among many of his followers, the disdain among better-educated Americans, are symptomatic of many divisions in our society today. The divisions I want to examine in this book are some of the defining dichotomies of our media culture. Understanding these dichotomies will certainly not fully explain the Trump phenomenon. But I hope it will contribute to understanding the changes in underlying assumptions that led us to this moment. It is no coincidence that these changes took place in almost exactly the period of Donald Trump's life—from the end of World War II to today.

I am afraid that this book will be misread in one important respect. It is *not* meant to be an elegy for elite culture. The loss of status of the elite arts and the humanities in the last fifty years is simply a fact, as is the rise of popular cultural forms. These new cultural forms (long-form television, rock music, rap, video games, social media, and many others) provide millions, indeed billions, of people with new opportunities for expression and participation. Traditionalists can always choose to dismiss these new forms as examples of what the critic Dwight McDonald called "masscult" and "midcult," but they can now speak only for their community, not for our culture as a whole.

There is a companion website for this book: digitalplenitude.net. The site contains additional text and examples as well as links to videos and other materials that could not be included in the printed version.

Acknowledgments

In its long gestation period, this book has gone through many rewritings and restructurings, and many of the ideas grew out of earlier work. Chapters 4 and 5 are based on a chapter entitled "The Aesthetics of Flow and the Aesthetics of Catharsis," which I contributed to *Technology and Desire: The Transgressive Art of Moving Images* (Intellect 2014), edited by Rania Gaafar and Martin Schulz. Portions of chapter 7 derived from "Procedure and Performance" in *Produsing Theory in a Digital World* (Peter Lang 2012), edited by Rebecca Anne Lind. Portions of chapter 8 were based on a paper entitled "Social Media and the Future of Political Narrative" in *Travels in Intermedia[lity]: ReBlurring the Boundaries* (Dartmouth College Press 2012), edited by Bernd Herzogenrath. All these are adapted and reused by kind permission of the publishers.

Throughout the process I have discussed my ideas and shown drafts to many colleagues and benefited tremendously from their observations and suggestions. I wish to thank colleagues from the School of Literature, Media and Communication at Georgia Tech, especially Lauren Klein, Yanni Loukissas, Blake Leland, Carl diSalvo, Michael Nitsche, Ian Bogost, Greg Zinman, Karen Head, Nassim JafariNaimi, Christopher Le Dantec, Janet Murray, and Richard Utz. I am particularly indebted to two colleagues, Leah Misemer and Joshua King, who assisted me during the final months of revisions. Their efforts extended to all aspects of the book: structure, accuracy and range of content, and style. We had hours of fruitful discussion about individual chapters and the book as a whole. The result is a much better book than I would have been able to produce on my own. Among my students over these years, I would like to thank Jill Fantauzza and Hank Blumenthal for sharing their insights into art and media; Brian Schrank for helping me

to appreciate the historical avant-garde; Rebecca Rouse for impressing on me the significance of performance in contemporary media culture; and Colin Freeman and Joshua Fisher, who have vastly expanded my understanding of digital media technologies and their cultural meaning.

Many fine scholars, new and old friends, provided advice and criticism on various chapters in the book, including Eduardo Navas, xtine burrough, and Eric Snodgrass. Others helped to shape and refine my ideas in private conversations and at conferences, including Bo Reimer, Wendy Chun, William Uricchio, Marion Colas-Blaise, Hans Bouwknegt, Katherine Hayles, Gunnar Liestøl, and Kathleen Fitzpatrick. I have presented parts of chapters as well as the larger thesis in numerous lectures at events and universities, including ISEA, Malmö University, Utrecht University, the National University of Tres de Febrero in Argentina, and the University of Luxembourg.

I wish to thank the anonymous reviewers of the book for the MIT Press. Among the editors at the Press, I must recognize first and foremost Doug Sery, who showed professionalism, judgment, and infinite patience in guiding this project from its earlier stages to final submission. Noah Springer, Kathleen Caruso, and Julia Collins devoted great skill and effort to editing and preparing my manuscript. Yasuyo Iguchi was the book's designer, and Sean Reilly prepared the art. The fine work of everyone on the production team illustrates the importance of the high-quality, professional production of printed books even in this age of digital plenitude.

My deep thanks to Maria Engberg, who has been my collaborator over the past ten years. Her insights into the current state of our media culture and her judicious criticism of my views have shaped my thinking in more ways than I can enumerate. Blair MacIntyre, a long-time colleague and collaborator at Georgia Tech, has been a tremendous resource for knowledge and insight regarding the development of digital technologies as well as their significance for our society. Michael Joyce has been a constant inspiration since our first collaborations in the 1980s. His ongoing exploration of the aesthetics of print in a digital age has been formative for my own thinking on contemporary media culture. I wish to thank my son David, who gave me advice on a variety of subjects, linguistic and otherwise.

Finally, I wish to thank my late wife Christine, who supported and inspired me in so many ways throughout my years of researching and writing this book.

Introduction

There are two developments in the second half of the twentieth century have that helped to define our media culture in the twenty-first. One is the rise of digital media: websites, video games, social media, and mobile applications, as well as all the remediations of film, television, radio, and print that now appear in digital form. Digital media are everywhere and provoke constant discussion and attention today. What nuclear power or space travel was for a previous generation, the iPhone and Facebook are for us today.

The other development is the end of our collective belief in what we might call Culture with a capital C. Since the middle of the twentieth century, traditional hierarchies in the visual arts, literature, and music have broken down. This has been accompanied by a decline in the status of the humanities—literary studies in particular, but also history and philosophy. This is an open secret: we all know implicitly that it has happened, but seem unwilling to acknowledge the consequences. We know that the words "art" and "culture" do not have the significance that they had a few decades ago. We can no longer assert with confidence that one form of art is better than another: that classical music is better than rap, that the novel is a better form of expression than the graphic novel, or that film is a more profound medium than video games. Or rather, if we assert such things, we can expect to be argued with or simply ignored.

The relationship between digital media and the decline of elite culture is the subject of this book. It is not a matter of cause and effect. Digital media did not by any means cause the decline of elite culture, which began before the computer had developed as a medium—that is, as a widely shared platform for expression and communication. But digital media now provide

an ideal environment for our flattened, or perhaps we should say lumpy, media culture in which there are many focal points but no single center.

This multiplicity, this loss of the center, is not a "problem" to be solved. It is simply the condition of our culture today.

Media and Cultural Change

This photograph (figure 0.1a) of an intersection in Manhattan was taken in the early 1960s. Compare it to a Google Street View image of the same intersection in 2017 (figure 0.1b). Our first reaction might be to notice how much our urban landscape has changed since then. New buildings make the street look more open and inviting. The cars today are smaller and sleeker (but we now have SUVs). Clothing styles have obviously changed too. Men do not wear dress hats today. But how important are the changes in comparison with the continuities? The structures and functions of buildings and streets are the same. Billboards and signs are ubiquitous. The cityscape still consists of restaurants and other businesses to service the population on their way to work in offices or on their way home to apartments or houses in the suburbs. In a fundamental sense, the conditions of daily life and even the ostensible level of technology appear similar. We do not have the flying cars and jetpacks that science fiction long predicted for us in the twenty-first century. The many changes in our material culture that have occurred in these decades have largely been incremental improvements "under the hood" to existing technologies and systems, such as better-engineered terrestrial cars and better climate control in public buildings and homes. Restaurants offer a greater variety of (sometimes) healthier dishes. Improvements in medicine have been very significant but also incremental, and the predictions that were made repeatedly during the intervening decades—such as that genetic manipulation and nanotechnology would eliminate cancer and heart disease or reverse the effects of aging—have not come true.

If we could somehow transport an American through time from 1960 to the present, she would have little trouble recognizing the material conditions of everyday life, except in the crucial area of media and communications. As she walked along the streets, she would be puzzled to see many of the passers-by holding miniature walkie-talkies to their ears or tapping on tiny keyboards and screens, while many others appeared to be listening to music through headphones attached to tiny transistor radios. If she walked into

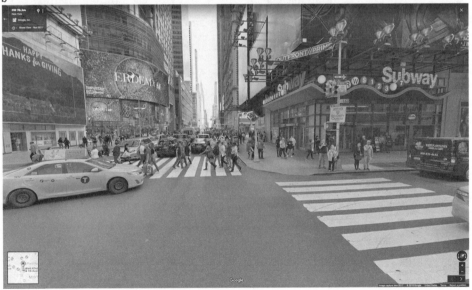

Figure 0.1a
Photograph of a New York City intersection, Seventh Avenue and Forty-Second Street, early 1960s. adoc-photos/Corbis Historical/Getty Images.

Figure 0.1b
Google Street View image of New York City, Seventh Avenue and Forty-Second Street, November 2017. Google and the Google logo are registered trademarks of Google Inc., used with permission.

an office building, she would be struck by all the individual computer consoles with video screens, which have not only replaced typewriters on the secretaries' desks, but also found their way to the desks of technical workers and even executives, who seldom typed their own documents in the 1960s. If she visited a home, she would find more computers—in a father's or mother's home office, in the children's bedrooms, and perhaps even in the kitchen. She might find the family watching television together, but it could now be an enormous flat-screen television with hundreds of channels as well as instant access to films and whole television series, streaming from yet another computer. More often, she would find various family members using their own media devices, and she would notice that the children were apparently typing messages to one friend on the same computer or tablet with which they were talking to another. A few years after our time traveler left her time for ours, Stanley Kubrick's *2001: A Space Odyssey* (1968) would have shown her an astronaut making a video phone call back to earth (handled by AT&T). Now everyone seems to be able to use their small computer screens to talk to and view each other, and their video camera, embedded at the top of the screen, is like a tiny version of HAL's oculus.

Perhaps nothing in our culture today would mystify a visitor from 1960 more than social media such as Twitter, YouTube, and Facebook. These forms of expression have analogies in practices that our time traveler knew (writing letters and greeting cards, making home movies or audio tapes, pasting travel photos into albums as keepsakes and inflicting them on friends and neighbors), but their technical configurations and their manic attraction for hundreds of millions of people around the world would have been unimaginable in 1960. This is not to deny the social changes that have occurred in this period in the life of American women, for example. In 1960, nearly 80 percent of women in their early thirties had never completed college and were married with children; by 2012 less than a third fit that profile (Cohen 2014). Such changes in family relationships and work status are enormously important. They might surprise a visitor from 1960, but they would make sense as part of long-term trends. Expanding roles and opportunities for women have been part of a progressive agenda in America and Europe for many decades. But what cultural critic or for that matter scientist or inventor in the 1950s or 1960s could have predicted Facebook?

In Europe and North America, certainly in the United States, changes in our media culture are among the most visible in our everyday lives. The developments in the 1970s and 1980s (cable television, VCRs, CDs, desktop computers and then laptops, and computer communication mediated by modems) were followed by video games, the introduction of cell phones, the World Wide Web, and the exponential growth of the Internet in the 1990s, and these technologies gave rise to smartphones and social media in the 2000s. All but the poorest among us have cell phones, and the use of computers and the Internet for entertainment and social communication now rivals or surpasses commercial and business uses. According to Statista (2017), 23 percent of all adults in the United States stream Netflix daily to their devices.

The key characteristics of our media culture today are ubiquity and diversity. All sorts of media products and services are available everywhere (at a price) and, despite the predictions, all these products and services have not melted into a single universal form. Virtual reality and the universal 3D interface have not eliminated desktops and laptops, and digital technologies have not taken over all forms of media entertainment. Most older forms are still here, although their status may have changed or diminished. Our time traveler from the 1960s could still experience live music in concert halls, comedy in clubs, live theater, and street musicians playing all the familiar instruments. She could still choose to read her novels on paper rather than in an ebook. And she could still visit art houses to watch classic films on the big screen rather than her tablet, computer, television, or smartphone. Digital technologies have become the occasion for greater diversity in our media economy rather than a single unifying medium.

These changes are not the result of technological developments alone, although we often speak as if they were. We say: "The cell phone has destroyed privacy in our society"; "video games make our young people less socially adept"; "social media are redefining the concept of friendship." We should understand such claims as a shorthand for a more nuanced relationship between technology and other aspects of human creativity and social interaction. Obviously, today's diverse media forms would not be possible without the hardware and software of the Internet (fiber optics, routers, Internet protocols, and so on). Some of the dullest technologies have been important in fostering the current mediascape. Disk storage has for decades followed a path similar to Moore's law for transistors—a

doubling of capacity every couple of years—and as a result we can easily store the enormous volume of text, images, and videos generated by the World Wide Web, video-sharing sites, and other social media. According to one study (Hilbert 2015, 2) the world's total digital storage capacity in 2014 was already a number too large to have any meaning for most of us: 4.6 sextillion bytes (a sextillion is a 1 followed by 60 zeros). Database software and smart programming has enabled search sites like Google to index the entire web and return answers to our searches in a fraction of a second (Levy 2011). What defines digital media today, however, is not just these technologies, but also how they are used, and here the changes depend on the innovations of a few individuals and the preferences and responses of millions of users.

It is much easier to predict the development of digital technology itself than the peculiar new forms that people fashion out of this technology. As soon as the Arpanet was put on line in 1969, it was relatively easy to imagine that a vastly expanded network of computers would one day allow individuals to share all sorts of textual information. Global hypertext, implemented around 1990, was envisioned decades earlier by Ted Nelson as *Xanadu*, a universal digital library in which everyone could write (for free) and read (for a price). No one, however, predicted the webcams of the 1990s, where a user could train a video camera on their pet hamster in his cage and broadcast his movements twenty-four hours a day. No one imagined that YouTube, which began as a site for sharing amateur videos, would become so popular so quickly that it could be sold to Google in 2006, eighteen months after its initial launch, for $1.65 billion—and no one imagined that a company that provided a searchable index to online data would have $1.65 billion to spend. AT&T tried to market its Picturephone (unsuccessfully) as early as 1964, but no one in the 1960s would have argued that a principal use of the connection between portable phones and the data network of the future would be to send text messages limited to 280 characters to friends and anonymous "followers." No one would have imagined that these brief messages could affect the course of the presidential election in 2016. These facets of today's media culture were not predictable because they are not extrapolations of technological know-how; they depend instead on the creative appropriation of technological change by individuals and groups. They are the substance of media culture.

Our Media Plenitude

It would be difficult to exaggerate the size and scope of our current media culture. Traditional television and film still have audiences in the hundreds of millions, sometimes billions (as television does during the Olympics and the FIFA World Cup), and the newer participatory digital media have now reached comparable levels. Internet World Stats (2017) put the number of Internet users in March 2017 at over 3.7 billion, about half of the world's population, and the number of Facebook users in June 2016 was over 1.6 billion. In 2016, approximately 500 million tweets were sent every day on the microblogging site Twitter (K. Smith 2017). YouTube (2017b) claims to have over a billion users. Both in absolute numbers and in rates of participation, more people in the developed countries are publishing or communicating in digital form than was ever the case in print.

Figure 0.2 is a visualization created in 2003 by Barrett Lyon of the many millions of IP addresses on the Internet, with special coloring to indicate network location. Lyon's image, which was at one time on display at the Museum of Modern Art in New York, makes the Internet look like the night sky photographed by a powerful telescope, and the analogy to the physical universe suggests how enormous the Internet is. We might be reminded of William Gibson's ([1984] 2000) decades-old definition of cyberspace as "a consensual hallucination experienced daily by billions of legitimate operators, in every nation, by children being taught mathematical concepts ... a graphical representation of data abstracted from the banks of every computer in the human system. Unthinkable complexity. Lines of light ranged in the non-space of the mind, clusters and constellations of data" (51). Gibson was writing before the World Wide Web was conceived by Tim Berners-Lee and long before the blogosphere and social media. Today our cyberspace is not limited to the "non-space of the mind": laptops, tablets, and smartphones now connect the information "abstracted from the banks of every computer" to our physical location and cultural life. Digital technologies take part in a vast media ecology that encompasses the analogue and the digital, the physical and the virtual.

The condition of media culture today is a plenitude—a universe of products (websites, video games, blogs, books, films, television and radio programs, magazines, and so on) and practices (the making of all these products

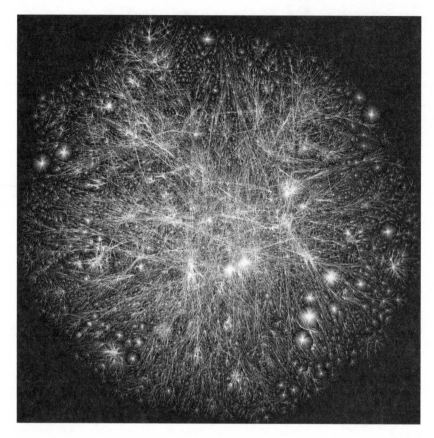

Figure 0.2
Visualizing the plenitude of the Internet: Barrett Lyon, Opte Project, 2003.
Note: The original image used red, green, blue, yellow, and cyan to indicate different locations.

together with their remixing, sharing, and critiquing) so vast, varied, and dynamic that is not comprehensible as a whole. The plenitude easily accommodates, indeed swallows up, the contradictory forces of high and popular culture, old and new media, conservative and radical social views. It is not only the size of our data universe that makes it a plenitude, but also its complexity in relation to our ability to access and assimilate it. The digital giant Google built its business on our need to trace threads of order through the plenitude. In a web culture that enjoys elaborate and often bewildering visual designs, the Google search page has remained simple and functional,

and its simplicity invites us to believe that we can gain control over the universe of digital information. And Google is only the most popular and visible of a network of portals that make the web momentarily coherent for us, including other search engines (Bing, Yahoo, Baidu), social network and news aggregators (digg, Reddit), and commercial lists (such as craigslist). Their services purport to organize all the media in our complex culture, but that is a fiction. The more an individual can master these organizing tools, the larger her sphere of control, but she cannot hope to manage more than a tiny fraction of the ever-expanding web.

The ambition of Google's founders, Sergey Brin and Larry Page, has been to extend their services to master all the dimensions of this digital world, including the digitizing of as many earlier media forms and as much content as possible (Levy 2011). So they purchased YouTube (the largest video portal); they implemented the Chrome browser to house their various media portals; they created Google Maps, which serves as a platform for absorbing location-based information into their digital system. They aim to digitize as much of the physical world itself as possible and incorporate it into their data store—with Google Street View as an adjunct to Google Maps, with the Android operating system as a platform for smart mobile phones and tablets, and ultimately with Simultaneous Localization and Mapping (SLAM) technology. Meanwhile, Google Scholar constitutes a vast textual library of academic and scientific work. Google also made it their goal with Google Books to digitize all the books in the world—a bridge too far, it seems, because of the objections of publishers, authors, and legal institutions to this incursion into their universe of print (Darnton 2011). Google, Amazon, and other media giants will not destroy, but may well refashion our notion of the book, scholarship, and the university.

The media plenitude today is not only digital. Our media landscape has not collapsed into the one single *metamedium* that digital enthusiasts have long predicted. Although it is Apple, Google, and Facebook that garner attention, earlier media remain important both in cooperation and in competition with digital forms. In the world of entertainment, movies are promoted on YouTube, written about in blogs and fansites, and sometimes made into video games. In politics, television news shows and print newspapers are in constant dialogue with tweets, political blogs, and politically motivated YouTube videos. At the same time, we should not forget that millions of viewers still watch traditional network television, sometimes even

broadcast in real time, that millions buy and read print paperbacks and magazines, and that millions go to see films and live theater. In addition to all these traditional mass forms, it is worth remembering that the plenitude of our media culture is also filled with old and new "minor" forms: card and board games, centuries-old forms for personal writing such as notebooks (how many Moleskine notebooks are sold to would-be Hemingways each year?), calendars, diaries, and journals, and expressive crafts of all sorts. Digital technology has not eliminated any of these yet; instead, the digital realm provides reflections, extensions, and remediations of many, but not all, earlier forms. So digital versions of Scrabble and Monopoly, social blogs and online calendars, graphics and photographic programs for laptops, tablets, and smartphones, websites and blogs for crafts and hobbies all now exist beside their analogue counterparts—all adding to the blooming confusion of the media plenitude. Even before the arrival of computers, the twentieth-century mediascape constituted a plenitude with vast collections of printed books, sound recordings, photographs, films, and so on. But the processes of communication were slower and participation by individual readers and viewers more constrained. The various media were separated and classified according to a hierarchy of forms. Libraries housed serious monographs on their shelves, with "special" collections for images and perhaps films. Many forms, such as comic books and popular genre fiction, were seldom collected or classified by libraries at all, until relatively recently in the case of comics (MacDonald 2013). We did not recognize as easily the interrelatedness of various media and media forms and of production and consumption.

The vision offered by the library, the great institution of the age of print, is that all the information and experience generated in our media world could be brought under one system of bibliographic control. But today there is no single hierarchy of knowledge or of media forms that can provide the basis for organizing all our texts, images, audios, videos, and digital media. The collapse of hierarchy, as much as the advent of digital technology, is the reason why our media universe looks like a map of stars rather than the concentric desks of the Main Reading Room of the Library of Congress.

Modernism and the End of Elite Culture

By the middle of the twentieth century, we were experiencing a great change in our understanding of who makes culture and for whom. Cultural conservatives such as Dwight MacDonald (2011) were acutely aware of this

change and simply hated it. In the 1950s he wrote that there is "High Culture" and "Mass Culture, or better Masscult, since it really isn't culture at all. Masscult is a parody of High Culture. ... And the enormous output of such new media as the radio, television, and the movies is almost entirely Masscult" (1). Such unembarrassed elitism may seem surprising and even amusing to us today. Movies do not even count as culture? But MacDonald, an influential critic who wrote for the *New Yorker* and was in fact a political leftist, illustrates how different cultural assumptions were prior to and even during this period of breakdown.

The meaning and status of art was being transformed. In the 1950s most people who cared about art still believed that it was something you found on the wall of a museum or gallery, and in that sense the drip paintings of Jackson Pollock were no more radical than the impressionist paintings seventy-five years earlier. But by the 1960s the definition of art could include a performance by Yoko Ono, who sat motionless on a stage while members of the audience came up to cut off pieces of her clothing. In 1974, Joseph Beuys was making art by locking himself in a room with a coyote. The boundaries of art and literature were expanding in other ways: what had previously been dismissed as popular entertainment (rock music, film, and science fiction literature) was gaining increasing cultural respect. By the 1970s, rock musicians were being asked what they were trying to express in their music, and academics and critics regarded films by Bergman, Godard, Antonioni, and even the popular Hitchcock as masterpieces. The elite cultures of traditional art, literature, and classical music were being challenged or more often simply ignored by rising popular forms. The "Great Divide" between high and popular culture was closing (Huyssen 1986). Today what was elite art has not declined in quantity—the many art communities remain vigorous—but it has lost its special status.

There was an assumed hierarchy, and it fragmented, and the fragments ended up on more or less the same level. Symphonies, rock songs, hip-hop, and reggae are now styles of music that happen to appeal to different audiences. Some people read novels; others prefer films. Some like the art they find in galleries and museums; others prefer comic books or the commercial art available in department stores and on the walls of indie cafés. As the distinction between art and entertainment has lost its legitimacy, universities have gradually broadened their curriculum to admit new kinds of works into traditional fields in the humanities. Some universities added departments for film and television studies, and most of those that did not

now include the study of these popular media in English, history, or music departments. Graphic novels, if not all comics, are appreciated as new literary forms, again often in catchall English departments, and courses in the appreciation of rock music have become common.

Within many communities in our complex media culture, hierarchies remain. But there is no single hierarchy; there are no principles acknowledged across all the various cultural communities. The communities that create and enjoy rock music or comics no longer regard their work as inferior to the much smaller communities that follow classical music or "serious" fiction (the kind reviewed in the *New York Review of Books*). This becomes clear when we consider what has happened to the names that were used to designate the activities of elite art and culture, which began to float freely through our culture, sometimes reclaimed by traditional arts and sometimes appropriated by popular entertainment of all kinds. The traditional, honorific meaning of the term "elite" became embarrassing. Few today claim to be part of elite culture, not even those authors of serious fiction, classical musicians, composers, and painters who had seemed to constitute a class apart in the past. Instead, the term is used to designate the best in almost any field, particularly sports: elite tennis players, elite quarterbacks, elite bowlers. And the term "artist" can be used for almost any kind of creative performer or maker: from painters and sculptors to those who inscribe tattoos (body art).

With the decline of elite modernism in the second half of the twentieth century, Art (with a capital A) came to an end. Artistic practices have not come to an end at all; there must be tens of thousands of acknowledged artists, by profession or vocation, in Europe and North America alone, many more in Asia and the less digitally connected areas of the world. What died was a shared belief in the centrality of art and literature and their power to redeem culture, a conviction of both romanticism and modernism. Even today, many, perhaps most, in the art community assume that they are doing the same important cultural work that their predecessors (thought they) did. But in the digital plenitude, there is a much larger (orders of magnitude larger) group of communities bringing forth products and performances that do not depend on the established traditions of visual art, literature, or music. These vast communities may make implicit or explicit claims to the status of art, or they may not make any claims at all.

It is not only Art that has come to an end. Other sanctioned forms of expression have suffered a similar decline, including reflective writing

and contemplative reading, and public and political debate. And again, reading, writing, and political debate are not in danger of literally disappearing. More words are being produced (on keyboards) and distributed (mostly over the Internet) than ever before: but extended writing, such as the essay, has lost its status as our culture's favored way to promulgate ideas. Blogs, microblogs, talk radio, and television are tremendously popular, but the frantic rhetoric of the blogs and political broadcasts does not constitute public debate in the traditional sense. Ideologically coherent politics is being joined (not replaced) by other kinds of discourse that do not look much like traditional politics. In just a few years, Twitter has become a major platform for this new, highly charged political rhetoric.

The fragmentation of hierarchies in the arts, humanities, and political discourse have been announced many times in many contexts since at least the 1960s, but this cultural moment feels different, in part because digital technologies, including social media, make the changes far more apparent. This book focuses on collapsing hierarchies in arts and entertainment rather than the eroding of social hierarchies during this same period. But clearly all sorts of hierarchies were coming under pressure at the same time. The 1950s, 1960s, and 1970s in America witnessed great strides in overturning hierarchies based on race, gender, and ultimately sexual preference. There is no simple cause-and-effect relationship between these movements for social justice and the waning of the elitism in the arts, but the forces for change in the arts and in social and political life often supported each other. Folk music singers of the 1960s took up themes of civil rights as well as the traditional workers' rights. Bob Dylan's "The Times They Are a-Changin'" and Joni Mitchell's "Woodstock" helped spread the messages of these social movements (especially to white, middle-class, young people). Progressive rock music supported freedom from antiquated social rules as well as opposition to political elites. These musical genres also gained importance from their association with the civil rights or anti-war movements. Folk and rock could claim to contribute to social change in a way that classical music could not.

Centers but No Center

By the end of the twentieth century, an educated person in the United States, and increasingly in Europe, no longer had to know certain authors, certain artists, or certain composers. The former elite arts are still enjoyed;

a few million still attend the opera; many millions go to art and history museums; collectors pay astronomical sums for famous paintings. According to the American Alliance of Museums (2017), there are approximately 850 million visits to American museums of various sorts each year, more than sporting events and theme parks combined, and arts and cultural production combined account for 4.32 percent of GDP. Claims are still made for the importance of various arts, but these claims only hold within a given community (however large or small) of patrons and practitioners. Economic arguments made for the arts (such as the GDP statistic quoted above) in fact indicate the uncertain status of the arts in our society today: why should it be necessary to justify the importance of the arts based on their contribution to the economy? The rest of our patchwork culture of groups, tastes, and practices pursue their own interests. Some, like the founders of the art-sharing site deviantART (2018), will generously claim that it was created "to entertain, inspire, and empower the artist in all of us"—in other words, that all expressive practices are arts and all are important—but this is still to deny that our culture has a center.

The nineteenth-century poet Matthew Arnold (2004) wrote: "Without poetry, our science will appear incomplete; and most of what now passes with us for religion and philosophy will be replaced by poetry" (134–135). In the nineteenth century, art was often characterized as a sacred calling (Shiner 2001, 194–212). After Schiller at the end of the eighteenth century, it was common to regard "art as the revelation of a superior truth with the power to redeem" (Shiner 2001, 194). As educated elites in Europe and North America became more ostensibly secular, art was regarded as an increasingly important antidote to the shock of modern urban living. Although twentieth-century modernism rejected the "bourgeois" art of the nineteenth century, the guiding assumption of the centrality of literature and art was hard to get rid of. Even the avant-gardes, such as the Futurists and Dada who ridiculed the art of their day, confirmed the importance of art by trying so hard to destroy it. The Dada artist Hans Richter (1978) wrote in his history of the movement that Dada's attempt to make anti-art had to fail, because "a work of art, even when intended as anti-art, asserts itself irresistibly as a work of art" (164).

The assumption that art and literature are central to culture and have the capacity to rejuvenate us individually or to save our society in general has ceased to be broadly compelling. It may still appear in the consciously

old-fashioned pages of the *New Criterion*, a journal whose purpose is to provide a conservative cultural voice and is proud to be elite. But such journals address only a particular community, one that is most likely pessimistic about the direction of our culture. Some digital media writers—for example, Jane McGonigal (2011)—have picked up the rhetoric of cultural salvation and now apply it to video games or other digital media forms. Others claim that films, television, or video games are art and therefore central to culture, or that they are not art but are nevertheless central to a new popular culture. Every permutation of the old modernist assumptions pops up somewhere, among some community, in our current media age.

In *Amusing Ourselves to Death*, Neil Postman ([1985] 2005) argued that television was destroying literacy and that this meant the debasement of both literary and political culture. In fact, in the 1980s, when Postman was writing about the ascendency of television, the inventors of the desktop interface for the personal computer were already in the process of constituting a new set of forms that would reconfigure the place of print, film, *and* television in our media landscape. Today, former elite culture, though no longer central, has not been replaced by any of these popular media or forms. Instead, each cultural form can serve as a center for a larger or smaller community of patrons or users. Some of these communities are enormous, close to universal, though probably also short-lived. The YouTube video of Justin Bieber's song "Sorry" has 2.8 billion views, more than the population of the United States and the European Union combined, and over two thousand times as many as the views of a video of a Leonard Bernstein performing Beethoven's Ninth Symphony in Berlin, which itself has over a million views. The size of the community matters for its economic power but not for its claim to being at the center.

Art and media are now the same thing. To say someone is an artist has become simply another way of saying that he or she works creatively in any recognized media form, old or new. Digital media today give participants in thousands of media communities the opportunity to call themselves artists, if they choose. The loss of the center means that there is no single standard of quality that transcends the various communities of practice. However much some may still long for "quality," the word does not have a global meaning. Professional communities will produce better work by their own standards than others. Professional videographers will produce more technically competent videos than amateurs who use a webcam and

post their videos on YouTube. But technical competence no longer makes a video better in any sense that our whole culture shares. If this seems ironic, we have only to remember that American television is technically the best in the world, but many in the United States and elsewhere would appeal to various standards to judge that much American television programming is of poor quality. There can be no general cultural judgment about American television, because there are no generally shared standards.

I am focusing on the United States, which has a low level of public support for the traditional arts. The situation in Europe is more ambiguous, and in general the distinction between high culture and popular culture has faded more slowly there. Germans even today, for example, speak of *Unterhaltungsfilme*: films designed merely to entertain as opposed to art films. It is interesting that Americans just speak of film or movies. Entertainment is for them the default category; "art film" is a special category. State support for opera and theater in France, Germany, and elsewhere in Europe also helps to maintain these traditionally elite forms, when they are not self-supporting. But even in Europe, opera, traditional theater, painting, and so on are losing any universally acknowledged claim to being culturally superior to film, popular or ethnic music, and television.

This is not to say that all cultural communities acknowledge the loss of the center. Many in the traditionally elite communities continue to assert or just assume a place in a hierarchy that only they still accept. They may come to some complicated negotiated position, in which places may also be ceded to some forms of popular culture. The National Endowment for the Arts provides a good example of this rhetorical compromise, in which jazz and popular theater, film, and even television are part of the creativity and vigor of the American art scene. Recently even video games, at least "artistic" ones, have been included under Media Arts (National Endowment for the Arts 2018). Meanwhile, many writers and practitioners in digital media believe that the work of their community is at the center of a new cultural order. It is an important part of the legacy of modernism to think that one's art contributes in a fundamental way to our culture's future.

It is therefore not just elite communities that are upset about the loss of the center. The so-called culture wars, which became a national issue in the early 1990s and have reemerged recently, were not fought solely or even principally over the arts and elite culture. Conservatives were also reacting to the loss of community and shared assumptions among the American

people as a whole. When conservatives complain about the "war against Christmas," they focus their anger on companies such as Starbucks or on the television networks. What they are really protesting against are manifestations of the long trend that Robert Jones (2016) characterized in his book *The End of White Christian America*: the breakdown of a hierarchy in which Protestantism, first in the mainstream churches and then in its evangelical form, constituted the religious and social paradigm for the whole society. When Trump promised in the election to "make America great again," the community of evangelicals allowed themselves to imagine that he could restore it to the center. But it is not just the religious center that has been displaced; popular culture has also fragmented in its tastes in entertainment, and here the multiplication of media technologies and the rise of Internet were important factors.

Commentators today lament the fact that we no longer share popular cultural references, as we did when there were only three television networks. In the 1960s, the argument goes, everyone could discuss around the water cooler (did all offices really have water coolers?) what happened that week on *Doctor Kildare*. In the 1959–1960 season, for example, 40.3 percent of all televisions in use on Saturday night at 10:00 p.m. were turned to *Gunsmoke* on CBS. By comparison, in 2016–2017 the hit *Big Bang Theory* had a viewership of 11.5 percent (Wikipedia contributors, "Nielsen Ratings"). Cable television, the VCR, and the DVD player all had a role in fragmenting viewing audiences for film and television, turning what might once have been a single community into many. More recently Internet streaming has completed the transformation. With the exception of some of the leading pop singers and a few actors (George Clooney or Angelina Jolie), there is no performer, television show, or movie that "everyone" has seen or can even name.

In 1976, cartoonist Saul Steinberg created a classic cover for the *New Yorker* magazine, representing a Manhattanite's view of the world. In the foreground Ninth and Tenth Avenues are drawn in detail. As we look west across the Hudson, the American continent recedes into a few major landmarks, while beyond the Pacific there are thin, colorless blobs for Japan, Russia, and China. The cartoon itself could be an emblem of the loss of the center, drawn at a time when New York had not quite given up its status as America's cultural capital. What happened to this clever cartoon is itself emblematic: it became in contemporary terms a meme. It was imitated

for countries, cities, and even small towns, always with the same joke: the immediate environment is huge and important, and the rest of the world recedes.

If you want to picture accurately the media culture we live in now, imagine an endless series of imitations of Steinberg's Ninth Avenue cartoon (figure 0.3). Almost every point in that culture, every genre of blog or social media or video remix, every craft or hobby, every manifestation of DIY (do it yourself), every MMORPG (massively multiplayer online role-playing games) as well as each traditional media form serves as the center for some community of users. For many gamers, for example (and this is clear from reading Ralph Koster 2005, James Gee 2007, and Jane McGonigal 2011), video games are at the center of digital culture and at the leading edge of our social and creative life. Games are at Ninth Avenue; everything else recedes. For moviegoers, the center is still Hollywood. For fan cultures of *Star Trek*, *The Matrix*, and *Lost*, as described by Henry Jenkins (2006b) in *Fans, Bloggers, and Gamers*, the center lies in the cross-media chains of films and websites and attended events and meetups. For the smaller world of serious fiction, the center is still New York.

To appreciate the variety and the ambiguity of media culture today, there may be no better barometer than Twitter. A search on Twitter for "#art" on an afternoon in the winter of 2016 produced pages with every imaginable variation on the concept of art: images of elite art, mostly paintings, mixed with cartoons, digital 3D graphic art, street art—some by well-known figures, many by the posters themselves. Some tweets were from people selling digital or physical artifacts: paintings, photographs, carvings, t-shirts, and so on. Often these were in a popular or retail style that the earlier elite art community labeled kitsch. The very fact that all these posters choose the hashtag #art indicates a desire to have that status. Every possible contemporary use of the term "art" must eventually turn up on Twitter.

Twitter illustrates what should now be obvious to anyone born after World War II. From that time on, no one had to justify going to a popular music event rather than an opera or to a film rather than an art gallery. In the decades that followed, it became increasingly true that no one had to apologize for watching television, reading comic books, or playing video games. Or rather, you had to justify yourself only if you belonged to a certain community that still kept to the standards of formerly elite culture—the classical music community or the fiction community. It remains hard

Figure 0.3
Saul Steinberg, "View of the World from Ninth Avenue." © The Saul Steinberg Foundation/Artists Rights Society (ARS), New York.

for many—the "winners" in popular culture as well as the "losers" in elite culture—to acknowledge this situation and to understand its consequences. The results are the inconsistent and confused conversations that we still have about art and culture. Once again, the breakdown of the modernist paradigm does not mean that modernism has been effectively replaced with a new paradigm, a new -ism (although there are many contenders, often with the prefix post-). High culture and art have not been replaced by television, video games, or anything else. There is no new universal paradigm.

Instead, our media culture has become additive, accepting new forms, such as video games, that sometimes cooperate with older forms, such as film, and sometimes compete with them.

Popular Modernism

When the status of elite culture changed and the barriers between elite and popular culture became increasingly porous, the dominant cultural paradigm happened to be modernism. Aesthetic and intellectual principles of modernism then filtered "down" into popular culture and were adopted by jazz and rock musicians, filmmakers, designers, and most recently digital media producers. A dialogue between elite modernism and popular culture had been going on throughout the twentieth century, but it became more productive in the 1950s and 1960s. At that time, when modernism was being superseded in the art community itself, a kind of "popular modernism" began to thrive in the larger media culture. John Lennon borrowed techniques from the avant-garde in his political protest music. The modernist notion of medium was appropriated by Marshall McLuhan to explain the impact of television and later by Alan Kay and others to define the computer as a new medium of expression and representation. Steve Jobs and his team at Apple applied a modernist aesthetic to the design of the Macintosh and then fifteen years later the iMac, iPod, iPhone, and iPad. The rhetoric of popular modernism is still influential today not only in writing about film, music, television, and video games, but also in the utopian predictions of digital media writers about virtual reality (VR) or artificial intelligence (AI). Such predictions are part of the complex and contradictory mashup of beliefs about art and creativity that characterizes our media culture in the twenty-first century.

Following McLuhan, popular modernists have emphasized the interactions and tensions as new media arise: first the challenge that television posed to the culture of print and now the challenge that digital media pose to print, television, and film. And it is true that these newer electronic and then digital forms have contributed to a reorganization of our media economy. In a plenitude that is increasingly digital, the role of printed books has been challenged. In the nineteenth and twentieth centuries, the "industrial age" of print, the printed book was itself the best evidence that our intellectual heritage is a comprehensible whole. But if books and

traditional scholarship once helped us order and organize our world, the digital plenitude is no longer comprehensible in the same way. The status of traditional humanistic reading and writing has obviously diminished in an era of social media. Google Books and other electronic services make texts instantly available, but they also place the book in visible competition with other media forms. The same is true of the university and the whole academic establishment. Despite utopian or dystopian predictions the traditional university will not be replaced in any near future by online courses (remember MOOCs?) or DIY education based on blogs and Internet search engines. On the other hand, because higher education in North America and Europe has been based for centuries on the scholarship of the printed book, the "end of books" does challenge that foundation. The loss of an agreed-on cultural center and the rise of amateur scholarship such as Wikipedia do threaten the status of the university, particularly the humanities. The same breakdown of hierarchy that happened in the arts in the 1950s and 1960s also happened in the humanities and the academic world in general. Here too, digital media arrived to offer new accessibility and broader participation in cultural tasks (such as the writing of encyclopedias and the practices of citizen journalism) that were once reserved for credentialed experts.

When we look at our current media culture from the perspective of the modernist enterprise that dominated the twentieth century, we confront a series of endings. We have already experienced the end of Art with a capital A, and we now face the end of the centrality of printed books and of humanistic scholarship. But just as the coming of digital media has abetted these changes, it is also supporting new forms of creativity.

Creativity in the Digital Plenitude

The electronic, stored-program computer was not a medium at its inception in the 1940s. The first generations of machines were designed to solve problems in numerical analysis for scientists and engineers. In the 1950s and 1960s, computers were used increasingly to manage large-scale databases for business and government bureaucracies. The creators of this new technology (such as Alan Turing and John von Neumann) understood the computer as a symbol manipulator, where the symbols could be numbers, letters of the alphabet, or other arbitrary systems. At the same time AI

provided a cultural metaphor for the computer. AI's claim was that intelligence was nothing more than symbol manipulation: humans were intelligent because their brains could manipulate symbols, and computers were becoming increasingly intelligent in the same way.

Beginning in the late 1960s, a new group of technologists (including Douglas Englebart's team at Stanford, Alan Kay and others at Xerox PARC, Steve Jobs and his colleagues at Apple) set about to redefine the computer as a medium for representation and communication. By developing the personal computer, the graphic user interface, 3D computer graphics, local- and wide-area networking, they helped to provide millions of users with a digital platform for reading, writing, and eventually aural and visual communication. These technologists had a modernist conception of what a medium is and of their capacity to engineer culture, but in fact they were designing the platform for media culture at the end of modernism. The digital media they helped create now support an enormous, heterogeneous world of media forms, makers, and users, a world with as many centers as there are communities, and more communities than anyone can know. If the printed book and the library were suited to define hierarchy and cultural order, networked digital media are suited to foster multiplicity and competing orders. The Internet and the World Wide Web provide an ideal environment for the various elements of traditional high culture and popular culture to coalesce into their own media communities. The fragments of modernism turn up in many of these communities: among film critics and enthusiasts, makers and critics of video games, industrial designers of computer interfaces, tablets and smartphones, graphic designers for print and digital media, and so on.

For some digital communities, then, it makes good sense to keep close to the modernist heritage. The stand-alone computer of the 1940s was a modernist machine, the physical embodiment of the finite-state logic of Alan Turing. But today, when each computer is part of a dynamic network of devices, applications, and users that constitute the digital plenitude, the grounding assumptions of modernism no longer suffice. The loss of hierarchy in cultural knowledge clears the way for greater participation in our media culture. Traditional universities coexist with online communities that share knowledge without any formal credentials. Gallery art coexists with online art of every style. In fact, style itself, which was the imperative of modern art, is now completely a matter of personal preference. Play

becomes a powerful metaphor for cultural participation, and playing in the plenitude means assuming there is no imperative, nothing that has to be done based on a controlling historical understanding. Everyone is invited to play in whatever corner of the plenitude she cares to, and all kinds of making and playing can be characterized as art or creativity.

While there are no universals in media culture today, there are many qualities worth exploring, because they are shared by many communities or because they are compelling remediations of the age of modernism. One of these is procedurality. Popular modernist writers today claim that this is the essence of the computer: its procedures (algorithms, programs) allow it to interact with other machines and human users in increasingly complex and creative ways. Video games and social media are procedural: they require human users to enter into a procedural loop that both constrains and empowers them. Procedurality is itself the latest version of mechanization, which has been a key condition of society and economy since the Industrial Revolution. While modernism was vitally concerned with the cultural meaning of mechanical and power technologies in the twentieth century, today's media culture is exploring how far procedurality and simulation can penetrate into and redefine creative expression as well as our politics and everyday lives.

Procedural media often favor a particular state of mind in their users. Video games and other contemporary cultural experiences aim through repetition to induce in their audience a state of engagement that the psychologist Mihalyi Csikszentmihalyi has named *flow*. The player of a video game, a Facebook user, or a YouTube viewer falls easily into a state in which she simply wants the experience to continue at a more or less constant rhythm. This flow state in digital media contrasts with another familiar state of mind often called *catharsis*. Popular films, novels, and a great deal of traditional music aim to evoke catharsis, an emotional release through identification with a main character. And even if the newest digital media favor flow rather than catharsis, neither aesthetic seems likely to eliminate the other. Neither is dominant in our time. Millions prefer to spend their leisure time watching films, whether in a theater or streamed to their computer; millions play video games; and of course many millions do both. What is new is that the flow aesthetic has an equal status with catharsis. Video games are now as legitimate a cultural experience as novels, though largely for different communities.

Remix is another facet of our current media culture that thrives in and through digital technology. DJs, dance remix, and hip-hop (all now supported by digital sampling and mixing machines) are among the most influential musical trends of recent decades. And the Internet's vast (commercially available and pirated) resources of photographs, films, television shows, and printed texts invite professional and amateur players to appropriate, edit, and combine samples into new versions. Remix is a repudiation of the modernist and earlier romantic notions of originality. Remixes on YouTube and throughout the web may be clever or trivial, compelling or mind-numbing; they may be original and derivative at the same time. Huge remix communities today reject the absolute values of authorship and intellectual property that seemed unquestionable in the heyday of the printed book. Yet even some of the pioneers of the current digital media technology protest against the "remix ethic" of borrowing and revising, because interfaces and applications can be revised and remixed as well as songs and films.

This is the digital plenitude that our time traveler from 1960 would discover. It would be overwhelming in its variety, and perhaps she would react by focusing on the ostensibly improved forms of media that are most familiar to her, such as digital films, HD television, and mobile phones. On the one hand, if she stayed in our time, she might come to regret the loss of a common cultural language, even for popular culture. On the other hand, if we put someone from contemporary media culture in our time machine and sent him back to 1960, he would be struck by the absence of media devices in daily life and the paucity of choices among media that were available. There obviously would be no World Wide Web, social media, streaming video and audio, email, or cell phones; he would have access to a few films each week in local theaters, programs in real-time on three or four television networks (without the option of a DVR for time-shifting), and music on the radio and on long-playing disks (but of course no iTunes store for instant purchase). Printed books in bookstores and libraries, however, would be abundant. There would be fewer media communities for him to join, but (perhaps) more shared cultural interests across those communities. The point is that from either perspective, 1960 or the present, the other world looks somehow defective. To a time traveler from 1960, the present is a chaos of media forms all competing for our attention, far too many to absorb and appreciate. The view from the present is that the earlier media culture is parochial, limited, and hierarchical, especially because

of the absence of participatory media. In 1960 a relatively small group of producers controlled the content for a huge audience of consumers. But the relative cultural unity of that period also meant the categorization and marginalization of women and minorities in the media to an even greater extent than today.

Although no one can travel back in time, there are many today who seem to be stuck in a particular moment in the past. I mean contemporary critics who evaluate our current media culture from a perspective that belongs to the mid-twentieth century. They assume that we should still have a unified media culture for art and entertainment and an agreed set of standards of evaluation. Whether they realize it or not, they are popular modernists who want to reinstitute a hierarchy of forms enlarged to include their own popular favorites, such as film or rock music, raised to the level of art. What they fail to acknowledge is that the same forces that freed us from a rigid definition of "high culture" have brought us to a plenitude in which there can be no universally shared hierarchy. It should be no surprise that the shift from that earlier cultural condition to the current plenitude entails both loss and gain. Chapters 1 and 2 of this book consider what is lost; the subsequent chapters consider about what is gained or at least what has changed.

Democracy in the Plenitude

While our media culture has fragmented into hundreds of communities with their own hierarchies, digital technologies have emerged to serve as the matrix for an explosion of new cultural forms. Is this a process of radical democratization of culture? The opportunities for individuals and groups to form their own creative communities in the digital plenitude are literally unprecedented. Would it be more accurate to call this condition cultural anarchy rather than democracy? It is not that the popular culture has won out over elite culture; rather, all possible cultural values coexist in a chaotic brew, especially on the Internet. Yet this anarchy is not in itself harmful. Our media culture is extraordinarily rich and as a plenitude completely undiscriminating. There is an infinite amount of garbage (judged by any one standard), but also a huge amount of compelling work. If we abandon the modernist notion that the purpose of art is necessarily to save culture, we can appreciate the diversity and openness of our current media.

The problem is not the plenitude of media forms and communities today. The problem arises when this anarchic media culture collides with social and political institutions that require shared assumptions in order to function. The chaos that we are experiencing in our political life today is directly related to the breakup of hierarchy and the loss of faith in education, in politics, and in the technological and scientific fields. The plenitude of digital media that supports remix and new forms of games and social networking also facilitates the chaotic brew of blogs, tweet streams, and fake news that have overwhelmed political discourse in recent years. Our institutions need to evolve in order to absorb or perhaps transform these new forms of discourse. It is not at all clear how they can do so and still preserve the notion of liberal democracy.

In the final chapter of this book, we will consider whether the loss of status of elite culture in the arts and humanities and the rise of digital plenitude are themselves among the factors that have contributed to the chaos of American politics today. The modernism of the twentieth century was the cultural matrix not only for extraordinary art, architecture, music, and film, but also for the extreme politics of fascism. Popular modernism today gives us not only remix and video games, but also the sort of popular fascism that goes under the name of populism.

1 The Great Divide

In 2013 the rapper JAY-Z released a video entitled *Picasso Baby: A Performance Art Film*, directed by Mark Romanek. It documents his performance in an unusual venue, a "white-box" hall of the New York Pace Gallery. As he raps, JAY-Z playfully confronts one by one a series of fans and "art-world types," as the *New York Times* article describes them (Trebay 2013). JAY-Z had adapted a work by the performance artist Marina Abramovic, who in 2010 staged a thirty-day event at MoMA, in which she sat motionless and stared at one seated individual after other. Abramovic herself appears as one of JAY-Z's partners. In *Picasso Baby*, director Romanek portrays the joyful atmosphere of an event in which well-known art figures as well as fans are delighted to be taking part. In the song, JAY-Z says he wants to own a Picasso; his lyrics refer to twentieth-century artists (Mark Rothko, Andy Warhol, Jean-Michel Basquiat, Francis Bacon), but there seems to be no particular rationale for his choices. JAY-Z feels no weight of the elite artistic tradition of the twentieth century. His list includes those who functioned comfortably within the elite community and those who were challenging the status of art itself. In the end, he claims to be a modern-day Picasso.

The video includes a brief introductory interview in which JAY-Z explains that he is bringing art and rap as popular culture back together. The point is to transcend the artificial barriers that separate high art from the life of everyday people, which rap is about. Artist Mickalene Thomas suggests a political dimension: "For a young black man in America to be on his level of success and rapping about art, and not what he's wearing, is the coolest thing." JAY-Z was raised by his mother in a housing project in Brooklyn after being abandoned by his father and had early encounters with guns and drugs. And the video certainly intends to suggest his acceptance by the

New York art community. The artist Marilyn Minter says, "JAY-Z speaks to the times we live in."

But what does this performance say about those times? What does it mean to be an artist today, and why does JAY-Z want to portray himself as one? The video is supposed to celebrate the openness of a culture in which traditional art and rap come together, and it perhaps does that for millions of viewers. One fan, Keith Hunt, comments on the YouTube video: "Rap is a complex and beautiful art form. And JAY-Z is one of the best of all time in this medium. I don't see anything weird about one of the best artists in his medium sharing his art at an art gallery." Yet the video provoked reactions from both the art community and the rap community. Some regarded it as derivative or silly; others criticized it simply as poor rap (that is, they judged it by the standards of the rap community, not the art world). The video, the performance, the comments by fans and artists, the reactions in the press and online—all reflect the complex and uncertain status of art among the various communities of our media culture. The great division between elite art and popular culture has almost, but not quite, vanished. What replaces that division is not a consensus about art, but the diverse judgments of these many communities. Each community is free to define its art as central, and some do, but they cannot enforce their definition across our culture, as the elites of the nineteenth and twentieth centuries were able to do. As we shall see, this is what the plenitude means for art today.

The Philadelphia (Orchestra) Story

In April 2011, the Philadelphia Orchestra filed for Chapter 11 protection from creditors; it was the first time that one of the "Big Five" American orchestras had gone bankrupt. The orchestra emerged from Chapter 11 a year later and continued to hold its seasons, unlike many smaller U.S. orchestras, but its bankruptcy was emblematic of the diminishing status of the traditionally elite arts. The orchestra once embodied the distinction between highbrow and lowbrow culture. In 1940 the flamboyant director Leopold Stokowski not only directed the music for but also appeared in the Disney film *Fantasia*, in which seven abridged and rearranged pieces from Bach to Stravinsky were played over fantastical and abstract animations. The film showed that American popular culture was already confident enough to seek to appropriate high culture, but in a way that still honored the hierarchy of art. Stokowski appears as a silhouetted figure in the

film, and Mickey Mouse treats him with nervous reverence. Popular culture approached elite culture on the latter's terms. At the time, this was still not enough for cultural purists. The columnist Dorothy Thompson wrote in the *New York Herald Tribune* that *Fantasia* was a symptom of "the collapse of the civilized world" (Telotte 2008, 37). Although Disney apparently thought that this marriage of classical music and popular animation would inaugurate a new art form, the film was unsuccessful in its first release, in part because it was considered too highbrow by the traditional audiences for the Disney classics and in part because of the costs of its innovative stereo technology (Telotte 2008, 37–41; Boone 1941).

The introduction of sound in film in the late 1920s and early 1930s allowed the preeminently popular entertainment medium to address all kinds of musical cultures. In the United States, opera enjoyed a high status at the beginning of the twentieth century, representing European culture at large. That status was, however, already beginning to change by the time of the Great Depression: it was becoming a symbol of the upper class and its lack of connection with the economic and social problems of the working classes. In 1935, opera furnished an ideal target for Groucho's sarcasm and Harpo's slapstick in the Marx Brothers' *A Night at the Opera*. Yet even this film acknowledged that opera was part of a legitimate high culture. The romantic leads (Kitty Carlisle and Allan Jones) were singers with operatic voices whose songs, while popular, were lyrical and meant to be appreciated as artful. *Fantasia* (1940) showed even greater respect for the classical music that it appropriated. The hierarchy of musical culture prevailed in the 1930s, even if it was beginning to be undermined by the economic importance and social status of popular music.

The situation was different twenty years later when another animated cartoon appeared: *What's Opera, Doc?* (1957). In this parody of Wagnerian opera, Bugs Bunny plays Brünnhilde to Elmer Fudd's Siegfried. The cartoon suggests how rapidly our culture's conviction in high art was fading, as the opera *Siegfried* was depicted without any serious dimension whatsoever. We could argue that opera still had enough status to be the subject of parody. These cartoons were, after all, shown as shorts preceding movies in theaters, so the audiences would include adults. *What's Opera, Doc?* still assumed the audience would know enough about opera to get the joke being had at the expense of this elite art. But the audience didn't need any particular knowledge of Wagner to appreciate the humor of Elmer Fudd lisping his arias. And it is worth remembering that Wagnerian opera was a preeminent symbol

of German high culture, whose reputation the National Socialists had seriously demeaned for 1950s Americans. Today's viewers, clicking through cartoons on YouTube, think of opera in a different way, as representing the arbitrary taste of a small class of well-to-do people. In 1992, *What's Opera, Doc?* became the first cartoon short to be deemed "culturally, historically, or aesthetically significant" by the United States Library of Congress and thus was selected for preservation in the National Film Registry (2013). Elite status was being awarded to a popular cultural work that itself made fun of traditional elite culture.

Throughout the first half of the twentieth century, opera and symphonic music as well as live theater were closely associated with economic and cultural elites in the United States, perhaps even more than in Europe. The association was not as close and restrictive in nineteenth-century America, as Laurence Levine showed in *High Brow, Low Brow* (1988), when Americans of all economic classes, at least in larger cities, might attend an evening of Shakespeare, presented by touring actors, or a concert of operatic arias, perhaps even by a European star like Jenny Lind. Toward the end of the century, however, cultural elites began to insist on "serious" productions and professional music making, and Americans with less education and less money stopped attending. In the new century, they went to the movies instead. Stage plays, operas, and symphonic concerts belonged predominantly to the elites, until the notion of elite art itself began to break down, affecting in particular the cultural position of classical music. Theater fragmented into a variety of forms, some popular and some less so, but it has obviously never regained the status it enjoyed before the coming of film.

A film from before World War II gives us another snapshot of the changing relationship of elite and popular in American culture: *The Philadelphia Story* (1940), based on an earlier play. This romantic comedy is set on the estate of the Philadelphia Main Line's Lord family. Tracy Lord (Katherine Hepburn) and her ex-husband C. K. Dexter Haven (Cary Grant) belong to "high society," and Tracy must ultimately decide between Dexter Haven and the reporter Macaulay Connor (James Stewart), a talented working-class writer. Although it makes fun of the upper class's ostentation and distance from working-class concerns, the film revels visually in Tracy and her relatives' wealth. Tracy may rediscover her joie-de-vivre in a brief evening with Macauley, but she ultimately chooses to remarry Dexter Haven and remain in her class.

For those who appreciate Hollywood's Golden Age, *The Philadelphia Story*, with its charismatic stars and literate script, is still a pleasure to watch. But it frames its central problem, American class disparity, in terms that are meaningless today. The film assumes that class is more than a matter of money—that it is still a valid, if unstable, social category. In 1940, it was possible to believe that class was ingrained, if not hereditary, and that high culture belonged to the upper class. Like *A Night at the Opera*, *The Philadelphia Story* could make fun of that idea, precisely because it was still current. For decades now, certainly since the 1960s, no one outside of those with inherited wealth believes in blue blood, at least in the United States. Certain art forms, such as opera and symphonic music, are associated with wealthy people, but these arts no longer validate the upper class. The tastes of certain social elites are now simply preferences, and the taste for traditionally elite art is not universal even among the economic elite. It no longer seems strange that a wealthy, educated man or woman might prefer country music to the operas that the Marx Brothers mocked.

If the reader is under age forty, none of these references may mean much. Why worry about the fate of opera or symphonic music? But that is the point. If the idea of elite art were still powerful, then every educated individual would feel that she should know something about the operas of Mozart or the symphonies of Brahms. Living in the media plenitude means that there are no such required areas of cultural knowledge.

Class in America

In *The Philadelphia Story* and other contemporary comedies, the "society column" remained an important feature of the newspaper. Today, where it still exists, it is an amusing relic. Debutante balls still exist too, but they have taken on the character of costume parties, performances largely regarded as a class-specific form of cosplay. *Socialite* is a term that designates a curious kind of celebrity, the kind possessed by Paris Hilton, notoriously famous for being famous. The rich and famous still fascinate a broad public, and the hereditary royal families of Europe are celebrities even in the United States. But on both sides of the Atlantic, society figures must share the pages of fan magazines with film stars, athletes, and rock stars. Rock and movie stars have become the model for the celebrity that royalty now share in, not the reverse. The phrase "rock star" (more than "king" or "queen") is now used

to describe a person whose very appearance constitutes an event. When Grace Kelly in the 1950s gave up being a movie star to marry the Prince of Monaco, she moved up on the celebrity scale. By contrast, her daughter Princess Stephanie has a celebrity that is patterned on that of a fashion model (which she was) and a movie star.

In 1926, Fitzgerald wrote in "The Rich Boy" that "the very rich ... are different from you and me," and twelve years later, in "The Snows of Kilimanjaro," Hemingway appropriated Fitzgerald's line and then added "Yes, they have more money." American culture has come to adopt Hemingway's position. We no longer believe that people in the upper class are essentially different from us. Class is as important as ever in American society, but we understand it exclusively in terms of money (and the education and luxury that money can buy). When the *New York Times* published a book entitled *Class Matters* (Correspondents of the New York Times 2005), the reporters made it clear that money defines class. Membership in the American upper class is hereditary, but only in the sense that wealth and education generally pass from parents to children. It may be true that, as Tocqueville maintained, America has always been less disposed than Europe to the idea of an aristocracy defined by inherited qualities or simply birthright. Still there was a sense of "proper people" that lingered in the United States in first half of the twentieth century and faded remarkably quickly in the second half (Levine 1988).

The fading of this belief coincided with the loss of status for the arts that were associated with elites. If no group of people could convincingly claim a special status, no art forms could either. The operas that Tracy Lord and her family attended in *The Philadelphia Story* were not superior to popular music, just different. This does not mean that we have reached some utopian state of cultural equality. Our educational systems and social groups continue to harbor assumptions about cultural hierarchies. But these assumptions are fragmentary, inconsistent, and not universally shared.

The Case of Music

In the 1950s, the Philadelphia Orchestra and the other American orchestras in the "Big Five" (and of course the ones in Europe) were still flourishing. But the shift in popular music from the big bands and crooners of the pre–World War II period to jazz and especially to rock and roll was changing

cultural attitudes toward music in general. Prior to the 1950s, few questioned that the musical tradition from Bach to Stravinsky was one of the great achievements of Western culture, incomparably more profound than popular music. Increasingly, however, the popular music of the 1950s and 1960s was made by people barely out of their teens for people still in their teens. And although the music had roots, for example in African American blues, it owed little to the classical tradition. This music posed perhaps the first successful challenge to the hierarchy of the arts in North America and Europe.

The Chuck Berry song "Roll Over Beethoven," covered later by the Beatles, captured perfectly what was happening. The song and youth culture in general did not harbor real hostility to the classical tradition, because it did not know or care about the music. Berry simply used Beethoven as a metaphor for the music of high culture that his music replaces for his youthful audience (Kozinin 2011). JAY-Z's song "Picasso Baby" celebrates the culmination of this cultural process. Like Berry, the rapper is telling Picasso to move over, but by 2013, recognized artists are happy to participate in his performance. JAY-Z is confident about his status in a way that Berry was not.

In the 1960s, music was one of the cultural activities in which the term "artist" began to be applied more and more widely without irony, until it included all kinds of musical performers. In fact, unlike popular singers, performers of classical music were and still are usually referred to more specifically as "soprano" or "violinist" rather than "artist." In the 1960s, *The Huntley-Brinkley Report*, NBC's nightly news program, used an excerpt from Beethoven's Ninth Symphony as its closing theme. It was a 1950s recording by Toscanini, an iconic figure rather like Stokowski, and the NBC Symphony Orchestra. Today it is unlikely that any television news show would use a classical music standard as a theme, let alone that an American network would maintain its own symphony orchestra. The term "artist" is now used simply to designate the performer column in the iTunes music interface.

Throughout this period, the community of composers, musicians, and audiences who believed in the evident superiority of classical music grew smaller and less culturally significant. Eventually, new hybrid figures appeared, such as Brian Eno and David Byrne, whose music, though not part of the classical tradition, was taken seriously as artistic expression. Classically trained composers, among them Philip Glass, crossed over into popular performance

with their minimalist music. In addition, a number of rock musicians in this period, such as Keith Emerson, Rick Wakeman, Rick Wright, and singer Annie Lennox, had some classical training. Meanwhile, the conservative symphonic sound was refashioned for large popular audiences in Hollywood film by John Williams, Vangelis, Howard Shore, and many others. Above all, the enormous audiences for rock, country, hip-hop, and various other popular genres demanded cultural recognition. By the end of the twentieth century, American culture had largely accepted the notion that all of the various musical styles or traditions were of equal creative potential. The audience for symphonic classical music had diminished, but not disappeared. Today, as we noted, even some of the great orchestras in large American cities, which were founded in the nineteenth century in a conscious effort by business philanthropists to bring European culture to the United States (Levine 1988, 104–140), find it difficult to fund their seasons. In Europe, the audiences are more faithful, and there is still significant government support, as there is for theater and opera (Judt 2005, 778–779). Opera in both America and Europe survives for audiences, who may dress up in an effort to recall the era of elite music, and at the same time film theaters have begun to broadcast opera to a secondary audience in high-quality stereo. Opera stars and soloists resort to gimmicks (e.g., the three-tenor concerts) to generate publicity and larger audiences. Meanwhile, the classical community endlessly debates whether and how to make classic music "relevant": to increase the size of its audience, for example, by making the concerts less stodgy (e.g., Wakin 2012).

In 1913, the première of Stravinsky's dissonant and rhythmically violent ballet *The Rite of Spring* led to a riot. Whether the rioters were in fact incensed by the music, rather than the choreography, it was certainly believable that a Parisian audience could care enough about the fate of music to break into fistfights over an avant-garde piece. It is unthinkable today that any music portrayed as classical could provoke its docile audience to riot. (However, fans can occasionally be moved to violence when a famous rock star cancels a concert.) If the music is not to a listener's taste, she goes elsewhere, for she has an infinite number of musical choices, available from a variety of sources, especially Internet streaming and download.

The plenitude now accommodates musical communities that intersect, cooperate, compete, and above all ignore each other. The formerly elite classical community is certainly present on the web. Classical music can be

purchased and downloaded on iTunes, and classical music magazines have websites. There are classical music blogs, and some opera stars have their own fansites. The diva Anna Netrebko is present, like any rock star, in most of the various digital forms from websites to iTunes to Facebook to YouTube to Twitter, although she will have much smaller numbers in all these forms than a rock star. (For example, in mid-2018, she had somewhat more than 50,000 followers on Twitter; Justin Timberlake had over 65.3 million.) She is regarded as a star within her community, but not necessarily across communities. The Internet does not put Netrebko in competition with rock stars, for she remains in a different community. The converging of musical tastes into one community has certainly never happened, although it was perhaps closer to happening in the period prior to the Internet when the American airwaves were dominated by three television networks and local radio chains with replicable formats. The plenitude creates numerous hierarchies, which can be braided into strands (sharing some common artists or performers) or held quite separate.

This in itself is an important shift from the mid-twentieth century. The great divide between elite and popular music has been replaced with numerous smaller divides and provisional connections. The Wikipedia article lists over 250 "genres" of rock music, each with a link to a descriptive article: including Bandana Thrash (a subgenre of Thrashcore), Krautrock, Swedish Death Metal, and The New Wave of New Wave (Wikipedia contributors, "List of Rock Genres"). The vastly popular hip-hop, which began as an African American subculture and spread to world-wide status, has dozens of genres too: including avant-garde hip-hop, chopper rap, and crunk (Wikipedia contributors, "List of Hip-Hop Genres"). We cite these names not to make fun of them, but rather to indicate the intensity of interest in these popular forms. Some of these genres imply not only a particular aesthetic but also a social status. To someone outside of the rock community in general, the differences between death metal, doom metal, and industrial metal may be hardly noticeable, but to those within the community it may a matter not only of taste, but even political significance. This is certainly true of hip-hop, where the international versions may not share the social and political concerns of African American culture.

People do not all enjoy the same music today. Some love steampunk-inspired chap hop; others hyper-ironic vaporwave; and many more have no idea what either of those genres are. With the technologies of streaming

music services, smartphones, and satellite radio receivers in cars, each listener has infinitely more choices than ever before. These technologies have perhaps made listeners less tolerant of music styles they do not like or understand. Headphones and earbuds make it easy to create a music bubble almost anywhere and to fill that bubble with one's favorite style.

Shocking Art

Our culture's response to art has changed and, in some ways, diminished in the recent decades. Because there is no elite whose position on art validates its significance for the rest of us, there is less at stake. Various art communities still fight over the work produced by their members, but outsiders are neither interested nor in general threatened. For the general public, the work of professional artists in the traditional sense is sometimes engaging, sometimes tasteless or incomprehensible, but it is not dangerous. The fact that art no longer shocks us shows how its cultural significance has changed.

In the first decades of the twentieth century, the Futurists and Dadaists set out to demonstrate the emptiness of the art of their day. They made noise and called it music; they performed plays that lasted three minutes and had no resolution; they pulled words clipped from newspaper articles out of a hat and called them poems. In *Dada, Art and Anti-Art*, Hans Richter (1978) described, for example, what he called the climax of Dada activity in Zurich: a performance in a large hall in April of 1919, in which a host of Dada figures appeared on stage one after another. One delivered a lecture on abstract art; another danced to the atonal music of Arnold Schoenberg. Tristan Tzara addressed and insulted the audience. Finally, when Walter Serner started to read his manifesto, "the young men, most of whom were in the gallery, leaped on to the stage, brandishing pieces of the balustrade … chased Serner into the wings and out of the building, smashed the tailor's dummy [his prop], and stamped on the bouquet. The whole place was in an uproar" (Richter 1978, 78–79). It seems clear from Richter's description that the audience itself was ready to be provoked, looking to become part of the performance. And the anti-art of the Dadaists delivered: it was meant to shock the bourgeois, to offend their sensibilities by insisting that their traditions of poetry, dance, and drama were meaningless.

Throughout this period in Europe and North America, the shocks continued. The New York Armory Show of 1913 helped to introduce the European

avant-garde to the United States, and the critics reacted appropriately (e.g., Longley, Silverstein, and Tower 1960, 177). The exhibition, which also visited Chicago and Boston, was viewed by approximately a quarter of a million people and received newspaper coverage in the exhibition cities and elsewhere. The shock clearly went beyond the art world itself (Lunday 2013). In 1917, when Marcel Duchamp submitted *Fountain*, his famous signed urinal, to an exhibition of the Society of Independent Artists, he was apparently pleased that he had anointed as art an object that even his avant-garde colleagues could not accept (Lunday 2013, 126–127). In the 1920s, the Surrealists continued to promote art as scandal: their best-known example was probably Luis Buñuel's film *Chien Andalou* (1929). In a sense, the negative reaction to the historical avant-grade only confirmed the importance of art; it showed that the avant-garde and its detractors still took serious art seriously, as something worth fighting over.

There were avant-garde movements all through the twentieth century, and most of the time, they were simply ignored, certainly by the public and sometimes by the elite art community as a whole. The most compelling of the avant-garde, such as Cubism and Surrealism, became influential in mainstream elite art and eventually commercial art as well. In the 1950s, the American Abstract Expressionists managed to be at least mildly shocking and mainstream almost in the same moment. The reception for Pollock and other American Expressionists indicated the changes that were already occurring in American culture in the 1950s. Pollock might be a great artist or not, but few in the art community could claim that his paintings were not art simply because they did not represent anything. They would also have to deny a whole strain of modern art from Mondrian to Klee to Kandinsky. The public outside that community, however, still expected a painting to look like something. Although no longer shocked enough to throw fruit, the public in the 1950s might also have the reaction that Pollock was not art because it apparently required no skill to produce. Anyone could drip paint on canvas. However, art critics such as Clement Greenberg, a leading American critic of modernist art, analyzed the subtlety with which Pollock chose his strokes and his colors.

The notion that Abstract Expressionism requires no skill and is therefore not art remains common today, as was illustrated by the documentary *My Kid Could Paint That* (2007), a film directed by Amir Bar-Lev that captures the ambivalences in contemporary attitudes toward art. Four-year-old

Marla Olmstead from Binghamton, New York, produced abstract paintings of such apparent quality that they attracted the attention of the art community and the market. Some of her work sold for thousands to wealthy collectors. A segment on the television show *60 Minutes II* (July 2005) presented Marla as a prodigy, but with the lingering doubt: is there really any aesthetic difference between a Pollock and the smearings of a four-year-old? Then the reporting team took the story in another direction; they began to suggest that Marla may have had help in producing the paintings. On the one hand, the paintings might not be art. On the other, perhaps abstract painting was art after all and required the sophistication of an adult artist. The audience had a choice of shocks: that this was art, that a child could produce it, or that the whole thing was a fraud, perpetrated by adults to raise the value of the paintings. But such cultural shocks are mild in the twenty-first century.

In the first half of the twentieth century, art could indeed be shocking through its very form: for example, it was shocking to insist that a mass-produced urinal was art because an artist had signed it. The 1960s and 1970s marked a turning point, because from this time on, art could no longer be a danger to the order of things simply because it abused the traditional materials and forms of art. Andy Warhol's repeated images of Marilyn Monroe or his Brillo boxes upset many in the art community in the 1960s, but they never led to public outrage. The more general reaction to the avant-garde in this period was bewilderment and disinterest. In 1960 the artist-musician John Cage created a piece that he performed with various objects such as a water pitcher and a rubber duck. His *Water Walk* was like other avant-garde performances of the period, except that it was once performed on the television game show *I've Got a Secret*. Cage's secret was that he was a composer. The host Garry Moore explained to an unsuspecting audience that they were about to hear something unusual, and his interview with Cage was both respectful and skeptical. Cage then performed for about five minutes by moving around on the stage producing the appropriate sounds with the various objects, while the audience listened and occasionally laughed. It was a bizarre confrontation between the avant-garde and popular culture, and the audience's reactions and the way the whole program was presented showed how the assumptions of elite art were breaking down. The audience did not storm the stage, as audiences had done forty-five years earlier when

the Dadaists performed. They were politer, perhaps not sure that elite art should still be respected, but also doubtful that this *was* elite art. Within the art and music communities, Cage's work was both controversial and highly influential. But for the public, any changes in the forms and materials for making music were no longer dangerous or shocking.

From the 1960s on, because artists could no longer rely on formal innovation to shock their audience, they had to resort to nudity, bodily disfigurement, threatened violence, and so on. The French artist Yves Klein used naked models covered in blue paint as "living brushes"; his painstakingly constructed photograph *Leap into the Void* shows Klein leaping, arms outstretched, from a second-story window. Performance and body artists became famous for dangerous or explicit acts of self-exposure or even mutilation. Carolee Schneemann's *Interior Scroll* was a performance in which she read from a paper scroll that she pulled out of her vagina. Chris Burden had himself shot and in another performance nailed to a Volkswagen. Performance artist Stelarc's various performances included piercing his own body and attaching a robotic third arm. Within the art community, the work of performance and installation artists led to a dialogue about the political and formal meaning of art after the collapse of modernism. But millions outside of that community did not participate in that dialogue. They may have been provoked to deny that this was art, not only because such performances did not require the skills expected of a traditional painter, sculptor, or even stage actor, but also because they judged pulling a scroll from one's vagina or hanging oneself up by hooks to be indecent. The shock came from the content.

In the United States, the shock can still be profound when it touches on religion, especially when it questions Christian beliefs or the tenets of patriotism as a kind of American religion. Ultimately, the combination of perceived obscenity and sacrilege put an end to the federal funding of experimental art. In 1987, for example, Andres Serrano created *Immersion (Piss Christ)*, a photograph of a small plastic crucified Christ submerged in urine, which enraged conservative American politicians (figure 1.1). Their response to Serrano's work was strongly negative not because he was profaning art, but because he was blaspheming religion and using public dollars to do so. He had received a small amount of support from the National Endowment for the Arts (Brenson 1989). The Republican Party worked to

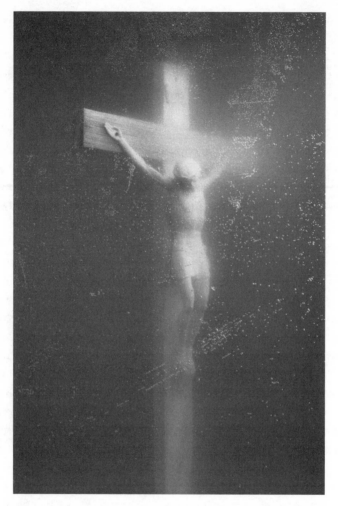

Figure 1.1
Andres Serrano's controversial *Immersion (Piss Christ)* (1987), courtesy of the artist.

defund and eliminate the NEA in the 1990s citing Serrano, performance art-
ist Karen Finley, and other funded artists. It was always the content of this
work, not its form, that provoked and threatened.

Art in the 1990s could continue to shock only by using abject materials
or invoking offensive social or religious themes, as did the art show *Sensa-
tion*, featuring the Young British Artists and including Damien Hirst's shark
suspended in a tank of formaldehyde (Barstow 2000). In the United States,

in particular, politicians expressed outrage whenever public money or public institutions were involved. But contemporary audiences were again not so much shocked as confused by contemporary art. In 1993 and again in 2012, *60 Minutes* presented a segment in which correspondent Morley Safer visited contemporary art exhibitions. Safer came to ask the question that the avant-gardes traditionally wanted posed: Is this art? But he affected to be bemused rather than scandalized. In the 2012 broadcast, Safer wandered through the Art Basel exhibition in Miami Beach followed by the curious television camera. A bemused Safer explored the strange installations and pieces that counted as art for the community of artists, dealers, and collectors. He and the television audience were clearly visitors, not members of this community, and the real shock came from the outlandish prices for the work on sale.

Art as a Special Interest

The modern category of art has a cultural history that extends back to the eighteenth century, when, as Larry Shiner documented in *The Invention of Art* (2001), art became a special and singularly important form of making. Prior to this period, there had been no universally held distinction between arts and crafts. There were painters, sculptors, poets, architects, and composers, but their callings were not necessarily joined under the term *art*, nor were they necessarily separated from jewelers and woodworkers. After the invention of art, the fine arts became "a matter of inspiration and genius ... meant to be enjoyed for themselves in moments of refined pleasure, whereas the crafts and popular arts require[d] only skill and rules and [were] meant for mere use or entertainment" (Shiner 2001, 5). In the first half of the twentieth century, art still enjoyed this remarkable status. The educated and moneyed elites were able to define what art was, and their definition was deemed to have value for the whole of our culture. Most in the working classes had at best limited access to forms of elite art. In the second half of the twentieth century, the forms of art anointed with the task of cultural redemption did not disappear, but they had to learn to coexist with all sorts of popular practices that include genre fiction, graphic novels, films, television shows, and video games as well as things that used to be considered crafts such a woodworking or knitting. In 2016, for example,

The Cut, a column in the online version of *New York* magazine announced: "A New Film Proves That Knitting Is an Art Form" (The Cut 2016). In one sense, this is a return to an era before art became a transcendent category. Today the gulf between the fine arts and the crafts has narrowed, and the crafts include not only physical activities such as woodworking and gardening, but also remix audio and video game design. In another sense, the situation is quite different, because the rhetoric of art from the nineteenth and twentieth centuries has carried over into the twenty-first. JAY-Z does not want to reduce Picasso to the level of a pop performer; he wants to raise himself to the level of elite artist.

The elite arts and popular entertainments have all become special interests, each with a community of practitioners and audience. Each may have many subcommunities, and any and all of these can overlap, sharing audience and practitioners. Some communities and audiences are much larger than others. A large community, for example, has formed around the painter Thomas Kinkade, who died in 2012. Kinkade's website (https://thomaskinkade.com) may be right in claiming that he was America's "Most Collected Artist." His paintings are nostalgic in content and sentimental in style. His obituary in the *New York Times* tried to have it both ways (Flegenheimer 2012). It acknowledged Kinkade's success in attracting a vast audience: "Rebelling against what he considered the elitism of modern art, Mr. Kinkade moved his focus to retail, not a traditional gallery system." The article, however, is careful to ascribe appreciations of Kinkade's work to the painter himself ("Kinkade referred to himself as the 'painter of light'") or to fans on Twitter ("Rest in peace, Thomas Kinkade. May your afterlife be as beautiful as your art"). The *Times*'s Arts section now addresses a variety of aesthetic communities: from opera and fine art to rock music and hip-hop and recently even to the enormously popular pop music of, say, Beyoncé. The changes over the past sixty years in what the *New York Times* chooses to cover in its Arts section could chart, somewhat belatedly, the breakdown of the great divide between high and popular culture. There is now a video games section in the online version of the *Times*.

Artistic elites had to contend with the growing importance of popular forms such as film and American jazz throughout the twentieth century, and their reactions to this challenge ranged from indignant rejection (Theodor Adorno) to conditional acceptance (Walter Benjamin). But the situation is different now. The traditional art community judges Kinkade's

painting as the definition of kitsch, the purest product of the "culture industry"—the term still used to describe the machine that markets as commodities pop music, Hollywood film, commercial television, and so on. The term "kitsch" only makes sense within the art and academic communities. A *New York Times* article (DeCarlo 1999) thirteen years before Kinkade's death addressed the issue: "For most high-art aficionados, Mr. Kinkade's light-dappled renderings of frothing oceans, fantastical cottages and feverishly colorful gardens, bearing titles like "The Blessings of Spring" and "Hometown Evening," may be impossible to see as anything but slickly commercial kitsch. But in view of Mr. Kinkade's popularity—his official Web site calls him America's most collected living artist—we might pause before dismissing his paintings out of hand."

The art world did not pause. It continued to dismiss Kinkade, and Kinkade, the only artist listed on the New York Stock Exchange, continued to sell printed and assembly-line produced oil paintings to thousands of customers each year. In 1999, the company reported $126 million in revenues. At the same time, the vast popularity of a painter like Kinkade does not give his aesthetic any more claim to being at the center of our culture: Kinkade too is a special interest, a particularly lucrative one. "Do you like Kinkade?" is the only kind of question that can transcend various communities with their various definitions of art.

As I write these lines sitting in a cafe in Atlanta, Georgia, I can see on the wall in front of me three paintings in a style vaguely reminiscent of Paul Klee. You can find every conceivable style of art decorating the interiors of business and public buildings—most of it mass produced, but some created by local artists and offered for sale in cafes, restaurants, and malls. This second- or third-tier art reminds us of the large and varied network that has formed in the space between the traditional high art community and the industry that provides decorative art and reproductions for consumers— the space between, say, Gerhard Richter and Thomas Kinkade. The important museums and galleries exhibit artists who have attained an elite status with collectors and critics. Below that level, there are artists who work in more or less the same way: developing a style and exhibiting. They may have exhibitions at less prestigious galleries and in countries other than the United States, and their art may be supported by public funds. At the local level, the exhibitions may be in art fairs or cafés, where their art is priced in the hundreds rather than the thousands of dollars. This "middle-brow"

network allows people with middle-class incomes to collect works in imita-
tion of the elite gallery system. Of course, this description only hints at the
complexity of what is regarded as arts culture today, which includes sales of
locally produced arts and crafts of all kinds (from painting and sculpture to
pottery and crafts). The Bureau of Labor Statistics website (2017) no doubt
simplifies and underestimates when it reports that there were 50,300 craft
and fine artists in the workforce in 2014. But the fact that it groups fine arts
and crafts together says something significant about contemporary culture.

All this activity goes on as it has for decades in physical galleries and
workshops, but it is also vastly amplified by digital forms. Any amateur
rock group can have its Facebook or Twitter page and website and sell its
music on Bandcamp.com. Thomas Kinkade is represented on the web by a
complete commercial website with a gallery locator and an online gallery
and shop. Along with such professionally managed sites, countless amateur
sites exist where visual artists display or offer their work for sale. With this
elaborate network of audiences and outlets, the traditional notion of mass
culture no longer seems adequate. The media plenitude today is not just a
mass culture industry, but also a myriad of amateurs and vocational artists
who fall somewhere between the mass marketing of pop stars and the gal-
leries of traditional art. This multiplication of forms and audiences would
not have been possible without the breakdown of the distinction between
popular and elite, and it has certainly been fostered by the web's capacity
for easy distribution.

Those who work in or with popular media do not necessarily want the
special category of art to be dissolved; instead, they often want to see their
forms (film, television, graphic novels, or video games) elevated to the status
that was enjoyed by the former elite arts. They want to appropriate the term
art to indicate that their work has the same central cultural mission assigned
in the past to elite art. JAY-Z is making this claim for rap today. Filmmakers,
critics, and scholars worked for decades to justify film as "serious" art. The
American Film Institute (www.afi.com) promotes the art of film, invoking
the vocabulary inherited from modernism. The Academy Awards ceremony
each year honors Hollywood films for their artistry, and one of the present-
ers is bound to say at some point that film shows us "who we are," "presents
us with realities we would rather not face," and so on (www.oscars.org).

The National Endowment for the Arts has for years been admitting popu-
lar forms into the canon of art while at the same time insisting that art

retains its special role in our culture. The Chairman's Message in the *2012 Guide* tell us that "the arts are all around us, offering hope, inspiration, and imagination to make us even better, individually and collectively" (National Endowment for the Arts, 2012, 1). Given the NEA's funded projects and examples, the arts include gospel singing as well as opera, film and television, and stage plays. Still, the definition of "art" does not extend throughout the plenitude. As we noted, the NEA has been prevented by the controversies of past decades from funding experimental performance or installation art. For political reasons, art for the NEA can no longer be allowed to shock, and there are other limits to its middlebrow definition. Video games are a form in transition. Yet as late as 2010, film critic Roger Ebert confidently predicted in a blogpost that "Video Games Can Never Be Art" (Ebert 2010). He had no doubt, of course, that film was an art form, even as early as the work of George Méliès. Ebert's post received over five thousand comments from those on both sides of the issue.

Beyond the makers of video games, there is a significant digital art community, which sees itself as a part of the larger community of traditional art. Digital artists exhibit at festivals such as Ars Electronica and the International Symposium on Electronic Art. Many digital artists, who want to be part of the traditional gallery and museum system, complain that their work (installation art with digital components or art that involves the Internet) does not get sufficient recognition beside the traditional media of modern and postmodern art. Still, these artists do belong to the same community and seem to agree that art has a special cultural status, whether it is appreciated by large audiences or not.

The traditional art community, of which digital art yearns to be a part, continues to represent a range of economic and social interests. Galleries and auction houses sell paintings of established masters from the Renaissance to the twentieth century for astronomical prices. At this writing (2018) the most expensive painting sold at auction is da Vinci's *Salvator Mundi* for $450 million. Museums run blockbuster exhibitions (Vermeer, Picasso, da Vinci) that attract thousands of visitors, many of whom are from outside of the art community. Contemporary art is represented by such exhibitions as *Documenta* in Germany and the *Venice Biennale*, which are celebrated in the art world and also relatively popular. About a million visitors attended *Documenta 13* in 2012 in the small town of Karlsruhe, and the art exhibited there extended across a large range of contemporary practices.

But even if contemporary artists at *Documenta* address political issues or try to appeal to a broader public, everything about the festival suggests the special (formerly elite) status of art and the artists.

There remains a need for exclusivity in the communities of artists who are heirs to the era before artistic hierarchy broke down. Whether we are speaking of the now-classic traditions of galleries and museums, the contemporary artists who are assimilated into the mainstream (such as David Hockney, Gerhard Richter, or Damien Hirst), or digital artists (whose work is not yet entirely accepted)—all of these constitute an implicit community for whom the mission of art remains central to culture. The boundaries of the elite art community have become blurrier in the decades since the 1960s, but there is a vast territory beyond the boundary, where popular and elite practices coexist in every imaginable combination. And precisely because the boundary is now blurred, the art world devotes great energy to deciding what constitutes art as well as what distinguishes good art from poor art. In *Artworld Prestige*, Van Laar and Diepeveen (2013) explored prestige as the currency of the art community, particularly for art of the past fifty or so years. Prestige is neither absolute nor eternal; the art community is constantly revising its hierarchy, redrawing its boundaries. The worst thing that can happen to an artist is to lose the brand of seriousness altogether, which moves his or her work definitely beyond the boundary. At the same time, so-called outsider art can be made serious through the work of curators and art critics and then moved inside the boundaries of elite art.

deviantART, a website that reflects all the ambiguities and ironies of our culture's current understanding of art, is clearly outside the boundary of the elite art world. The site claims to have 45 million members and 361 million unique works of art (deviantART 2018). Its production of original art therefore surpasses the total holdings of the Louvre every few days. deviantART constitutes many interlocking communities producing various forms of (mostly) visual media. Many of the vast store of works are incandescent 3D illustrations, in some ways close to the aesthetics of Thomas Kinkade, but in the digital medium rather than paint. But that is only one strand of deviantART's universe: the site is its own plenitude of possible expressive forms. Although the name suggests the historical avant-garde's desire to be disruptive, the majority of the vast membership of contributors seem to show little interest in the traditions of elite art.

deviantART suggests the most radically democratic of positions: that art is synonymous with creative expression. The notion is common in our culture today that everyone can express himself or herself in different ways, that traditional visual art is creative, but so is mathematics, physics, and engineering, and so on. Product design is called art (Steve Jobs was an artist, according to his biographer, Walter Isaacson). Traditional crafts are also arts. The point is not that this is a misuse of language, as if only the formerly elite arts deserve the name. Our culture has long applied the term "art" metaphorically to these and other practices. The point is rather that, with the fragmentation of the hierarchy, the term has lost its ability to function as a metaphor. Painting, physics, quilting, product design, and chess are all arts in the same way.

A counterpart to deviantART is Artsy (artsy.net). While deviantART uses the web to publish huge amounts of popular work and insists that these all deserve the name of art, the Artsy website insists that elite art can be popular. Artsy's collections are not user generated; they come from the art community's museums and galleries. Its goal is to make images of the world's art available to web users with the same ease and some of the same mechanisms as a social media site. When you join the site, you receive a welcoming email that reads: "Our mission is to make all the world's art accessible to anyone with an Internet connection. Discover, learn about, and collect art from the world's top galleries and museums.... Art is better with friends. You can use this link to share Artsy." The link invites you to share Artsy through email, Facebook, or Twitter. The email goes on to offer you the opportunity to contact a specialist to help you begin collecting. Perhaps even more effectively than deviantART, Artsy attests to the dissolving boundary between elite and popular in the realm of art.

The breakdown of hierarchy in our culture has gone beyond art to encompass other forms of sanctioned cultural knowledge. In *Cultural Literacy: What Every American Needs to Know*, E. D. Hirsch and his colleagues (Hirsch, Kett, and Trefil 1987) argued that Americans, particularly students, had lost a fund of shared knowledge about their culture and history. The book appeared at a time when it still seemed feasible to shore up and reinstate the hierarchy of knowledge. Hirsch insisted that there were facts, authors, and historical figures that "every American" should know. He went on to produce a *Dictionary of Cultural Literacy* and a series of textbooks and to create an organization, The Core Knowledge Foundation, which

continues today and has a web presence (www.coreknowledge.org). In the 1980s Hirsch was criticized (and praised) for his elitist attitude. And it is true that his list was heavy with what counts in the humanities as knowledge (particularly about literature) and with canonical male authors like Shakespeare and Thoreau. But in a democratizing spirit, he also attempted to canonize popular knowledge from baseball, comics, Hollywood film, and so on. Hirsch's argument was a practical and classically American one: that this popular knowledge was needed in order to take part in contemporary discussion of issues of the day. Hirsch would not acknowledge, however, that his list simply codified the standards of a particular community—in this case the community of American academics and writers in the 1980s. Hirsch's work was subsumed into the political debate called the "culture wars," which included the crippling of the NEA at the end of the twentieth century.

Although the culture wars have flared up today, the terms are different, and the culture over which the war originally was fought has long ago become a special interest. Hirsch has turned out to be wrong. There is in practice almost no common cultural ground on which everyone meets, nor do we really expect everyone to meet anymore. We can find smart, successful people with any particular ignorance we care to mention: a physicist who cannot name a single rap artist; a rap artist who cannot name a single composer from the nineteenth century; a college student who has never seen a film by Ingmar Bergman; a construction worker who has never visited an art museum. By the same token, we can find people who break all of these stereotypes: a construction worker who loves Italian opera; a college professor with a passion for skiffle music; a rapper (e.g., JAY-Z) who collects twentieth-century art. This is precisely the condition of plenitude, in which there is enormous diversity and everyone is ostensibly free to follow some cultural threads and ignore others.

Shiner (2001) claimed that by the beginning of the nineteenth century the fine arts had been "given [their] transcendent spiritual role of revealing higher truth or healing the soul" and that "this conceptual revolution along with its related institutions still governs our cultural practices"(6). He was wrong in one important respect. From the late eighteenth to the later twentieth century, the institution of art was indeed believed to do the work of salvation for the whole culture. This was clearly the understanding of Schiller, Shelley and Wordsworth, Matthew Arnold, and most of the

modernists. Today, while many in the art community continue to believe the vital importance of fine art, the rest of our media culture feels free to borrow the rhetoric of high art or to ignore it.

Communities and Creativity

The development of digital media did not cause the breakdown of the hierarchy of art and other high-cultural forms. The two happened in parallel after World War II, and indeed by the time the major digital media (video games, the personal computer, the World Wide Web, mobile phones and tablets) were fully developed, the breakdown of hierarchy was unavoidable. But digital media have been developed in a way that provides an ideal framework for the plenitude of forms that have arisen out of the fragments of modernist culture. Producers, designers, and programmers have fashioned these technologies into a fluid environment in which all sorts of practices are possible and equally legitimate. On the World Wide Web, the official web page for the Metropolitan Museum has the same status as deviantART, although deviantART has considerably more visitors (it scores much higher in the ratings of www.Alexa.com). The web with its social media often accessed by mobile technology now constitutes the matrix for today's communities of expression and participation.

In *Convergence Culture: Where Old and New Media Collide*, Henry Jenkins (2006a) describes today's media communities: "New forms of community are emerging ... : these new communities are defined through voluntary, temporary, and tactical affiliations, reaffirmed through common intellectual enterprises and emotional investments. Members may shift from one group to another as their interests and needs change. ... These communities, however, are held together through the mutual production and reciprocal exchange of knowledge" (27).

The knowledge production Jenkins is referring to might include an archive of fan fiction that recycles the characters and situations of the story-worlds of *Star Wars*, *Star Trek*, *Twilight*, or *Harry Potter*. Alexandra Alter (2012) catalogues these and more examples in "The Weird World of Fan Fiction," pointing out: "They're amateur writers—with millions of readers. After years in the shadows, they're starting to break into the mainstream." She notes that the erotic novelist E. L. James wrote fan fiction before producing the print bestseller *Fifty Shades of Gray* and its sequels. In the plenitude of digital

media, however, there is nothing particularly weird about fan fiction. It is produced by a series of networked communities that taken together, as Alter recognizes, have millions of readers. What the article refers to as the "mainstream" is simply the community of readers of print fiction by established publishing houses.

Jenkins's definition of "community" thus applies not only to fan fiction, but also to our whole cultural plenitude today. The knowledge that defines each community is canonical only within that community. It may be intricate knowledge about the Starship Enterprise or the customs of Wookiees or the backstory of minor characters in the *Harry Potter* novels. It may be knowledge of Jane Austen's novels or Beethoven's symphonies. Although most people, if pressed, might still maintain that knowing *Hamlet* or *Macbeth* is more important than knowing Voldemort's seven horcruxes, the works of Shakespeare too have become community knowledge rather than common knowledge. There is nothing that people outside the community are required to know.

The established communities of art and culture of the past have changed comparatively slowly. Even the avant-gardes of the twentieth century with their rhetoric of revolution needed years or decades to break into and redefine the mainstream of the visual arts. For example, the important serial composers Schoenberg, Webern, and Berg of the early twentieth century are still seldom played by major orchestras. Film was not considered an art form worth studying in universities until the 1960s or later. But in the digital plenitude today, Jenkins's communities "defined through voluntary, temporary, and tactical affiliations" may form in mere weeks or months, employing the technologies of social media. Fan fiction has an honorable pedigree by these standards, with an early community forming in the 1970s around the *Star Trek* television series. Before the web, fan fiction was distributed using mimeograph or copying machines, and the process was necessarily slow and limited. When fan fiction and "fan work" moved to the web, participation could increase tremendously, and communities could ramify and mutate quickly. The aggregator site https://fanlore.org lists dozens of *Star Trek* fansites, many of which may contain hundreds of individual story contributions or more. Groups or even individuals may assemble their own online communities, as Thomas Kinkade (or his company) succeeded in doing around his own paintings and furniture products. Kinkade's website with its virtual gallery served as a focus for the community and continues

to do so after his death, and the physical manifestations include a chain of galleries (stores) and even a community in the American sense, a gated neighborhood featuring street after street of Kinkade-inspired architecture. Kinkade's art community mimics the elite worlds of art and design of the past, and it functions parallel to and independent of the traditional gallery system (Glaister 2012; Flegenheimer 2012).

Participatory fansites, DIY communities like deviantART, the remixes of YouTube, and the template-bound self-expression of social networking sites all testify to a new conception of *creativity* as a synonym for art. The conception developed from the fragments of the collapsed elite culture and now includes the making or refashioning of almost anything from the new practices supported by social media, to all the older practices of visual art, expressive writing, filmmaking, and so on. This creativity may be blandly appreciated as universal, but it can only be evaluated in relation to one or more of the appropriate communities. There is no single standard, and no community's creative practice is central to all of our culture.

In recent years, writers (including Andrew Keen, Jaron Lanier, and Nicolas Carr) have argued that digital technology is demeaning our culture and debilitating us as individuals. They have criticized the effects of email and Google on our attention spans and of the new participatory world of social media on our creative powers. In *You Are Not a Gadget*, Lanier (2010) was particularly concerned with creative expression: "Something started to go wrong with the digital revolution around the turn of the twenty-first century. The World Wide Web was flooded by a torrent of petty designs sometimes called web 2.0.... Anonymous blog comments, vapid video pranks, and lightweight mashups may seem trivial and harmless, but as a whole, this widespread practice of fragmentary, impersonal communication has demeaned interpersonal interaction.... A new generation has come of age with a reduced expectation of what a person can be, and of who each person might become" (loc. 162 of 3410, Kindle).

It is the DIY communities of remix and social networking that Lanier believes are so destructive. Like many other digital media critics, he seems to want to return to a prior state of culture. He complains that Web 2.0 culture is not producing "artists" like Ani DiFranco (Lanier 2010, loc. 1588 of 3410, Kindle), whose contemporary folk music is one of dozens of popular music genres that have won increased legitimacy since the collapse of the musical hierarchy. Lanier's own hierarchy of art, then, contains DiFranco,

and he associates his hierarchy with the task of defining "what a person can be." He has inherited from elite culture the assumption that art plays a central role, but he has expanded the definition of "art" to include popular forms that the elites of the past would never have acknowledged.

This move is common among digital media critics as well as many critics and scholars of film, rock music, and television, who want to promote certain forms of popular culture into a new artistic hierarchy. This is an important aspect of popular modernism, which we will consider in chapter 2.

2 Popular Modernism

On January 9, 2007, Steve Jobs was on stage at the Macworld conference giving one of his flamboyant product presentations. He saved the most important product, the iPhone, for last. The giant screen projected images appropriately punctuating his words, as Jobs began. "Every once in a while, a revolutionary product comes along that changes everything," he said. Most designers or engineers would be lucky to work on even one such revolution in their careers. But Apple (and Jobs himself) had pioneered several: "In 1984, we introduced the Macintosh. It didn't just change Apple; it changed the whole computer industry. In 2001, we introduced the first iPod. And it didn't just change the way we all listen to music. It changed the entire music industry." With the iPhone, Jobs told his audience, whose applause became more enthusiastic at each pause in his narrative, Apple was reinventing the telephone and changing everything again (Jobs 2007). Claims that a new product is revolutionary—that it changes us as individuals or society as a whole—have become the standard rhetoric of digital media culture. We hear it from industry leaders, writers, and academics:

> The Internet enabled so many other phenomenon [sic] that it's startling to realize the Internet as we know it only arrived in the '90s. But it didn't take long to change our lives forever. (Daniel 2009)

> Video games touch everyone, everywhere. You can't escape their reach. They have shaped pop culture, economics and the lives of millions of people for over six decades. (from *Video Game: The Movie*, cited in Parker 2012)

> If we take the computer as a carrier of a way of knowing, a way of seeing the world and our place in it, we are all computer people now. (Turkle 2004)

> The current explosion of digital technology not only is changing the way we live and communicate but also is rapidly and profoundly altering our brains. (Small and Vorgan 2008)

The idea that media technologies can have such a revolutionary effect is a popular expression of modernist views from the last century. Where twentieth-century modernists believed that art should be revolutionary, digital writers today assume that media and media technology should be. Where modernist designers, such as those at the Bauhaus school, believed that the proper use of technology could reform society, today's digerati (both writers and designers) believe that digital media have the power to transform society or even human nature.

Popular modernists often exhibit a useful forgetfulness of a past that might get in the way of the revolution. They imagine history in the way common among speakers in TED talks, where there are three or four great ages of technological development culminating in the new age the speaker is promoting. Steve Jobs certainly believed in the power of well-designed technology to refashion media culture and conducted a campaign over decades to make digital technology "transformative."

For traditional, elite modernism, art and society needed to start over from first principles. In a pamphlet, the Futurist Marinetti suggested bombing Venice in order to get rid of the past. Popular modernism goes further; it does not even need to remember elite modernism. Over the past fifty years, the breakdown of the hierarchy of art and culture has meant that popular modernists could take whatever fragments they chose from the modernist past and leave the rest. That is, popular modernists do to modernism what earlier modernists did to the traditions of nineteenth-century art and design. Digital writers and designers have borrowed the early modernist imperative of revolution, along with a modernist's own lack of gratitude toward the past. As popular modernists, they know just enough history to believe they can overcome it. The final line in Apple's classic Think Different ad campaign is: "Because the people who are crazy enough to think they can change the world, are the ones who do."

It is especially ironic that today's popular modernists care so little about the history of modernism, because in some ways the impulse to popularize was already a facet of early modernism. Modernist artists wanted to go beyond the elite culture of the nineteenth century or even to bring down the elite. After the Russian Revolution, the Constructivists aimed to educate the peasants and bring them to an awareness of history and the triumph of socialism. Likewise, the goal of the Bauhaus was to design the future

through the application of modernist first principles. Because it was to be a future for everyone, the Bauhaus curriculum emphasized the applied arts and crafts. Students learned in workshops, sometimes working on applied projects that the Bauhaus school could sell to the public or industry (Whitford 1984). The Bauhaus teachers were often artists themselves (e.g., Klee, Kandinsky, Moholy-Nagy) whose reputations would eventually rank them among the century's artistic elite, but they also applied modernism to the problems of graphic and industrial design. When the Nazis closed the school in 1933, refugees carried its principles to the United States and elsewhere, and modernist ideas from the Bauhaus and other sources became increasingly influential in commercial design. Another popularizing movement in the 1920s and 1930s was Art Deco. Although it rejected the spartan design philosophy of the Bauhaus, Art Deco nevertheless borrowed from modernist principles to inform designs as diverse as railway stations, household furniture, radios, and dishes.

By the 1950s, then, bringing modernist ideas into popular culture was nothing new. Yet this period was different. Modern art itself had become traditional, firmly established in the elite museum and gallery system. The Museum of Modern Art (MoMA) in New York had opened in 1929 and occupied its current location starting in 1939. By the 1960s, modern art was being challenged, not for being radical, but for being too conservative. Within the art world, the challenge took the form of such new practices as performance and installation art. The challenge from popular culture came from jazz and rock-and-roll musicians and to some extent from writers and film and television producers. These diverse talents were ambivalent about the high culture they were challenging. The makers of popular culture did not always seek to abolish hierarchy; they sometimes wanted recognition for their own works as part of a new elite. They wanted film to be recognized as the equivalent of literature. They wanted 1950s jazz or 1960s rock music to gain a place alongside classical music: they called on Beethoven not so much to roll over as to move over. In some cases they adopted the names and forms of elite art from the previous era. Gradually, too, styles and forms of popular culture filtered "up" into the art and music communities. The division between elite and popular was becoming permeable in both directions.

Popular Modernism: Formal, Progressive and Avant-Garde

Modernism had always been a network of related ideas about the nature and purpose of art. One strand of modernism emphasized formal innovation that focused on changing the form, and even the materials, of art. In painting, for example, artists worked to free themselves from what André Bazin once called the "original sin" of Renaissance painting, meaning the attempt to represent the world with perfect visual fidelity. They devised new styles such as Fauvism, Cubism, and Abstract Expressionism. Art historians or critics such as Clement Greenberg saw this formal innovation as the great achievement of modernism. In addition to this formal modernism, there was a political strain, as artists and designers believed their work could contribute to a new social order.[1] Futuristic, progressive, and technologically oriented, the Bauhaus sought to design a better society through the aesthetic principles of simplicity and purity: "the creation of a new man for a new, more humane society was the Bauhaus's true goal" (Siebenbrot and Schöbe 2009, loc. 234 of 4191, Kindle). The German government financed the design school, more or less generously, until the Nazis shut it down.

There were also the avant-gardes of twentieth-century modernism, such as the Futurists, Dadaists, and Surrealists, who appeared to want a more thorough-going revision of art and culture. The term "avant-garde" has often been treated as a synonym for modernism, because generations of modernist artists, beginning with the Impressionists in the nineteenth century, saw themselves as ahead of and opposed to mainstream art. But as wave after wave of -isms (Constructivism, Suprematism, Futurism, Surrealism, and so on) swept through modern art and culture, artists had difficulty remaining avant-garde, shocking, and contrary to the mainstream. Various modernist artists (e.g., Picasso, Kandinsky, Pollock) themselves became a new mainstream, against which the next generation of avant-garde artists rebelled. The formal modernist styles, such as Cubism and Abstract Expressionism, in particular, began as shocking, and therefore avant-garde, but then moved comfortably into the museum and gallery system. By the midcentury, high or elite modernism, as described by the critic Clement

1. In his work on video games, Brian Schrank (2014) has developed a closely related but distinct version of the distinctions between the formal and political avant-gardes. I am indebted to his work.

Greenberg, was thoroughly mainstream. In 1939, Greenberg himself wrote a famous essay entitled "Avant-garde and Kitsch," in which all modernism was avant-garde in its fight against nineteenth-century mainstream art, which he called "kitsch." Yet, by the 1950s, Greenberg was the champion of Abstract Expressionism, which itself had come to dominate elite, mainstream art, at least in America.

Meanwhile, some of the twentieth-century avant-gardes were true avant-gardes in the political as well as artistic sense—on both the left and the right. The Futurists associated themselves with the Italian fascists; the Dadaists, at least in Berlin, with the leftists. As the cultural historian Peter Bürger put it, these historical avant-gardes imagined a revolution in which art was integrated into everyday life (Bürger 1984). Life itself became art, or rather you lived in such a way that your day-to-day existence was artistic, a performance. In this new order, the hierarchies of traditional art were gone, but so perhaps were the hierarchies of traditional society and politics. The seductive idea of art as life and life as art returned repeatedly in the twentieth century.

These strands—the formal modernism of the mainstream, the progressive modernism of the Bauhaus, and the radical modernism of the avant-garde—all found their way into popular modernism. Sometimes popular modernists emphasized formal innovation, sometimes political change, and sometimes they combined the two. For example, jazz critics saw musicians such as Miles Davis and the Modern Jazz Quartet as pursuing formal perfection. Rock music in the 1960s combined formal innovation with a sense that society could be remade. John Lennon and Yoko Ono created their own synthesis of rock music and politically inspired avant-garde performance. Marshall McLuhan was a technological modernist who substituted the idea of media for art: it was the evolution of media, not high art, that changed culture and human beings themselves. Finally, there were popular modernists, such as Steve Jobs, for whom the themes of technological innovation, cultural expression, and social change converged in the digital medium.

Popular modernism has never been a self-conscious movement. It is my name for an explosion of different expressive forms from the 1960s to the present. The strands that I identify here—formal, progressive, and political—are my attempt to impose order on this extraordinary creative diversity. And the figures I focus on here—the Beatles and particularly John

Lennon, Marshall McLuhan, and Steve Jobs—are somewhat arbitrary choices out of dozens or hundreds of musicians, filmmakers, writers, and technologists. Nevertheless these examples of popular modernism were all extremely well known and can help us understand one of the paths that our media culture has traveled in the last half century.

Popular Music and Formal Modernism

The development of styles and trajectories was key to formal modernism. Modernist painting could (at least superficially) be understood as a series of stylistic experiments from the Impressionists in the nineteenth century to the Abstract Expressionists in the twentieth. Classical music seemed to follow a trajectory from Romanticism to the atonality of the serialist composers and the experimentalism of composers in the later twentieth century. Individual composers and painters each had their own style or styles, all of which contributed ultimately to redefining the art of painting or music. Such trajectories can also apply to both jazz and rock and roll, although in both cases the trajectories were far more compressed. For jazz, an intense period of stylistic development occurred over a few decades. For rock and roll, it was a matter of years.

In the song "Rock and Roll Music," Chuck Berry sings "I got no kick against modern jazz, unless they try to play it too darn fast." Especially after World War II, jazz became "modern" and began to be viewed by the musicians and jazz critics as an art form. One of the first styles that asserted its importance was Bebop, which was indeed played "too darn fast" in the style of Charlie Parker and his followers. Parker, Dizzy Gillespie, the Modern Jazz Quartet, Miles Davis, John Coltrane, and many others participated in a larger project to develop jazz both individually and collectively as serious modern music. In *Blowin' Hot and Cool*, jazz critic John Gennari (2006) wrote that "jazz was finally achieving its due measure of intellectual and cultural legitimacy. And this had much to do with cold war-era assumptions about race, class, and culture—literally what the words 'art,' 'artist,' 'culture,' 'intellectual,' and 'critic' had come to mean in the discourse of high modernism that now adorned jazz's public image" (378). Jazz followed elite modernism in another way. It seemed to reach a period of maturity in the 1950s and 1960s. By the 1970s or 1980s, jazz had completed this trajectory. This is not to say that jazz musicians ceased to play with style

and creativity, but rather that jazz styles had diverged along separate lines or converged with other music, such as rock itself. There was an end to jazz in exactly the same way that elite critics such as Arthur Danto talked of the end of modern art—the end of a sense of a shared trajectory (Danto 1997).

Chuck Berry's song did have something against modern jazz. In the 1950s jazz was seeking to be serious and at the same time bidding for broad popularity beyond its specific urban audiences. Rock and roll, in competition for this broader audience, quickly overtook jazz as the favorite American popular music, and in so doing made jazz itself seem an elite form, as Gennari suggested. The Modern Jazz Quartet preferred to give concert performances, and even the jazz in clubs was no longer dance music. No one who was even vaguely sober would attempt to dance to John Coltrane's saxophone solos. Rock and roll was from the beginning a form for teenagers who wanted accessible music, not concert music. It was symbolic that in the teen rebellion film *The Blackboard Jungle* (1955), the rebellious students smashed their teacher's collection of jazz records (Cooke 2008, loc. 8754 of 15141, Kindle). With groups such as Bill Haley and the Comets, rock and roll developed out of African American blues, harmonically simple and with a limited number of themes. But rock and roll, too, began a trajectory toward greater formal complexity and musical ambitions.

The formal development of the Beatles is probably still the best-known example of this development. Growing up in Liverpool in the 1950s exposed them to waves of American rock and roll. They absorbed and imitated these styles in their early years, but then produced a series of albums that marked their search for a characteristic sound. Their ambition reached its highpoint in 1967 with *Sgt. Pepper's Lonely Hearts Club Band*. In 2012 *Rolling Stone* magazine ranked *Sgt. Pepper* as the greatest rock and roll album of all time: "Issued in Britain on June 1st, 1967, and a day later in America, *Sgt. Pepper* is also rock's ultimate declaration of change. . . . No other pop record of that era, or since, has had such an immediate, titanic impact. This music documents the world's biggest rock band at the very height of its influence and ambition" (Rolling Stone 2012a).

This review asserts the Beatles' importance as artists rather than mere entertainers, just as jazz critics were doing for Davis and Coltrane. For critics such as Doyle Greene (2016) in *Rock, Counterculture and the Avant-Garde*, their later albums such as *Sgt. Pepper's* make the Beatles explicitly modern or postmodern artists (19–31). Greene writes that the album as rock's gesture

toward the avant-garde "was part of rock's drive to become a respectable art form, and as much as the highbrow was incorporated into rock and roll, the upshot was that rock developed cultural capital as a music that could be highbrow in its own right, namely *Sgt. Pepper's Lonely Hearts Club Band*" (185).

With its variety of musical forms and unusual instrumentation, both electronic and acoustic, *Sgt. Pepper's* confirmed the path of formal experimentation that the Beatles had chosen years earlier. The experimentation continued until the album *Abbey Road* in 1969, after which the trajectory disintegrated as the group itself did. McCartney produced a series of commercially successful albums in the 1970s and beyond, but none of these had the same degree of formal innovation. Lennon returned to simple rock-and-roll forms.

The Beatles were by no means alone in the formal experimentation and expansions of rock music in the 1960s. Other significant innovators included Frank Zappa, the Velvet Underground, and Pink Floyd (Greene 2016). Dozens of other groups and solo performers took part in what was both a competition and a shared project. Nor were the Beatles alone in coming to the sense that the project was over. In his history of rock and roll, *The Seventh Stream*, Philip Ennis (1992) called the early 1970s "a pause"—a moment when rock and roll seemed exhausted by the death of various performers and the breakup of the Beatles and other groups. Although he uses the word "pause" and not "end," rock and roll in the 1970s did seem to bring an end to the trajectory that had begun with its emergence from blues in the 1950s. The experimentation that followed was more diffuse and often concerned with performance rather than the formal characteristics of the music itself.

Where did the popular modernists of jazz and rock music get their modernist impulses? Elite modernism had been reflected in popular culture for decades: for example, German Expressionism in the cinema of the 1920s or Art Deco in the 1920s and 1930s. In one sense, Hollywood and European film, as the marriage of a new mechanical visual technology with an entertaining narrative form, had always been a popular modernist experiment. As the boundaries between elite and popular dissolved in the 1950s, there was increasing contact between the art communities and the communities of jazz and then rock music, at least in major cities such as New York and London. African American writers appealed to jazz in the struggle for the

recognition of black culture's importance in America. Some jazz musicians and jazz writers inherited from the elite arts the desire to make a canon and tell a coherent history in which jazz comes to maturity just as modern art does. In the 1960s, the rock movement had gained enough cultural status that it no longer seemed strange for the leading figures to meet or at least know about artists and composers. The Beatles made contacts with artists across the spectrum from elite to popular, although the contacts tended to be rather casual. Lennon met Allen Ginsberg, worked with filmmaker Richard Lester on a film other than the Beatles' movies, and contributed to works by playwright and critic Kenneth Tynan (Norman 2008). Paul McCartney met William Burroughs and began listening to the music of Luciano Berio, Karlheinz Stockhausen, and especially John Cage. He was particularly disposed to think about stylistic trajectories in music (Miles 1997, 234–237). Another pioneer group The Velvet Underground created a unique musical signature by collaborating directly with one of the avant-garde pioneers of the 1960s. Doyle Greene (2016) writes, "the Velvets' avant-garde credentials were firmly established when they began their association with Andy Warhol ... in late 1965" (145). The era's concern for style, of course, went beyond music to a whole range of choices in films, television, dress, hairstyles, and possessions of all sorts. As Tony Judt (2005) remarks in his history of postwar Europe (and here he is speaking of American as well as European popular culture): "In the 1960s people paid particular attention to style. This, it might be thought, was hardly new. But it was perhaps a peculiarity of the age that style could substitute so directly for substance" (395). The peculiarity was that popular culture was adopting an attitude that characterized formal modernism: that style *was* substance. People looked to rock musicians (and to some extent other celebrities such as film stars) to define a lifestyle for a younger generation, to turn art into life.

John Lennon and Yoko Ono as Political Modernists

If McCartney was the Beatle who felt most strongly the influence of formal modernism, Lennon was influenced, ultimately quite profoundly, by political modernism. Political modernism, which had flourished in the 1910s and 1920s, returned in the 1950s and 1960s in the form of the Black Mountain artists, Happenings, Fluxus, and the Situationists, who even played a role in the student revolts in France in 1968. Fluxus artists staged events

and created pieces that were formless attacks on the formal purity of elite modernism. They returned to the desire to bring together art and life that characterized the earlier avant-gardes, and in that important sense, Fluxus too was political. Lennon consciously connected himself to this political avant-garde tradition, with Fluxus artist Yoko Ono serving as his link. Working and living with her from 1968 on, Lennon became an important projection of the political avant-garde into the popular realm. Before he met Ono, Lennon had produced two volumes of short prose pieces and illustrations, *In His Own Write* and *A Spaniard in the Works,* which could be characterized as popular writings in the style of James Joyce. These books revealed Lennon as a formal popular modernist without any pretension to being part of the elite literary tradition. Perhaps for this very reason, literary critics tended to enjoy and praise his writing (Norman 2008, 360).

Meeting Yoko Ono changed Lennon's understanding of his place in popular culture. Lennon had come to loathe the celebrity that he had achieved as a Beatle, and he saw Ono as a path to a new kind of creativity. He grew less and less interested in joining McCartney and their producer George Martin in the pursuit of formal innovation. Lennon realized that he could put his celebrity to productive political use, and he began to write and perform in a style that was as artless as possible. Some of his most successful pieces after the Beatles were nonsongs. "The Ballad of John and Yoko," where Lennon simply sang about his relationship to Ono and their political activism, was autobiographical with no pretense to artistry or allegory. His most popular songs from this period were ones in which he directly addressed the audience with his message of peace: "Imagine" and "Give Peace a Chance," whose melodies were infectious, yet simple to the point of being simple-minded.

Making his own celebrity into a kind of performance, Lennon helped to popularize the avant-garde. Like the historical avant-garde, he resorted to shock tactics. For example, the cover of his album *Two Virgins* showed Ono and Lennon completely nude. It was easier for Lennon to shock because millions of fans and the press followed everything he did. He could in fact hope to achieve what the various avant-gardes of the twentieth century could not. Even if the early avant-garde wanted to have a broad impact, the esoteric nature of their work kept their audiences small. At best they might manage to shock art patrons, who themselves formed an elite. (There were exceptions: for example, the Russian Constructivists who played an active

role in the cultural life of the early Soviet Union until Stalin shut them down.) But the 1950s and 1960s saw a real change. Some of the avant-garde, such as Alan Kaprow with his Happenings, began to attract the larger audiences of youth culture. Andy Warhol and Pop Art effected the breakdown of the hierarchy of the art world from within. Some Fluxus artists became well known in the increasingly fluid cultural scene in New York. Even before meeting Lennon, Yoko Ono was influential enough to be able to perform her transgressive *Cut Piece* in Carnegie Hall in 1965. But Lennon's audience at the height of the Beatles phenomenon dwarfed that of Ono or any of the other artists of this period in size and scope, as fans eagerly awaited each new single or album, listened to the Beatles' songs on the radio every night, and read about the Beatles' personal lives in tabloids and fan magazines. The public watched, as Lennon metamorphosed from a rock musician to a performer whose mission was to make art into a way of life that appealed to popular culture. The transition seemed almost effortless. In March 1969, Lennon married Ono in Gibraltar and went to Amsterdam for their honeymoon, which was a "bed-in for peace" (Norman 2008, 594–595). For a week the two stayed in bed in the Amsterdam Hilton and received reporters with their message of the need to appeal directly to the people to end war, in particular the Vietnam War (figure 2.1). Their efforts continued throughout the year. In December the couple went to Toronto to publicize a song and a poster campaign ("WAR IS OVER! If you want it."). There they were interviewed by Marshall McLuhan, and the exchange is revealing:

McLuhan: "Can you tell me? I just sort of wonder how the 'War Is Over,' the wording ... the whole thinking. What happened?"

Lennon: "I think the basic idea of the poster event was Yoko's. She used to do things like that in the avant garde circle, you know. Poster was a sort of medium, media, whatever." (Beatles 2013)

The goal of Yoko Ono's avant-garde was not all that far removed from the spirit of the musical community that Lennon already belonged to, for the rock and folk movements of the 1960s saw their music as defining a new way of life. Stars such as Lennon and Bob Dylan were elevated to cultural heroes, figures who changed people's lives. The idea that rock stars were for popular culture what novelists and artists were for elite culture has continued in the decades since, and many rock icons pursue the work of being political in the largest sense. We are not surprised by the political

Figure 2.1
John Lennon and Yoko Ono, "Bed-in for Peace," Amsterdam Hilton, 1969. Image
courtesy of the National Archive of the Netherlands. CC BY-SA 3.0 NL.

engagement of Bob Geldof or Bono. But it was hard to imagine in the 1930s
or 1940s that a musical performer, although vastly popular, could fashion
himself or herself into this kind of cultural-political persona. The political
engagement of movie stars and singers of that earlier era was largely limited
to charities and entertaining the troops during World War II under govern-
ment auspices. Figures who seemed too overtly political, such as Charlie
Chaplin, were not welcome in Hollywood.

McLuhan and Popular Modernism

It is appropriate that Marshall McLuhan (1962, [1964] 2013) was the one to
interview Lennon on his trip to Toronto in 1969, for McLuhan was working
through a metamorphosis of his own—from traditional academic to pop-
ular modernist. An English professor whose research interests extended
from Elizabethan writers to James Joyce, McLuhan refashioned himself in
the 1960s as a student of "media" and described what he saw as the wan-
ing of print culture and the arrival of a culture based on electric media,

principally television. For about ten years, he was publicly celebrated as a prophet of new media. His academic colleagues, still committed to the culture of print and mistrustful of television, found his works, including *The Gutenberg Galaxy* (1962) and *Understanding Media* (1964), obscure and filled with unfounded generalizations. His appearances on television and his paid lectures for corporate America gave them the impression that he had abandoned the community of scholars. McLuhan became famous enough to appear as himself in a hilarious cameo in Woody Allen's *Annie Hall* (1977), where he appropriately takes a Columbia University professor of communications to task for not understanding his work.

It is not clear whether McLuhan himself fully understood his debt to modernism. First and most obviously, he was modernist in insisting that contemporary culture was undergoing a revolutionary change. The site of his revolution was media, not just art. Nevertheless, there is an important parallel between McLuhan's work and the art historians' work on medium, particularly the influential art critic Clement Greenberg. Greenberg promoted the idea that modernist painting had a stylistic trajectory from the nineteenth century to the twentieth—that modernist painting was historically committed to developing its medium. In his famous lecture "Modernist Painting" (Greenberg 1960) and elsewhere, Greenberg helped to define (American) high modernism with its assumption that the purpose of art is to explore the essential qualities that make each particular artistic medium unique. Although McLuhan never referred to Greenberg and may not even have read his work, McLuhan became the popular modernist representative of the ideas about medium that Greenberg articulated for the art world (Bolter 2014; van der Meulen 2009). In this way McLuhan helped to introduce the elite concept of "medium specificity" into popular culture. He not only applied the modernist way of looking at art to all the uses of media for communication and entertainment; he went even further. His expansive definition made medium the technological basis of all culture. In *Understanding Media*, he explained how each new medium changes human nature by providing a potentially revolutionary "extension" of the human senses. For McLuhan, each medium had defining technological qualities that lent it a transforming power. The first chapter of *Understanding Media* is entitled: "The Medium Is the Message." It is not the content of a medium that matters, but rather its unique technical nature as medium.

McLuhan was a traditional academic who found a radical formula for reaching a new audience of readers, many of whom were not academics themselves and were attracted by his quasi-historical generalizations that explained all culture in terms of a procession of media. And with the rise of digital media technologies in the 1980s and 1990s, a new class of popular writers appeared, eager to apply McLuhan's logic. As popular modernists, they easily accepted his assumptions about the essence of "the medium" and the central role of the artist, redefined now as the technologist-artist.

They set out to show how the computer fulfilled its role as a new medium and how it fostered a new form of creative expression. When digital modernists speak of the need for a revolution, they are seeking, whether they know it or not, to relive the excitement that the first modernists experienced in the years before and after World War I. Writing about digital art and design, for example, in *Digital Mosaics* Steven Holtzman (1997) claimed that we should not simply repurpose old techniques and materials from legacy media, stating, "repurposing ... isn't where we'll find the entirely new dimensions of digital worlds. We need to transcend the old to discover completely new worlds of expression" (15). He assumed that designers *do* in fact need to find entirely new worlds of expression. This rhetoric found its way into the industry. We recall that when Steve Jobs introduced the iPhone in 2007, he claimed it was nothing less than the third revolution that Apple had engineered: the Mac in the 1980s, the iPod in 2001, and now the iPhone.

Popular modernists approach video games and other digital media in the same spirit in which McLuhan approached television in the 1960s: they look for the essence of the digital. McLuhan based his analysis of television on the fact that a televised image was composed of a relatively low number of visible scan lines. For McLuhan, the effects of television derived from the viewers' need to complete in their minds the coarse image on the TV screen. Similarly, digital media writers today make a medium-specific argument for the computer. Almost all agree that the defining quality of the computer medium is *procedurality*. The computer is a procedural machine, constructed to execute an explicit set of rules embodied in each program. The computer can be made to simulate any system that can be described formally. Accordingly, all digital media, especially video games, are simulations, and each simulation is a procedure that constructs a little world with its own logic and texture. Espen Aarseth has put it: "The computer game is the art of simulation. A subgenre of simulation, in other words. Strategy

games are sometimes misleadingly called 'simulation' games, but all computer games are simulations" (2004, 52).

Today's popular modernists expect that digital media technologies will play a defining role in shaping individuals and culture as a whole. We are often told that the computer has changed the way we write or even the way we think. We cited several examples of that rhetoric at the beginning of this chapter. Let's add one more, Steven Johnson (2006): "I am much more of a technological determinist than an economic determinist. So the question for me isn't: What is capitalism doing to our minds? Rather, the question is: What is the reigning technological paradigm—combined with both market and public-sector forces—doing to our minds?" (205).

Popular modernists followed McLuhan in believing that the form of a medium *is* its content. What matters about any medium and almost any artifact in the medium are its formal properties, not the particular content that the artifact might hold. They have followed McLuhan in asserting that media transform human nature and culture, and they often make another claim as well: that the digital medium has the power to encompass all other media. The digital medium, they say, can simulate or incorporate film, radio, static images, and printed books. This is medium specificity, and yet at the same time a claim of universalism. The computer is the final medium, the one that achieves what all other media have aimed at (Manovich 2013). For popular modernists in McLuhan's mold, our media culture is not a plenitude, because the digital medium promises ultimately to bring everything together.

Steve Jobs

Steve Jobs was forty-four years younger than McLuhan and fifteen years younger than Lennon. Like Lennon, Jobs was a practitioner rather than a theorist. Walter Isaacson, his biographer, calls Jobs an artist: "He thought of himself as an artist, which he was, and he indulged in the temperament of one" (2011, 561). While John Lennon was captivated by the avant-garde, Steve Jobs felt far more strongly the pull of progressive modernist design. Both Lennon and Jobs were largely self-educated and picked up the fragments of the paradigm of modernism they happened to come across.

The two archetypal figures of the personal computer industry, Steve Jobs and Bill Gates, were famously both college dropouts. Gates dropped out

of a more successful and traditional education at Harvard after two years. Jobs's college experience was shorter and less orthodox: he ceased being a formal student at Reed College in his first year. In his time at Reed, Jobs did sit in on a course on typography, but his intuitive understanding of modern design came through his careful appreciation of its products, particularly those of European designers like Dieter Rams. His most important influence, perhaps, was the engineering culture in America that had developed since World War II. Exposed to the culture of tinkering by his father and his father's engineering friends in a middle-class neighborhood in Los Altos, California, Jobs developed a passion for understanding mechanisms. The computer was the ultimate mechanism, and Jobs came of age at the right moment to take part in the computer hobbyist culture of the 1970s. In the decades that followed, Jobs had two opportunities to introduce modernist principles into computer culture, and he made extraordinary use of both. They came in the first and second incarnations of the company he founded. In the 1980s he introduced the Macintosh. In the late 1990s and 2000s, when he returned to Apple, he and his team created the iMac, iPod, iPhone, and iPad (Isaacson 2011)—each one revolutionary, according to Jobs and his adoring followers in the industry. In so doing, he put iconic, popular modernist designs on the desks and in the pockets of tens of millions of consumers.

Jobs commissioned television commercials marking those two moments. The first of these was a piece of cinema, rather unlike anything that had previously been aired as a prime-time commercial. It was shown just once, on January 22, 1984, and in the most visible advertising slot on American television, during the Super Bowl (Cole 2010). Made by the dystopian film director Ridley Scott, the commercial depicted a dreary regimented society, like the one in Orwell's *1984*. We see an athletic woman, eluding heavily armed police as she runs through a theater where rows of despondent workers (or are they prisoners?) sit watching the address of a dictatorial leader on a giant screen. She hurls a hammer at the screen, causing it to explode in a blaze of light and wind, as the narrator explains that the introduction of the Apple Macintosh will prove that "1984 will not be like *1984*." Everything about this piece points to revolutionary political change. But it announces a formal revolution too, the replacing of one medium with another. When the cinematic screen shatters, the commercial becomes a

critique of film itself, suggesting that Apple's computer will be a device that renders old-style cinema obsolete.

Throughout his life, Jobs loved Dylan and the Beatles, both of whom represented the avant-garde and political aspects of popular modernism. Yet Jobs himself was drawn to the progressive modernism of Bauhaus and later European design, and he was determined to apply that aesthetic to the computer revolution. Jobs's famous visit to Xerox PARC in 1979 was a revelation for him, although some Apple engineers were already aware of the innovative work that Xerox was doing to define the graphical user interface (GUI) for their Alto computer (Isaacson 2011, 95–101). The difference between the Xerox Alto and the Apple Macintosh is the difference between the GUI of engineers and the GUI of designers working in the tradition of twentieth-century modernism. Xerox had developed most of the interface mechanics, but Apple fashioned those mechanics into a design aesthetic.

Jobs employed a trained graphic artist and designer, Susan Kare, to create fonts and icons for the Macintosh. The problem was to do more with less: to make legible and attractive symbols for the medium of the low-resolution computer screen of the time, where each character could only be composed of a few rows of pixels. Beyond his intuitive sense of design, Jobs himself had had a notable contact with the Bauhaus tradition when in 1981 he attended the International Design Conference in Aspen and visited the Aspen Institute, whose campus had been designed by Herbert Bayer. In 1983 Jobs addressed this conference with a talk entitled "The Future Isn't What It Used to Be" and made it clear that he understood the importance of design aesthetics. He embraced McLuhan's modernism: the computer is a new medium, he explained. And he embraced the Bauhaus: the design of personal computers should be clean, clear, simple (Isaacson 2011, 125–127).

Jobs and his company became famous for a fanatical insistence on consistency and transparency in the design of the Macintosh. Unlike Microsoft, Apple did not license its operating system to other manufacturers, because Jobs believed that having one company craft hardware and software together assured the quality and unity of the user's experience. Apple's published design guidelines ensured that, in writing programs for the Macintosh, third-party developers would make their interfaces consistent and legible. In his concern to control every aspect of the user's experience, Jobs was denying not only the business sense of Gates and Microsoft

(whose Windows operating system came to dominate the computer market) but also the "Internet ethic" of the technology community of the time. In the 1980s, the programmers and researchers in universities and corporate labs, who created the software infrastructure of the Internet, formed a relatively small, homogeneous group, and their culture inclined them to share programs and scripts and to make their software infinitely customizable. They believed in "open systems" or in Richard Stallman's "free software," whereas Apple's system was corporate-owned, closed, and hard to modify. At the same time these programmers and researchers had no training in visual design and little interest in expanding the computer to a large audience of consumers.

Jobs's insistence on control did not come from a conservative political philosophy. He admired the culture of the 1960s, listened to the era's music, and even traveled to India in search of enlightenment (as the Beatles and numerous children of the 1960s had done before him). Jobs's passion for popularizing modernist design somehow coexisted with this love of youth culture. The "1984" commercial was meant to show that the computer could be a force either for personal expression and freedom or (if badly used, as IBM was doing) a technology of anonymous regimentation. When it came to the Macintosh, however, the aesthetics of the Bauhaus and European minimalist design triumphed over the impulse to promote freedom of expression. Popular modernism like classic modernism could be totalizing. Jobs would later argue that his meticulously designed systems in fact freed their customers to concentrate on being creative in their work of making content with his systems.

A second commercial in 1997 introduced the second great modernist period at Apple (kreftovich1 2010). In 1985 Jobs had left the company after losing a power struggle with the board of directors. By the mid-1990s, the Apple Macintosh line was in danger precisely because it had become a technology platform rather than the marriage of form and function. On his return Jobs wanted an advertising campaign that would capture the spirit of the company he intended to resurrect, and he chose a marketing line suggesting revolutionary change: "Think Different." The first commercial in the series consisted of a montage of short, silent videos of famous figures of the twentieth century: an utterly eclectic group including Einstein and Edison, Gandhi and Martin Luther King, Bob Dylan and John Lennon, and Mohammed Ali and Ted Turner. A voiceover (originally the actor Richard

Dreyfuss and in a later version Jobs himself) led us through this parade of figures and ended with the words: "While some may see them as the crazy ones, we see genius. Because the people who are crazy enough to think they can change the world, are the ones who do." This script could be a liturgy for popular modernism. It praised change and breaking down the status quo, but it did so in the name of human progress. The figures chosen for the video exemplify excellence in as many human endeavors as possible. No notion of the historical avant-garde could include Thomas Edison or Buckminster Fuller, but they could all be modern in the sense that their achievements came from a commitment to first principles and technological innovation. Together, these figures announced that Apple would return to innovation as a cultural imperative.

The products of Jobs's second tenure at Apple perfected the design aesthetic that he had sought to achieve the first time. Under the lead designer, Jony Ives, the Apple team applied a modernist look first to the iMac and then to a series of portable devices (the iPod, iPhone, and iPad). The principle of totalizing design becomes apparent when we listen to the promotional videos released for these products, in which Ives and the Apple team describe with fetishistic love the angle of the iPhone's beveled case or the crispness of the text on the retina display of the iPad. In all this, Apple is continuing a tradition that proceeds from the workshops of the Bauhaus and Swiss graphic design, through Scandinavian product design, to the devices of Braun and Sony. The rhetoric is also in the spirit of McLuhan. As Jobs said in the Macworld speech with which we began this chapter, and as his team reiterates with each new device, Apple's products are designed to change the way we read, listen to music, or make phone calls. They incarnate the idea of progress through technological innovation. As a popular modernist, Jobs was always confident that good design could bring order to the chaos of our media plenitude. In the end, of course, he could only do so for Apple products and their communities of users.

The Future as Popular Modernist Kitsch

The popularization of modernist thinking was not limited to leading figures like Lennon, McLuhan, and Jobs, and it was not limited to elegant expressions, like Lennon's anti-war performances or the iPad creation of Jobs and Ives. The appropriation of modernist ideas into popular forms had

already occurred with Art Deco beginning in the 1920s. There were all sorts of comic and kitschy borrowings, as well, drawing on the excesses of modernist art and design. Visions of a future of pure technological advancement run throughout the twentieth century: cities of flying cars and mechanized buildings, spaceships and colonies on other planets. These extrapolations of the modernist fascination with technology became the stuff of science fiction films, pulp novels and stories, and comics. Even when the technology ran amok, the fascination remained. We can draw a line from *Metropolis*, the silent sci-fi epic directed by Fritz Lang in 1927, to the science-fiction novels of the 1950s, such as Isaac Asimov's Robot series of stories and novels, to the television series *Star Trek* in the 1960s and subsequent iterations of the show in the 1980s onward, including today's *Star Trek Discovery*. In all these cases, humans build and readily inhabit worlds of mechanistic design. The decor of the Starship *Enterprise* comes across as a parody of the design principles of the modern American furniture of the mid-twentieth century. The characters in *Star Trek* seem content to work for months or years on a spaceship in which most natural forms or materials have been replaced by plastics and alloys. In at least the original *Star Trek* series, poverty and war on Earth itself are things of the past. Obesity is also apparently a solved problem in the twenty-third century, for everyone in the future fits beautifully into spandex jumpsuits. Humans live on a technologically utopian Earth, which perhaps explains why they venture out to explore the galaxy, where all the human weaknesses of greed, prejudice, and ignorance are now embodied in the alien races of Klingons and Romulans. Silly and endearing as it is, *Star Trek* is an example of progressive modernism brought to a fully popular idiom. The popular modernist vision of the future is characterized by the thorough application of technology to as many spheres of human activity as possible, and one function of science fiction has always been to realize that vision.

Another expression of the popular modernist future was artificial intelligence, a school of thought that arose in the 1950s, inaugurated by the pioneer computer scientist Alan Turing in an article in the philosophy journal *Mind* (1950). In the 1950s and 1960s, the AI movement was made up of a group of talented computer specialists dedicated to technological futurism: John McCarthy, Alan Newell, Marvin Minsky, and others. While some made significant contributions to computer science (McCarthy, for example, invented the programming language LISP), they were all committed

to the philosophically simplistic notion that the digital computer was the ultimate model for the human mind. They made extravagant claims that computers would soon surpass humans at proving mathematical theorems and translating from one human language to another. These claims became failed promises, eventually leading to a drop in government funding for research and general interest in AI in the 1970s and again in the 1980s. AI programming techniques were by no means failures, however; what failed was the modernist vision of the computer as an ideal thinking machine, a replacement for human beings. Today computer systems are close to achieving many of the goals envisioned by AI, including image recognition and reasonably good speech-to-text translation. But they generally do so through creative programming techniques, not by understanding or modeling how humans accomplish these tasks. Pattern-matching algorithms have accounted for many of the successes (MacCormick 2012, 80–104), and these algorithms (even the "artificial neural networks") bear no necessary similarity to the way that human beings "match patterns." Meanwhile, although robots of all sorts are increasingly finding places in industry if not yet in the home, they do not have the versatility, personality, or (in most cases) humanoid look of C3P0.

Although the popular modernist vision of AI has not disappeared, AI does not have the cultural cachet that it enjoyed earlier. One reason is that new metaphors emerged in the 1980s and 1990s along with new digital technologies. Computer graphics became more and more important for both practical and entertainment applications. For example, computer graphics special effects came to be an essential feature of the Hollywood blockbuster. Around this time, virtual reality (VR), in a sense the ultimate application of computer graphics, became a cultural symbol for the promise (and the potential danger) of digital technology. The vision of a total VR world, in which people wore their headsets all day and conducted all their working, learning, and playing virtually, became a new popular modernist fantasy. The AI vision lingers mainly in the guise of the intelligent, autonomous robot. And the technical success of various forms of AI has led to an elaboration of an old fantasy, now called the "singularity." As Raymond Kurzweil explains it, humans will eventually supplement their bodies or leave them behind altogether to join a world of vastly superior digital intelligences (Kurzweil 2005). In Kurzweil's vision the object of design, the computer, takes over and becomes the designer. It is sometimes hard to tell

whether those who propose the singularity see this future as utopian or dystopian. Robotics engineer Anthony Levandoski has gone so far as to found a tax-exempt church of AI called the Way of the Future (Heffernan 2018).

Forgetting (Popular) Modernism

If modernism became popular modernism in the second half of the twentieth century, it is natural to ask what happened to postmodernism. According to Frederic Jameson (1991), postmodernism also rejected the division between high and low culture and drew freely from popular sources. Postmodern writers, architects, and artists were heirs to the tradition of the elite arts; they played casually with the fragments of modernism, but still with the sense that these were the fragments of their own tradition. In fact, postmodern art was not any more popular than the modern art it superseded. By the 1970s, the hierarchy of art had broken down so that postmodern artists could no longer have pretended to speak for the whole culture, even if they had wanted to. They were working in and for their own community, with the same claim to cultural status that popular writers and filmmakers had for their larger communities. Popular films and novels as well as rock music, music videos, and graphic novels played with the fragments of modernism, but they also responded to popular forms that came before. Ridley Scott's sci-fi blockbuster film *Alien* (1979) combined the Hollywood monster film with progressive modernist space epics like *Star Trek*. His popular masterpiece *Blade Runner* (1982) projected film noir into a dystopian modernist future. These were examples of what we might call *popular postmodernism*. What postmodernism was to modernism in the art community, popular postmodernism is to popular modernism in the larger media culture. That is, popular postmodernism is a second wave of the popularizing of art culture in the late twentieth century.

Popular postmodernism has not replaced popular modernism, however. The fragments of modernism and postmodernism both continue to leave an impression on contemporary media culture today. To the end of his life, Steve Jobs, for example, was not particularly interested in the postmodernist elements that were filtering into popular culture all around him. He was committed to the values of perfect design that he inherited from modernism, and he insisted on originality and ownership, not just as a matter of economics, but also on principle. Under his leadership, Apple was involved

in numerous patent infringement litigations with companies, including Samsung, Nokia, HTC, and Motorola. And when it came to design, Jobs had no use for digital sampling, crowdsourcing, or DIY, believing that designs should be carefully crafted by experts (like himself) to create platforms for users to exercise a subsidiary or at least different form of creativity. In his view, Apple's designs empowered users precisely because they provided interfaces and services that users themselves did not know they wanted. Walter Isaacson (2011) quotes Jobs: "People don't know what they want until you show it to them. That's why I never rely on market research" (567). This paternalism does not fit with popular postmodernism, but is perfectly consonant with a modernism that proceeds from first principles.

The assumptions of popular modernism remain compelling in many communities today. The rhetoric of technological change—progressive modernism with just a dash of the avant-garde—is apparent in almost every article written about digital technology. Even today, contemporary science has not abandoned progressive modernism: the idea that science and technology lead us cumulatively to more knowledge and control. The popular modernism of technologists like Raymond Kurzweil, promising brilliant artificial intelligence and a kind of immortality for humans, still captivates audiences of geeks. These utopian visions, which have really hardly changed since the science fiction pulps of the 1930s, have their place in the plenitude along with the popular postmodernism of social media and remix. Steve Jobs's death does seem to signal the waning of the purest form of popular modernism, but waning does not mean dying. Tens of millions of customers love the elegant design of their iPhones (or the derivative Samsung devices). But they have no abiding commitment to the aesthetic; they use their iPhones and iPads to access the careless interfaces of Facebook and Flickr.

If modernism was the story of European and American culture in the twentieth century, there is no dominant cultural story today. Some in the academic world are preoccupied with the attempt to find an "ism" to follow postmodernism. But postmodernism was always the late phase of modernism, and it is futile to try to describe a "post-postmodernism," a "digimodernism," or a "super-," "hyper-," or "metamodernism" (Fjellestad and Engberg 2013). Implicit in all such terms is the idea that our cultural plenitude still has an underlying unity that needs naming. The breakdown of modernism throughout the second half of the twentieth century was

also the end of a coherence of culture in that sense. Popular modernism is what modernism became on its way to dissolution.

Postmodernism as an elite aesthetic is fading along with modernism, and the fragments of both are constantly being absorbed into contemporary media culture. This blending is exactly what modernism is not supposed to permit, for it was supposed to provide a unifying principle to culture. In that sense modernism and the avant-garde are coming to an end. As so many critics have pointed out, the avant-garde has to be ahead of the mainstream. If there is no identifiable mainstream, how can there be an avant-garde? The term "avant-garde" is now used in popular culture simply to mean "unexpected and original," or even just "cool." The art community still speaks of the avant-garde in the historic sense, of overturning our culture's assumptions about art and admonishing us to adopt a new politics. But this notion applies only within the art and literary communities themselves. For all the other communities that have appropriated the term "avant-garde," it is not really disruptive. As Thomas Frank (1997) demonstrated in *The Conquest of Cool*, the elements of counterculture (popular modernism's avant-garde) were ultimately appropriated by business culture and became mainstream.

3 Dichotomies

Let us take stock of where we are. The rise of digital media in the second half of the twentieth century occurred at a time when a cultural consensus that had held for decades was coming apart. Our culture as a whole was losing its conviction in the special status of the high arts (the visual arts, classical music, and serious literature). Since the eighteenth century, those working in these fields were not simply regarded as having a special skill; they were now figures with a special, quasi-religious role in our society (Shiner 2001). They were supposed to be men and women of unparalleled originality, and the art they made played a critical, even salvational role for us individually and as a culture. The educated classes accepted the hierarchy in which certain creative forms—literature, classical music, painting and sculpture, and perhaps architecture and drama (but not woodworking or glassmaking)—and their practitioners fulfilled this key role. Throughout this period, even into the twentieth century, economic and cultural hierarchies were more or less aligned. The wealthy and powerful supported these arts, while popular forms—Hollywood film, dance music, genre fiction, and so on—were for the lower classes (and for the middle and upper classes when they wanted simply to be entertained). Although there were many ways in which this situation was challenged earlier, the hierarchy really started to break down in the 1950s in the United States and somewhat later in Europe, especially with the rising status of jazz, rock music, and popular film. While the student movements of the 1960s failed to radicalize the liberal political democracies of Europe and North America, the 1960s did succeed in driving irreparable fissures into the existing cultural structures. In place of a single cultural hierarchy, what remained was a collection of communities large and small: a very large community that listened to rock

music, smaller ones that preferred folk, jazz, or classical music, and so on. People could and did belong to multiple communities, each of which had its own standards and hierarchies. Members of the traditional cultural elites could still assert that their music, literature, or art was at the center of culture, but their claims carried less and less weight. In general, communities today live in peaceful coexistence or mutual ignorance. No one from the rap or rock communities is ashamed not to know the difference between Stravinsky's music and Schoenberg's, just as no one from the classical music world need be ashamed to be unable to distinguish East Coast from West Coast rap.

Meanwhile, the economic and cultural elites have split apart. Prior to the 1950s, to be educated and wealthy implied certain cultural preferences. If you were rich and had gone to good schools, you were supposed at least to acknowledge the value of classical music and high art. Today, we are not at all surprised if a billionaire prefers blues or rap to classical. For example, during the 2012 presidential campaign, *Rolling Stone* (2012b) reported that Mitt Romney, one of the wealthiest men ever to be a major candidate, likes the Beach Boys and country music. And although (obviously) only the wealthy can participate in the fabulously inflated high art market today, we are not shocked to discover a football or basketball player who collects fine art. Cultural conservatives, who do not accept the fragmentation of culture that I am describing, often complain that today's young people say everything is a matter of taste or preference. But at least in arts and entertainment, that is where we all are: in the absence of an agreed paradigm, choices have necessarily become matters of taste and community.

When the breakdown of the hierarchies occurred, modernism happened to be the dominant paradigm. As that paradigm shattered, its fragments were often appropriated by figures in popular culture. Much of the rhetoric of elite or high modernism expanded into popular culture, while at the same time modernism was being superseded within the art community itself. Starting in the 1950s and 1960s, figures in jazz and rock music, film, and television began to talk and be talked about in terms that had been reserved for elite artists. The assumptions of modernism, particularly relating to the notion of medium, were picked up by writers and thinkers of all sorts. Marshall McLuhan borrowed some of those assumptions and translated them into his version of media studies, and many writers on digital media ultimately received their ideas from him. For them every significant

digital technology defines a new medium whose special qualities change the way we take pictures, make and listen to music, tell stories, visualize the world, write, or think. Modernism has also been tremendously influential in the fields of graphic and industrial design, although of course here the influence of modernism had been acknowledged since the time of the Bauhaus. Steve Jobs absorbed modernism through the vernacular of product design in the 1970s, and he was strongly influenced by the popular modernism of rock music in the 1960s. His iPod, iPhone, and iPad are among the most compelling recent expressions of popular modernist design.

This is the cultural matrix into which digital media were born. The fully electronic, stored program computer was perfected in the 1940s and 1950s, but it took much longer to develop the machine into a series of media forms. By the 1980s, Microsoft, IBM, and Apple were offering millions of consumers proof that the computer could function as a means of communication and representation. Revolutionary as it was, the computer did not bring about the breakdown of the cultural hierarchy. In recent decades, however, digital technologies have been deployed in a way that facilitates and shapes a culture of communities. Networked digital media are part of our heterogeneous media landscape, which still includes most of the older forms (printed books, films, recorded music, radio, television) as well as their digital counterparts. The Internet is an ideal medium for members of geographically dispersed communities of interest to connect and communicate. Large and small media communities today have their place in a plenitude that, like the Internet itself, has no single center.

The Rise of Popular Modernism

Popular modernism did not share the fate of elite modernism. It has diffused through our media culture, providing a rhetorical foundation for the enthusiasm and creativity of many of the most visible media. Popular modernism was and to some extent remains an often-naive application of the ideas of high modernism, but precisely for this reason, popular modernist writers, designers, and builders have not felt the burden of working within an elite tradition. After forty or more years of postmodernism, the contemporary elite art community is still working through and around the legacy of modernism. Meanwhile, popular modernists in digital media feel free to borrow from the modernist and postmodernist past (and everywhere

else besides), and they proceed with confidence to offer us the products and services of Apple, Google, YouTube, Twitter, Facebook, Instagram, and thousands of other software and hardware firms. The project of filling the world with designed artifacts is an inheritance of the twentieth-century tradition, but filling the world with *media* artifacts and practices and indeed redesigning our world *as a medium* is a peculiar and ambitious contemporary variation of popular modernism.

We have identified in the preceding chapters the elements of popular modernism that have inserted themselves into contemporary media culture:

1. The importance of the new. The need to jettison tradition and create something "completely new and different" is as old as modernism itself, but even today the rhetoric of digital media is still founded on a fascination with the new. Every year major players like Apple are expected to offer "revolutionary" products and therefore criticized if the newest iPhone is merely an improved version of the previous model.

2. The breakdown of hierarchy. Popular modernism arose because the fragmentation of the modernist paradigm in the arts was happening in tandem with the rising status of rock music, film, and popular forms such as comics. Insofar as high modernism was associated with high art, popular modernism was a break from modernism, but only a partial break. Popular modernists borrowed the vocabulary of elite art and culture for their own work. Even today they often seem not to want to flatten the hierarchy of culture but rather to join it: to insist that the new arts of rock music, film, or television belong with the traditional elite arts. Jay-Z claims, not entirely facetiously, to be the new Picasso.

3. A fascination with technology. Modernism reacted with both fascination with (the Futurists) and revulsion at (Dada) the pace and power of technological change. That fascination is obviously as strong as ever in this era of digital media. If the Futurists were obsessed with the power and speed of the automobile and airplane, the popular modernists of digital media today focus on what they regard as the key quality of digital technology, procedurality, which defines the ways in which human agents engage with digital media forms.

4. A preoccupation with style. High modernists understood art as style. Each individual artist developed a style, which, at least in the case of the

most influential artists, formed part of the larger history of art. Popular culture in the 1960s also became preoccupied with style, in a way that in the nineteenth century only the upper classes or well-to-do bourgeois could afford to be. Media celebrities—and above all musicians—became fashioners and arbiters of style. Changing musical styles became key elements in a person's cultural image that included preferred TV shows and movies, dress (and more recently body art), forms of speech, and so on. This concern for style continues today, when every participant in our media culture is expected to express his or her own identity within the templated constraints of a Facebook page or Twitter profile.

These elements of popular modernism, already prevalent in the 1960s and 1970s, formed part of the cultural background for the rise of digital media from the 1970s on. The early creators of digital media technologies, such as Alan Kay and Steve Jobs, were children of the 1960s, and they understood the project of defining the "digital medium" in popular modernist terms. They certainly believed in the importance of the revolutionary quality of the medium as well as the power of the digital to bring modernism to the people. Kay was convinced that the computer could be a "personal dynamic medium" for everyone, particularly for children, and Jobs wanted the Macintosh to be "the computer for the rest of us."

As modernism dissolved into popular modernism, the "Great Divide" closed, and the definition of art broadened to include almost all forms of creativity. The heirs to elite art (painting, sculpture, installation, performance, and all the forms that art has taken in the last fifty years) are reunited with all the crafts that were demoted from the status of art in the eighteenth century (Shiner 2001). And whatever is not art, can be design. Design, in the contemporary sense, was born in the late nineteenth and early twentieth centuries with the Arts and Crafts movement in Britain, the Deutscher Werkbund, the Vienna Secession; modern industrial design emerged under their influence. Throughout much of the twentieth century, design remained secondary in cultural status to art. Where artists were free to express themselves (or even to stand outside of and above society itself), designers worked under constraints, at the behest of an employer or client. Today, however, art and design have roughly equal status and are sometimes synonymous in meaning. The status of art has been not lowered to the status of design; instead, a modernist notion of artistic creativity is

now being applied to design, and like the term "art" the term "design" is being extended to more and more activities—beyond the crafts to industrial products, architecture, engineering, and more. Design includes digital artifacts that inform or entertain: interface design or user experience design. In universities, technical institutes, and art schools, design itself has become a discipline with its own curriculum, journals, and a myriad of approaches including participatory design, collaborative design, user-centered design, co-design, and so on. These approaches aim to democratize the design process by including the perspectives and creative insights of users and otherwise marginalized groups.

Just as the website www.deviantart.com is for the artist in all of us, our media culture now also credits the designer in all of us, as both terms "artist" and "designer" attest to versions of the universal quality of human creativity. The layered nature of digital media opens opportunities for creative practice to ever-greater numbers of participants, both because one can be creative at so many levels and because digital media hardware, software, and forms continue to multiply, suggesting ever more ways to be creative. A relatively small group (perhaps tens of thousands?) engage in the designing of new hardware platforms; a larger number (hundreds of thousands or perhaps millions?) make new software both commercially and in the amateur and open source movements. Tens of millions employ the hardware and software for such practices as image creation and sharing, remix, fan fiction, macroblogging and microblogging, and web design. New media forms are hived off from existing ones, and each new form opens a new realm for creative practice. Critics of digital media culture, such as Jaron Lanier (2010) and Andrew Keen (2007), complain that this leveling means that we can no longer distinguish good work from poor, but they ignore the fact that the creativity of all such work can only now be measured relative to the standards of some community of practice. The community may be vast in numbers, but its standards are always parochial. All work looks very different and often not very meaningful to those outside the community for which it was intended. If a creative work (and that can now be a song, a poem, a film, an iPhone app, or a video game) appeals across communities, it does so with changed meaning.

Sometimes a work can constitute its own temporary community; the phenomenon of "going viral" exemplifies this fleeting coherence. The music video *Gangnam Style* meant something different to Western viewers

or the millions of other Asian viewers than it did to Korean fans of the K-pop musician Psy. All were brought together temporarily by the video, which the world has collectively viewed more than three billion times on YouTube. Such temporary and casual digital communities can form in a matter of days or weeks. Longer-lasting communities form around software, such as online role-playing games like *World of Warcraft* or of course Facebook itself. One of the characteristic creative acts of this era of plenitude is to form a new community that coheres and lasts. Again, within each community there are standards, but these standards do not reach across communities. What we gain from this flattening and broadening is the tremendous enthusiasm of today's media culture. There is an unprecedented degree of energy and participation in the making of traditional and especially digital media artifacts. This energy is why the media plenitude is a plenitude. In the following chapters we will examine some of the ways in which that energy is manifested in our media culture today.

Describing the Plenitude

The purpose of chapters 1 and 2 was to establish the historical context for what follows: an attempt to describe the plenitude today. My argument so far may make it seem that this is an impossible task, because we cannot identify any single set of characteristics of our contemporary media culture. The temptation to come up with a set of such characteristics is strong among popular writers and even some academics. So we are told that ours is a network culture, a remix culture, a Facebook (or social media) culture, a video game culture, and so on. But none of these media or media practices are truly universal. They define large (sometimes enormously large) communities of participation. But for every one of these communities, there are also outsiders, millions of people (even in United States and other developed countries) who do not participate. Each community is defined by the way that it intersects with or distinguishes itself from others: musical tastes divide us into communities, as do preferences for film or video games, for literature or television, for and against various social media. There are too many such differences for us to brand our whole media culture with any one practice.

So what can we do to try to understand our current cultural moment? The strategy I propose is to choose a few characteristics that seem to me

catharsis	flow
originality	remix
organic/spontaneous	procedurality/datafication
history	simulation

Figure 3.1
Some dichotomies in contemporary media culture.

to delineate large parts of our media culture. These characteristics can be thought of as aesthetic, social, or technological values or preferences. They can be arranged in pairs, each with its opposite number (figure 3.1).

To explain each pair briefly:

1. **Catharsis** and **flow** are contrasting values in entertainment and art. They describe two possible aesthetic or emotional responses in people who listen to music, read novels, or go to films, play video games, and so on.

2. **Originality** and **remix** have also become contrasting values in entertainment and art. Remix takes fragments (samples) of the works of others and fashions them into new experiences. Where our culture used to value originality above all else in creative endeavors, remix is now an alternative practice that is widely accepted.

3. **Procedurality** is shorthand for a range of technical and social impacts of digit technology and processes. This term (together with datafication) can also describe a fascination with these processes and the way in which communities (such as social media users and video game players) are willing to insert themselves into digital procedures. Its opposite (**the organic or spontaneous**) includes practices and forms of media that cannot be easily reduced to procedures and data.

4. Many digital media writers have characterized the computer as a **simulation** machine, and the key quality of simulation is replayability. We can always reset the variables and play the simulation over. I use the term "simulation" to suggest a way of looking at individual or collective life that is not only ahistorical but anti-historical. Its opposite is a conviction that **history** is serious, once and for all, and not replayable.

These dichotomies are by no means the only possible ways to divide up our media culture, and they are not as rigid as my brief descriptions suggest. They are extremes, and there are all sorts of positions in the middle. As we shall see repeatedly, each pair defines the endpoints of a spectrum. A movie can, often does, have elements of flow within its overall cathartic structure. A popular song may combine samples with original passages. Many of our cultural practices combine procedurality with spontaneity. Nevertheless, these dichotomies do describe real tensions or oppositions today. A preference for catharsis or flow may determine whether you go to the movies or play video games (and which industry thrives). Differing views on the value of remix have led to civil or criminal penalties for young people violating intellectual property.

There is also a sense in which one term in each pair represents our supposed media future and the other our tradition or our past. All the new "hip" terms are in the right-hand column. "Catharsis" was and remains the aesthetics of mainstream film; "flow" is the aesthetic of video games. "Remix" is the term for practices in music and digital media production that started in the 1970s and 1980s and flourishes today as never before. Before remix, our creative culture was committed to originality: certainly that commitment is a tenet of modernism and even sometimes popular modernism. "Simulation" (as discussed in this book) is a term from digital culture. But even if procedurality, catharsis, flow, remix, and simulation are characteristic of large digital communities today, that does not mean that their counterparts will disappear. These hip new qualities remain in a creative tension with their opposites.

4 Catharsis

It is often said that we are living in the second Golden Age of Television in America. The first Golden Age of Television was the 1950s, the decade in which television expanded rapidly in popularity, reducing radio to a monochromatic formula of popular music and local weather, and threatening (but not succeeding) to relegate American movies to the same status as live theater. This first Golden Age of Television certainly had a role to play in the formation of popular modernism. What made television golden in the 1950s were two genres that exploited what was understood as the *liveness* of this medium: news (for example, CBS News programs featuring Edward R. Morrow) and live televised drama (*Playhouse 90, Philco Television Playhouse, Kraft Television Theater,* and so on).

The second Golden Age takes place in a mediascape that is vastly larger than that of the 1950s. Instead of three networks, there are dozens, and much of their programming consists of reality TV, infomercials, and specialty programs (cooking, home improvement, weather, shopping, and sports channels). Those who speak of the current Golden Age are, by definition, resurrecting a notion of hierarchy in television, because for them, the gold consists of "serious" drama: limited-run and especially long-form television series that develop their characters and stories from episode to episode over the years of the series' life. Although the long-form structure has been evolving since at least the 1980s with, for example, *Hill Street Blues* (Thompson 1996), it became dominant around the turn of the century. Since then, television drama has become progressively more sophisticated in genres that range from political drama (*The West Wing*) to dystopian zombie horror (*The Walking Dead*). David Carr wrote in the *New York Times*, for example: "The growing intellectual currency of television has altered the cultural conversation in fundamental ways. Water cooler chatter is now

a high-minded pursuit, not just a way to pass the time at work. The three-camera sitcom with a laugh track has been replaced by television shows that are much more like books—intricate narratives full of text, subtext and clues" (2014). Carr was suggesting that television shows have moved up what remains of the media hierarchy to claim a place next to novels. We could add that these shows now rival film as well as novels.

Although television drama is now often more innovative than Hollywood film, it depends on the same aesthetic principles—principles that were in turn derived from melodrama and nineteenth-century fiction and are the basis of all popular narrative forms of the twentieth century. A typical Hollywood film centers on one or a few characters, who have a major challenge to overcome. The conflict ultimately grows out of overcoming these obstacles and, at the same time, reveals the nature of the main characters. Popular screenwriting manuals, such as Dan Decker's *Anatomy of a Screenplay* (1988) or Syd Field's *Screenplay: The Foundations of Screenwriting* (1984), clichéd and formulaic as they are, do indeed capture the essence of most successful Hollywood dramatic films. Such films tell their story in three stages: the first establishes the main character and sets up the conflict, the second develops this conflict toward a climax, and the third resolves it. The resolution brings about an emotional release in the audience, which has identified with the main character and become involved in his or her conflict. This formula held for *Casablanca* (1942) as it did for *Titanic* (1997) or even recent cathartic science fiction such as *Avatar* (2009) or *Interstellar* (2014).

Catharsis in contemporary popular drama is a story of conflict and resolution that inspires the viewer to empathize and ultimately identify with the fate of the main character(s). The outcome may be happy (Neo overcomes the evil avatars in *The Matrix*) or sad (in *Titanic* Jack freezes to death in the water, even though it certainly looks like there was room for Rose to let him up on that piece of wood). In either case, the viewer experiences an emotional release. Catharsis defined the aesthetic of the various Golden Ages of Hollywood film and television, as it did the aesthetic of the Victorian novel and melodramatic theater in the nineteenth century, as well as many other forms in the twentieth century.

This characterization of catharsis is so general that it might seem to include all storytelling and drama for all time. But this is not the case. The term "catharsis" comes from Aristotle's *Poetics*, which described what happens when an audience experiences a special kind of drama, Greek tragedy

of the fifth century BC. But whatever Aristotle meant by catharsis has little to do with the emotional responses that Steven Spielberg or James Cameron are aiming for today. It may be that all good stories have the sense of an ending. But not all traditions of storytelling and drama have aimed at creating psychologically believable characters who make us care about them. Catharsis in the twentieth and twenty-first centuries is based on a notion of character that did not exist (at least not in European literature) prior to the nineteenth century. And even in European and American literature and drama in the twentieth century, catharsis has not been the universal goal. In fact, the avant-garde literary artists of the twentieth century, dramatists and novelists, have generally rejected catharsis. In this they followed the influential German modernist Bertolt Brecht, who expressly did not want his audience to experience catharsis but instead to maintain a critical distance from the action and the characters (Curran 2001). As the Brechtian stage director and activist Augusto Boal put it in this *Theatre of the Oppressed*: "What Brecht does not want is that the spectators continue to leave their brains with their hats upon entering the theater, as do bourgeois spectators" (Boal 1979, 103).

Mainstream Hollywood film, however, has almost always aimed to create compelling story arcs and characters with which the audience can identify—at least for dramas if not comedies. Methods of narration have become more sophisticated. For example, films today often feature unprepared flashbacks or abrupt changes of location. Filmmakers expect the audience today to figure out from the context or the dialogue that the young person on the screen is the main character twenty years earlier. In the 1930s or even the 1960s, a text on the screen or perhaps atmospheric music or an unfocused camera shot would have been given as a clue. But the principles of the story arc and characterization have not fundamentally changed: they are the same in *Arrival* (2016) or *Manchester by the Sea* (2016) as they were in *Titanic* (1997) or in *Gone with the Wind* (1939).

Since cathartic drama is still thriving in mainstream film and on television, it is by no means a dying medium. It is probably the case, however, that the audience for Hollywood drama and dramatic television is growing older. Fewer young people (and perhaps still fewer young men than women) have been attracted to *Mad Men*, *Downton Abbey*, and *Game of Thrones*. The median age of *Mad Men* viewers was over 50, beyond the prized 18–49 demographic (Adgate 2015), while *Downton Abbey* was a huge hit

with women between ages 35 and 49 (Los Angeles Times 2012). But, in the plenitude of our media culture, fewer does not mean few in absolute numbers. *Downton Abbey* or *Game of Thrones* had viewing audiences of about ten to fifteen million. Although none of these television dramas can command the unified attention of popular culture, as major television shows did in the 1950s, 1960s, and 1970s, they still constitute a significant viewing community and help to shape media culture at large. Like Hollywood film, the television actors become celebrities sought after for interviews on television and in fan and popular magazines; the characters they create—the Dowager Countess, Don Draper and Peggy Olson, Cersei Lannister and Jon Snow—become cultural icons, at least for a few years. Some of these dramas also resonate beyond their immediate community by crossing over to other media. For some successful television series (such as *Game of Thrones* and *Lost*), fansites and blogs have sprung up with or without encouragement from the producers.

Fragmented Stories

Ever since its first films in the 1960s, the James Bond series has always been completely contemporary, both fashioning and reflecting the styles of each decade. At the same time, since the 1970s, there has also been something old-fashioned and nostalgic about the films, as they looked back to those first films, which could cater without embarrassment to male fantasies of sex and power. In the more recent films featuring Pierce Brosnan and Daniel Craig, Bond suffers repeated defeats, often when he is indirectly the cause of a lover's death. These are framed as moments of catharsis, when the audience is meant to identify with the hero who is (temporarily) humiliated. Yet these are only moments. The formula for a successful new Bond film is to achieve the proper mix of all the elements that have made the whole series successful. Scenes in which the audience identifies with Bond in defeat are carefully layered with chase scenes, fight scenes, love scenes, scenes of discovery, betrayal, and bureaucratic incompetence. Audiences are so familiar with all these elements that the new film needs only to allude to each one to bring all the necessary associations to mind. This is the reason that a Bond film, or other action-adventure franchises, can evoke so many different generic moments so rapidly. Bond can discover that he has been betrayed, evince disillusion, and respond, all within a few minutes. At the

same time the films are becoming increasingly nostalgic: the highly praised *Skyfall* (2012), directed by Sam Mendes, put Bond back in his old 1960s Aston Martin and sent him home to the family estate in Scotland for the showdown with the film's evil genius. By the end, after another cathartic moment with the death of the female M, who had been Bond's boss and mentor for seven films, *Skyfall* reset the series apparently to its starting point, with new characters for Q, M, and Miss Moneypenny. All this in two hours. The point is that the Bond series is characteristic of a contemporary form of cathartic storytelling in Hollywood genre films: instead of taking 120 minutes to follow out one entire story arc, a film can now evoke several appropriate genres in a scene or two. Such films are artfully sewn together from a set of cleverly joined fragments. This is Hollywood's version of remix (see chapter 6).

Stories can be fragmented in other ways too—for example, by placing the various parts of the story in different media. In the early 2000s, game designers, in particular Jordan Weisman and Elon Lee, put together the first alternate reality games (ARGs). In *The Art of Immersion*, Frank Rose (2011) described how "[Weisman's and Lee's] line of thought evolved into the notion of a deconstructed narrative. They could write a story, fabricate the evidence that would have existed had it been real, and then throw the story out and get an online audience to reconstruct it" (11). The storylines of the first major alternate reality games (*The Beast, Majestic,* and *I Love Bees*) were predictable blends of sci-fi and detective fiction. Predictability was a necessary evil (or virtue), because it helped the online audience solve puzzles and put the story together. However, the fragmentation of the story into small segments and puzzles diminished the opportunity for identifying with the main characters. Even in Bond films, there are still cathartic moments; in ARGs the cathartic moments are reduced or absent altogether. Although lacking catharsis, ARGs are highly participatory, a hybrid of game and story where the game elements and the mental work of puzzle solving dominates—hence preference for the detective genre. ARGs are particular examples of a larger genre of storytelling, often called *transmedia*.

For decades, novels and films have been remediated as television series and sometimes vice versa. The 1968 novel *MASH: A Novel about Three Army Doctors* became a film (*M*A*S*H*) in 1970, and then in 1972 a television series (*M*A*S*H*) that ran for eleven seasons. The comic *Batman* became a campy live-action television series and film in the 1960s, then starting in the

1980s a seemingly endless series of rebooted film franchises, animated car-
toons, and video games. Superman, the X-Men, and a dozen other DC and
Marvel heroes have followed similar trajectories from comic to film. Video
games too (*Tomb Raider, Resident Evil*) have become movie franchises. In
the 2000s, this remediating practice became more organized and elaborate,
particularly with the addition of various forms of social media. *The Matrix*,
directed by the Wachowskis, was the most influential early example of a
full-fledged transmedia ecosystem, including not only a movie franchise
(the first film appeared in 1999) and three video games (two single-play
action games, *Enter the Matrix* and *The Matrix: Path of Neo*, as well as *The
Matrix Online*, an MMORPG), but also animated episodes made available
on the web (the *Animatrix*) and further expanded by its fans with wikis and
Internet forums (Jenkins 2006a, chap. 3). Since *The Matrix*, several transme-
dia projects, such as *Lost* and *The Walking Dead,* have begun with television
series rather than films. The vast Marvel Universe of superheroes began as
comics and has expanded to include films (the *X-Men* films, *Spider-Man*
films, and many more), television series (such as *Agents of Shield*), graphics
novels, plays, toys, and theme park attractions. But whether they begin as
film, television, comics, even conventional novels, all of these transmedia
properties consist of a set of nested story arcs and moments of catharsis,
with principles adapted to their particular genre—science fiction and fan-
tasy, action-adventure, political thriller, or horror.

The narrative arc of a successful transmedia project can branch in many
directions. *Lost* lasted for six seasons and a total of 121 episodes, its enor-
mously complicated story told in flashbacks, flashforwards, and "flashside-
ways" (to a parallel narrative that competes with the main one). There were
numerous climaxes and resolutions throughout the years before the grand
resolution at the end of season six. This degree of complexity and tempo-
ral confusion alters, but does not undermine, the traditional Hollywood
experience. Although the grand resolution in episode 121 oozes catharsis,
the traditional sense of an ending is somewhat compromised by all the
competing versions of the story that have already been told or implied.
Fans continue to debate the significance of *Lost's* ending, which consists of
a collage of Hollywood clichés. What does seem clear is that the last scene
circles back to the very first episode, in which the main character Jack woke
up on the floor of an island jungle. At the very end Jack has returned to
the bamboo forest and dies. The ending and the entire series are a nostalgic

remix of many dramatic gestures that characterize Hollywood film. As in traditional Hollywood film, character is central to long-form television drama such as *Lost*, although the audience is encouraged to identify with a far greater number of characters than in relatively short two-hour films. Television drama no longer needs to be realistic to be cathartic: science fiction, fantasy, and horror can all qualify as long as they offer characters that the audience can care about and identify with.

The Cinema of Immersion

The new digital media form that is most closely connected to traditional film is 360 video, sometimes also called VR video. In November 2015, all the subscribers to the *New York Times* found a strange piece of cardboard included with their Sunday paper. It was a viewer called Google cardboard to be used in conjunction with a smartphone. A few filmmakers had been experimenting with 360-degree videos for several years, and now the *New York Times* was recognizing and promoting this as a new genre. Collaborating with the *Times*, filmmaker Chris Milk (2015a) was able to reach a new audience with films such as *Clouds over Sidra*, about a young Syrian refugee in a Lebanese camp. Most of the techniques in *Clouds* are typical of documentary, and in fact Milk could have made an effective "flat" documentary that we could experience in the theater. However, the viewer's ability to look all around while the narrator, a voice actor playing Sidra, describes conditions does add to our sense of the physical world in which Sidra lives. Everything in this VR documentary is calculated to move us to sympathy and identification.

For Chris Milk this is precisely the point. He believes that his new form of filmmaking is ideally suited to sympathy and identification, which can "engage an audience on a deeper human level than any other medium that has reached them" (E. Johnson 2015). In his March 2015 TED talk entitled "How Virtual Reality Can Create the Ultimate Empathy Machine," Milk (2015b) explained that this new technology becomes a machine that "feels like truth." Milk took his film to the World Economic Forum in Davos, Switzerland, so that the economic and political elites, who could presumably actually improve conditions in the refugee camps, could experience firsthand Sidra's daily life. Milk claimed that they understood the situation in a way they had not before. For Milk, VR film is like traditional documentary

only better. It remediates documentary film into an experience that is more compelling, more emotionally engaging, because it locates the viewer in the scene. The catharsis is greater because the viewer is closer to the reality of the camp. This is a classic argument of remediation: VR film is better than traditional film at doing what film has meant to do all along (Engberg and Bolter 2017).

VR film has already developed into multiple genres, some of which remediate other Hollywood genres or other digital genres. If you visit the www.with.in website, offering "Extraordinary Stories in Virtual Reality," you will find music videos (*Kids*), animated films (*Kinoscope* and *Invasion!*), and remediations of television shows or traditional films (*Mr. Robot* and *Notes on Blindness*) in addition to the documentaries. And there are numerous other sites and a great deal of "amateur" videos as well, such as short horror films of varying quality. YouTube offers its own VR channel with videos that represent a range of user interests (YouTube 2017a). There are encompassing views of sporting events and individual user exploits such as flying in a glider, diving with sharks, and rollercoaster rides. Many of these videos are reminiscent of the early IMAX films, which had little or no story and simply reveled in the wonder of a new visual technology.

VR film is ultimately more film that it is VR, and it relies on the traditional filmic techniques to engage its viewers. VR film also depends, of course, on digital technology to record and display a moving image in 360 degrees. It is clearly a hybrid. It does not offer any form of interactivity other than looking around. The viewer remains just that: a viewer, not a user or player. On the other hand, video games, the first fully digital form to achieve major cultural and economic status, *are* interactive, yet even some video games remediate film.

Catharsis in Video Games

In the first-person video game *Gone Home* (2013), your name is Kaitlin Greenbriar. You are returning to your family home in Portland, Oregon. You find your parents and your eighteen-year-old sister Samantha have all gone; the house is deserted. A note Sam left on the door implores you not to worry. As you explore the rooms, you find more notes, items in drawers and on the floor, and these bits of evidence lead you to uncover the story of a developing romance between Sam and a fellow student Lonnie.

(The subtitle of *Gone Home* is *A Story Exploration Video Game*.) Sam's audio journal provides details of their difficulties; above all, Sam's parents disapprove of the lesbian relationship. Ultimately Sam leaves home to join Lonnie and start a life together. You learn all this gradually as you move through the rooms of the house, which has become a book for you to read or a movie to watch. Although *Gone Home* uses conventional game mechanics, the video game is unusually quiet and atmospheric. Exploring the dark and empty house can generate moments of tension, but no monsters ever jump out. There is nothing to kill, no points to amass, and winning in this game simply means coming to understand what has happened. Violating the genre expectations of video games as it did, *Gone Home* received mixed reviews (Wikipedia contributors, *"Gone Home"*). The domestic drama of the game could have been a short novel or made-for-TV movie. In her review for adventuregamers.com, Emily Morganti (2013) wrote: "Many people read books for the opportunity to see life through someone else's eyes, but it's rare for a game to do it as well as this one does."

It is unusual, but not impossible for a game to achieve emotional identification, and often *indie games* (created by small teams or companies without the backing of a major or so-called AAA game studio) are the most successful. The crowdfunded game *That Dragon, Cancer* was created by and grounded in the experiences of two parents of a terminally ill child. Its simple gameplay and graphics along with a minimal, evocative musical score for strings and piano are calculated to engage the player's emotions. Another recent cathartic game is *What Remains of Edith Finch,* which a reviewer likens to a "haunting short story collection" (Webster 2017). Like *Gone Home, Edith Finch* invites the player to explore an abandoned house, each of whose rooms contains notebooks or papers that allude to the fateful story of one of Edith's relatives. Andrew Webster attests to the cathartic effect in his review: "Every story comes around to the same conclusion: death. So why did I often [find] myself shocked when the moment came? I suppose I regretted having to let go of one character—and the world—to hurry on to the next. ... Within this one family you get to see and experience so many different types of lives. Ones tragically cut short, others long-lived; ones filled with warmth and kindness, others hardened by loneliness."

Webster could be describing a series of short stories rather than a video game. *What Remains of Edith Finch* is a narrative experience in more than

Figure 4.1
Giant Sparrow, *What Remains of Edith Finch* (2015), reprinted with permission of
Annapurna Interactive.

one sense. The player is in fact reading a journal written by the seventeen-
year-old Edith Finch as she revisits her family home. Passing from room to
room, Edith and by extension the player discovers other texts, which are in
turn narrated by other, now dead, family members (figure 4.1). As soon as
Edith or the player begins to read, the text itself evokes a visual scene (like
a flashback in a movie) that the player can now experience and participate
in. The narrators and especially Edith remind us of the earnest voice-overs
in films of an earlier period, films like *To Kill a Mockingbird* (1962).

We could go on adding examples: emotionally engaging games such as
The Brothers: A Tale of Two Sons and games with inventive narrative styles
such as *Life Is Strange,* about a teenage girl who suddenly develops the abil-
ity to travel back through time and alter events. Even some games with typ-
ical shooting and slashing violence can be cathartic. Released in 2013, *The
Last of Us* is a post-apocalyptic role-playing game in which you play Joel, a
grizzled but still athletic survivor of a plague that afflicted the human race
twenty years earlier. Joel is joined by a teenaged girl Ellie, whom he meets
during his journey across the wasted United States from Austin to Salt Lake
City in an effort to find sanctuary. The plot is familiar from a whole genre
of novels, television series, and films. One game reviewer (Moriarty 2013)

compares *The Last of Us* explicitly to Cormack McCarthy's novel *The Road*, which was also made into a film. The scenes in the game are cinematic with high-quality graphics, including motion capture from the convincing voice actors.

These various games show us how storytelling and emotional engagement can be integrated into the most successful of fully digital media. They all borrow heavily from earlier media, from film and television, and in particular from certain genres such as the "serious" Hollywood drama, the detective film, the horror film, and so on. When they pass the conventional test of bringing the player to tears, it is through skillful deployment and adaptation of techniques that the player as viewer has seen before. A character (sometimes the player as character) faces excruciating choices that lead to the death of a friend or family member. They reflect on loss in conversation with other characters, often in cut scenes that play out with beats and pauses familiar from film and television dramas. The emotional moments are highlighted by evocative background (nondiegetic) music, just as we have come to expect in films since the 1930s. Since the middle of the nineteenth century, our media culture has taught itself how to evoke catharsis in novels, plays, film, and television, and those same techniques are now being applied to video games. Some minor adjustments have been made to permit the player a degree of interactivity. But the interactions are largely unrelated to the aspects of the game that generate the emotional engagement and the moments of catharsis. Interactivity and emotionally engaging coherent storytelling are difficult to combine (Ryan 2006). Game scholar Ian Bogost (2017) has argued that video games should simply leave storytelling to the novels, film, and television.

This is one reason that cathartic video games constitute a relatively small genre in comparison with the huge and varied genres of puzzle games, role-playing games, and shooters. With decades of technical and cultural development behind them, video games already constitute their own plenitude with many varied genres. Wikipedia (Wikipedia contributors, "Video Game Genre") lists dozens of video games with overlapping characteristics and audiences, including: ball and paddle, pinball and platform games, shooters, role-playing games, strategy games, sports games, and so on. Only a fraction of these aim to provide a story with coherent characterization. What the rest strive for we shall see in the next chapter.

The Past and Future of Catharsis

Catharsis is a particular way of telling a story, emphasizing how action grows out of character, leading to conflict and eventually to a dramatic resolution. This way of telling a story has flourished in film and television and is making its way fitfully into contemporary digital media such as games, but it is not universal, despite the claims of a number of philosophers and psychologists (e.g., Bruner 1985, 2004; Dennett 1988; Boyd 2009; Dutton 2009; and Pinker 1995). Those who insist on the universal importance of catharsis are ignoring the diversity of world culture throughout history and of our media culture today. The kind of psychological storytelling they assume to be universal is a style that was perfected in the past two centuries in realistic novels, plays, and film. It is not found in Greek poetry or drama, for example; it is not what Aristotle meant by storytelling (*mythos*). Greek tragedians never aimed for the psychological realism developed by nineteenth-century authors from Austen to Tolstoy and popularized in twentieth-century film. Cathartic storytelling is a modern genre, not a universal human practice. Telling stories in this way looks back to the nineteenth and twentieth centuries, not to Aristotle's time. But this kind of storytelling does indeed look back: it is nostalgic. A preoccupation with the past—longing for it, regretting it, wanting to return and change it—is a central theme of Hollywood drama today as it has been for decades: "We'll always have Paris," Bogart says to Bergman at the cathartic end of *Casablanca*. Now, the second Golden Age of Television has made nostalgia into a defining motif with hits such as *Mad Men* and *Downton Abbey*. In the dystopic *The Walking Dead,* the characters are living in a permanent state of reminiscence for the time before the apocalypse.

There is another kind of nostalgia in today's Hollywood film and television: a looking back wishfully to a time when serious drama was a dominant media form. The audience for such drama is now aging, although cathartic storytelling can remain potent even for younger audiences, when the form is suitably adapted. Consider the *Harry Potter* phenomenon of the last two decades. Millions of teenagers and pre-teens read the novels voraciously and saw all the films of this cathartic saga of good and evil. There is no reason to think that serious Hollywood drama is doomed simply because it is less widely popular than it once was. At the same time, a popular alternative has gained in visibility and status in our media culture, particularly because of video games, as we discuss in chapter 5.

5 Flow

From Catharsis to Flow

When the science fiction film *Edge of Tomorrow* (2014), directed by Doug Liman, came out, *Wired* magazine called it "the best videogame you can't play" (Watercutter 2014). The film's main character, Bill Cage, repeats the same day again and again—a day of futuristic combat with aliens. Each time he dies, Cage wakes up again on the previous day. Everything is as before, with the crucial difference that he remembers all the previous versions of that fatal next day. The repetitions are the film's equivalent of a video game's replayability, and Cage's battle skills improve, just as a player's skills improve through replay. But Cage is not a player. He is a character in a narrative film, so the repeated days are in fact consecutive scenes in the film and thus take on a cumulative meaning. They tell a continuous story in which Cage gradually struggles to overcome the alien enemy and break out of the time loop. The film has a traditional narrative arc in which a relationship develops between the male and female leads as they fight the aliens together. In the final scene, with the alien threat defeated, Cage smiles. He has transcended replay, and the film can now resolve itself in typical Hollywood fashion. Film's sense of an ending triumphs over the video game.

This is how *Edge of Tomorrow* illustrates a tension in contemporary media culture. Hollywood still offers catharsis, as it has for decades, but it is both intrigued and concerned that video games offer something else, a different aesthetic experience with its own strong appeal. Films like *Edge of Tomorrow* may appeal to some gamers, but it is clear that there are millions of players who prefer the mechanics of the video game to the narrative, cathartic power of film. The *Wired* reviewer says of the romantic plot in *Edge of Tomorrow*: "the romantic subplot is probably necessary just because, you know,

people like having feelings at movies, but still feels tacked on" (Watercutter 2014). In fact, that romance is crucial to the emotional structure of *Edge of Tomorrow* as a Hollywood film.

Video games' economic importance is obvious. In 2015, revenues for video games sales totaled $23.5 billion (Morris 2016), and there are large communities of players whose media universe centers on video games, not film or television. In the twentieth century, film promoted itself as the preeminent popular medium, but the eroding of hierarchies now applies to film as it did earlier to the traditional elite arts. Film can no longer claim to perform a function for our whole culture when there is no whole. When Golden Age Hollywood promised to tell the story of our culture, it was usually the story of a cultural mainstream. Now it is even clearer that Hollywood's promise is meaningful only to one, admittedly still large, audience in the plenitude.

New audiences, also in the millions, seek their cultural centers elsewhere—in video games and social media. One of the principal pleasures offered by both video games and social media is the experience of *flow*. Flow is an aesthetic principle for first-person shooter games, for platform games, for puzzle games. It is also the state induced by watching one YouTube video or Netflix episode after another or by monitoring Facebook feeds for hours on end. As early as the 1970s, the psychologist Mihaly Csikszentmihalyi (1991) applied the term "flow" to describe a particular state that he had identified in his subjects: "I developed a theory of optimal experience based on the concept of *flow*—a state in which people are so involved in an activity that nothing else seems to matter; the experience itself is so enjoyable that people will do it even at great cost, for the sheer sake of doing it" (4). Csikszentmihalyi's flow can be evoked by activities common to many ages and cultures. He liked to cite rock climbing or tennis as examples—vigorous physical activities in which the participants lose track of time, fully engaged in the work of the moment. But he also argued that his flow state has something in common with forms of meditation or religious experience.

Still, many of the experiences that we are going to discuss in this chapter go beyond Csikszentmihalyi's definition. His definition of "flow" requires concentration: when you are climbing a rock face, you had better be fully focused on that task. For Csikszentmihalyi, listening in a focused way to someone playing the piano can induce flow, but playing the piano is a stronger flow experience (108–113). Our media culture today offers a variety of

passive experiences that share a key characteristic with Csikszentmihalyi's flow: the pleasure of losing oneself. The pleasure may be intense or muted. Playing a video game can demand as much focus as playing the piano. Other digital media, like earlier media, demand less concentration. Watching YouTube videos one after another is like spending the evening watching sitcoms on a conventional TV set. Whether active or passive, all flow experiences simply ... flow. They offer the viewer, player, or participant not only pleasure in the moment, but also the seductive possibility that the moment might go on indefinitely. We shall see that there are different ways to extend the moment. Ambient music flows in a different way than social media does, and both are different from the flow of a role-playing game.

It is above all this feeling of indefinite extensibility that distinguishes flow experiences from cathartic ones. Catharsis wants to, indeed has to, come to end, whereas flow wants to continue forever.

Music provides good examples of both. While classical music in the nineteenth century (and a good deal of Hollywood film music in the twentieth) is cathartic, flow is a quality of many other kinds of music, including non-Western forms such the Gamelan music of Java and Bali and Indian sitar music, as well as the minimalist music of Philip Glass and others or the ambient music pioneered by Brian Eno. In contrast to the emotional rise and fall of cathartic music, flow music is emotionally monochromatic, consisting of highly repetitive motifs and sometimes with no clear melodic line at all. It lacks the harmonic structure of classic Western music with its tensions and resolutions. Flow music is mood music. As the liner notes of Brian Eno's *Ambient 1: Music for Airports* put it: "Ambient Music is intended to induce calm and a space to think." Flow music is often written to serve precisely this purpose—to define a mood as the listener does other things, as the subtitle of Eno's album suggests. Flow music does not have to be minimal or experimental, however. One of the most influential phenomena of the late twentieth century, hip-hop, constitutes a high-intensity flow music. Through its repetitive harmonic and rhythmic structure, a hip-hop song typically evokes and sustains a mood throughout. Appreciating how the beat fits with the rapped lyrics, which may contain only minimal repetition, is key to the listener's experience of hip-hop. Take a now classic example, the song "Lose Yourself" by Eminem. This music maintains a high emotional level with only a slight increase in intensity during the refrain. The rejection of a cathartic ending is what brings together Philip Glass's

avant-garde music with the crossover performances of Brian Eno and with the massively popular rap of Eminem or Jay-Z. The background music of most video games too is endlessly looped, even when it borrows orchestral color from the Hollywood action-adventure genre.

These two aesthetic forms are often, indeed usually, combined. Cathartic music, especially classical music and some forms of jazz, contains elements of flow—passages that seem to offer the possibility of endless repetition. For example, Ravel's *Bolero* is characterized by flow within a cathartic frame-work: the repetitious theme and the orchestration rise in volume and intensity until reaching a bombastic conclusion and release. On the other hand, avant-garde sound performances and even ambient music sometimes aim for a dramatic resolution. Rap musicians today have proven open to integrating other, more conventionally structured forms, especially R&B, into their songs or inviting others singers themselves to remix—creating hybrids that combine flow with more traditional song elements.

I am not suggesting that the dichotomy between catharsis and flow can fully characterize today's music or any other aspect of media culture. This dichotomy, like the others in this book, defines a spectrum. But the dichotomy, for music as for other expressive forms, offers a framework for understanding some important media communities today. For, if catharsis characterized the aesthetic goal of popular media in the twentieth century, the aesthetic of flow promises to be even more important for digital media in the twenty-first.

Games and Flow

The game designer and evangelist Jane McGonigal (2011) believes that in order to solve global social and political problems we should all be playing more video games. In her TED talk "Gaming Can Make a Better World," she shows an image of a gamer who is about to achieve an "epic win." The photo captures, she explains, "a classic games emotion … [a] sense of urgency, a little bit of fear, but intense concentration, deep, deep focus on tackling a really difficult problem." (You can see the image in her TED talk: McGonigal 2017.) She claims that this intense concentration in a game can be harnessed for social change by turning real-world problems into collective online games. Whether we agree with her that video games can change the world, McGonigal and many other writers on games are clearly

right about the intensity of engagement that games can generate among dedicated players. It is the sense engagement that Csikszentmihalyi identified as flow, and flow is as important to video games as catharsis is to Hollywood film.

Although video games have a much shorter history than film, they have certainly developed as much diversity in the past thirty years. As we noted in the last chapter, genres (each with player bases in the millions or tens of millions) include: puzzle games, platform games, role-playing games, first-person shooters, and several others. If the classic way to enjoy a film is to sit in a darkened hall with an audience around you, absorbed in the light show on the large screen, the classic way to engage with a video game is still to sit alone in front of a screen with your controller or keyboard. As digital writers constantly remind us, video games are interactive, which means that through her participation, the player is subsumed into the procedural circuit of the game. Interactivity involves a different form of involvement than the catharsis of popular film, because the player experiences the game as a flow of events in which she participates. In a first-person shooter, such as the *Halo* games or *Half-Life 2*, the player falls into a consistent frame of mind for relatively long periods, as she moves through each level and engages and kills enemies. A game may offer some pauses along the way, for example, with noninteractive, cinematic cutscenes; such scenes are felt as breaks in the flow that is the principal attraction in playing. But elaborate, nearly photorealistic shooters are certainly not the only games that pursue the aesthetic of flow. Platformer games (such as the *Super Mario Brothers* series) and puzzle games (*Tetris, Bejeweled*) also insert their players into a potentially endless event loop.

Game designers understand the importance of this loop and the psychological state it induces. Jesse Schell (2008) notes that "it pays for game designers to make a careful study of flow, because this is exactly the feeling we want the players of our games to enjoy" (118). Jenova Chen agrees: "Descriptions of [Csikszentmihalyi's] Flow experience are identical to what players experience when immersed in games, losing track of time and external pressure, along with other interests. Gamers value video games based on whether or not they provide a Flow experience" (Chen 2007, 32). Controlling the flow of a video game requires a goldilocks strategy: an effective flow experience lies in a channel between boredom and anxiety. "Flow activities must manage to stay in the narrow margin of challenges that lies between

boredom and frustration, for both of these unpleasant extremes cause our mind to change its focus to a new activity. Csikszentmihalyi calls this margin the 'flow channel'" (Schell 2008, 119). If the gameplay is too easy, the user's attention will wander, and she will no longer be "in the zone." If play is too difficult, she becomes anxious and will again lose the sense of satisfying engagement. As generators of flow, video games may have a winning state, but winning itself is not the point. The point is the player's engagement in the activity itself. As game designer and theorist Brian Schrank (2014) put it: "Despite the range of things to be considered when developing games that flow, the aim is always the same: players lose self-consciousness in the enveloping action" (33).

Although flow is by no means a new form of experience, our current media culture pursues the aesthetics of flow with particular enthusiasm. Video games today enjoy an economic and cultural status far beyond that of traditional games or forms of play, and they are no longer a pastime only for adolescent boys. Some genres—for example, online "casual" games—are popular among women. They account for about 70 percent of the players of matching games like Tetris (D'Anastasio 2017). In fact, 31 percent of all gamers are women, and the average age of women players is 37 (Entertainment Software Association 2017). Furthermore, game studies is now a recognized academic discipline with programs in major universities in the Americas, Europe, and Asia. Video games have also become "serious": they are used in education and training, in the communication of health issues, and in politics for propaganda and for motivational purposes (Bogost 2007).

Video games show us how digital media in general lend themselves easily to flow. For flow experiences often depend on repetitive actions, which contribute to the feeling of engagement and absorption that Csikszentmihalyi describes, and video games—like all interactive computer interfaces, indeed like virtually all computer programs—operate on the principle of repetition. The user becomes part of the event loop that drives the action: her inputs to the controller, mouse, or keyboard are processed each time the computer executes the loop and are displayed as actions on the screen (Polaine 2005). The user not only experiences flow, she actually becomes part of the program's flow. This is true, if in different ways, for applications throughout digital culture, such as YouTube, Facebook, and Twitter.

Flow Culture

Film, television, and fiction belong to catharsis culture. Flow culture flour-
ishes in digital media such as games. Its manifestations seem more novel
than those of catharsis culture, not because flow itself is new, but rather
because digital media forms have extended the aesthetic experience of flow
to new communities. The most prominent and popular social media plat-
forms appeal to their hundreds of millions of users in part through the
mechanism of flow. The stereotype, which contains some grain of truth, is
that flow culture is youth culture. Young people spend their days immersed
in flows of text messages, tweets, Facebook posts, and streaming music,
while older adults prefer to experience their media one at a time. For exam-
ple, a Pew Research survey from 2012 showed that almost half of all adults
between ages 18 and 34 use Twitter, whereas only 13 percent of adults over
age 55 do (Smith and Brenner 2012). The younger you are, the more likely
you are to multitask: those born after 1980 do so more than Generation
X, which does so much more than the baby boomers (Carrier, Rosen, and
Rokkum 2018).

Flow experiences can occur in many different places (from a mountain
top or a tennis court to a living room), and they can involve extreme physi-
cal activity or passive sitting. By contrast, catharsis requires concentration
on the story or music as well as passivity. It is true that portable devices
allow people to watch a dramatic movie on an airplane or to listen to
cathartic music anywhere, but these same devices are also ideal for staging
a flow experience. Digital music players allow listeners to create their own
playlists and define their own sound environment wherever they go. The
music itself may be cathartic or flowing; whatever the content, moving
through the world accompanied by one's music constitutes a personalized
flow experience. As Michael Bull (2013) put it, the users (he focused specifi-
cally on young urban users moving through the city) "appear to intuitively
tune their flow of desire and mood to the spectrum of music contained in
their iPods" (501).

The past few decades have seen changes both in the range of activities that
induce flow and in the status of those activities. The kinds of activities that
Csikszentmihalyi adduces (hobbies, sports, games) have in the past occu-
pied a lower position in the cultural hierarchy than elite art or even film.

The flow evoked by the exertion of sports and games could only be recognized as worthwhile when we began to appreciate the recuperative or integrative power of play. For Europe and North America, this has happened gradually in the past two hundred years, as the middle classes began to have leisure time to watch or participate in sports and to visit the countryside for recuperation. In the twentieth century, spectator sports grew in status as indicators of nations' strength and character. The modern Olympic Games clearly served and still serve this function for good or ill (one thinks of the 1936 Berlin Olympics). And of course baseball came to be regarded as the perfect expression of the American values—its so-called national pastime. For popular culture, sports became both more and less than art and entertainment. Here again, the breakdown of the hierarchies of art in the midcentury freed our culture to rethink the value of aesthetic experiences offered by games, sports, and hobbies. Flow experiences could then become as legitimate as cathartic ones. An eventual result, decades later in the 1990s, was the rising status of video games. Now that the word "art" can include almost every creative or expressive activity, video games and other flow activities have come to occupy a place almost beside cathartic drama, at least for some communities.

With the important exception of the flow induced by portable music devices (transistor radios are decades old), the other major flow forms of the digital age (social networking, messaging, image and video sharing) were all initiated in the late 1990s or early 2000s. Blogs came first in the 1990s, and Facebook was created by a Harvard undergraduate in February 2004 (though it did not become widely available until two years later). The four founders of Twitter sent the first tweets to each other in 2006. The first YouTube video (which includes one of the founders standing in front of the elephants at the San Diego Zoo) was posted in the spring of 2005. These and dozens of other social applications made possible the rapid growth of a participatory flow culture that now reaches billions of users (Polaine 2005).

Each of the genres of social media provides a different flow experience. YouTube, for example, remediates television and video for the World Wide Web. A typical YouTube session begins with one video, which the user may have found through searching or as a link sent to her. The page that displays that video contains links to others, established through various associations: the same subject, the same contributor, a similar theme, and so on (figure 5.1). Channel surfing on traditional television can be addictive,

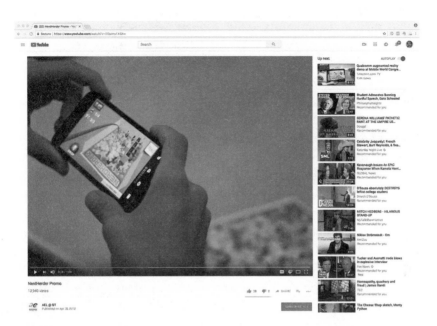

Figure 5.1
YouTube's interface encourages flow.

but the content of one channel tends to have little to do with that of the next. YouTube's lists of links and its invitation to search for new videos give the viewer's experience more continuity, with the opportunity to watch an endless series of close variants. In *The Language of New Media*, media theorist Lev Manovich (2001) argued that the digital era presents us with an alternative to narrative film that he called "soft" or "database" cinema, in which video segments can be selected from a larger repository and put together in any order: "After the novel, and subsequently cinema, privileged narrative as the key form of cultural expression of the modern age, the computer age introduces its correlate—the database. Many new media objects do not tell stories; they do not have a beginning or end. ... Instead, they are collections of individual items, with every item possessing the same significance as any other" (218). YouTube is the realization of "database" video or cinema and is now a companion to the cathartic experience of the Hollywood film.

Like other microblogging sites, Twitter offers each user a personalized stream of short messages from all the posters that the user has chosen to follow—including personal friends, celebrities, news organizations,

companies, and nonprofits. If she follows enough sources, her stream of messages will change as fast as she can refresh her screen. As with YouTube, but far more easily, she can contribute to the conversation by "retweeting" the messages of others or writing her own. The resulting stream is an unpredictable combination of public and private communication. Twitter interleaves the messages from all the sources so that there is no coherence between consecutive messages and no need for the process ever to end. Those trained in traditional rhetorical practices may find the individual tweets and the whole stream almost meaningless. But for Twitter regulars, the rhythm of short texts is satisfying in its own right.

Multimedia microblogs such as Instagram, Tumblr, and Snapchat privilege images and audio, and each platform offers a subtly different version of flow. Snapchat enforces a staccato rhythm by making its photo messages, "snaps," necessarily ephemeral. The stated purpose is to encourage playfulness among senders and recipients and to counteract the tendency to treat social media services as a permanent record of your online identity. It might seem that Snapchat enables you to lose yourself in the moment without having to regret the next day the selfie that you took in that moment, but it is possible for the recipient to make and save a screenshot. You may lose yourself in the social media plenitude, but others can almost always find you.

Social media such as Facebook and YouTube are often said to be exercises in online identity construction (Boyd 2014). We will discuss that aspect of social media in chapter 8. For now we will just take note of the fact that social media as flow experiences are therapeutic, helping an individual to negotiate her relationship to her social world. Csikszentmihalyi (1991) himself ascribed a therapeutic value to flow experiences. He suggested that in a secular and often hostile world, flow gives individuals a feeling of control in their own smaller domains (games, hobbies, work activities). Flow becomes "the process of achieving happiness through control over one's inner life" (6). Csikszentmihalyi's flow culture is one in which individuals aim at nothing higher than personal satisfaction. The psychology of flow does not encourage them to think of themselves as actors in a larger social or political drama. At least from 1800 to the end of the twentieth century, politically aware citizens were encouraged to see their own history as marked by the same dramatic curve as that of their state or nation. Flow culture does not endorse such a view. Instead, the identity constructed on

Facebook and YouTube is static or homeostatic: its modest goal is to keep itself within bounds, within the channels provided by a Facebook page.

Our Time Traveler

Much about flow culture would mystify our time traveler from 1960, but not because flow experiences were unknown in her time. In 1960, flow experiences were already available in two very different spheres: first, in sports, games, and hobbies practiced by millions; second, in the special realm of avant-garde art. Composers such as John Cage were already fashioning minimalist performance pieces that involved little or no variation over minutes or hours. Our time traveler could have watched this art develop throughout the 1960s and beyond. She could have sat through Andy Warhol's experimental films *Empire* (eight hours and five minutes) and *Sleep* (five hours and twenty minutes). These experiments in very slow flow as an aesthetic were known only to relatively small communities of artists and their audiences, in New York and other centers. In the 1970s, however, she might well come to hear the music of Eno or Glass. And Indian Yoga techniques, which Csikszentmihalyi mentions (1991, 103–106) acquired an increasing following in the 1960s and 1970s, popularized by rock stars and Hollywood actors. All the while, the breakdown of artistic hierarchies was eroding the distinction between the avant-garde art (music and performances) and various sports and other pastimes.

Our time traveler of course knew television, which was already a dominant element in media culture in 1960 and had developed a version of flow that sociologist Raymond Williams (1974) later described. In the 1960s, television was watched one channel at a time. For Williams, the flow of (American) television was characterized by a continuous succession of programs and advertisements on one station and was in fact a strategy for lulling the viewer into remaining on one channel. The increasing availability in the 1960s and 1970s of the television remote control gave the viewer some control over the pace and content of the flow, and channel surfing is still a common flow activity. Viewers can now choose among several different modes of consuming television programs (watching them when broadcast, recording them for later viewing, or choosing programs on demand from the Internet), and each of these modes potentially alters the flow of the viewing experience.

A relatively new addition is "second-screen" television, in which viewers watch a television show while using their mobile phone, tablet, or computer to query a website associated with the show. On the second screen, they may take a quiz, get extra information, play a video game, or purchase a product. Second-screen viewing attracts a large fraction of the audience, especially for certain genres of shows (Flomenbaum 2015). While this kind of second-screen experience is planned and provided for by the producers, the majority of viewers from baby boomers to millennials multitask with another digital device while watching television, whether the show calls for it or not (Statista 2018a). For all such viewers, what began as a cathartic experience may turn into flow, as the viewer develops her own rhythm in moving between the broadcast program and the web.

Observing young people using social media today, our time traveler would be struck by precisely that quality that many contemporary dystopian critics deplore: how social media users divide their attention among multiple social media channels. These critics are in fact like time travelers themselves, applying standards from the 1950s to contemporary media culture. Like television channel surfers, the flow experience of young social media users comes both within media channels and among them. They may watch several YouTube videos one after another, but they may then decide to tweet about what they see (or another subject altogether), all the while monitoring their Facebook newsfeed and listening to music on Spotify. Their flow aesthetic is what Engberg (2014) has identified as *polyaesthetic*. The popular term "multitasking" does not capture this frame of mind very well, because the various channels are not experienced as tasks; instead, the seamless flow along one channel or among many is an aesthetic experience, a new form of the pleasure that Csikszentmihalyi first described.

Another quality that would surprise our time traveler is precisely the one that so many digital media writers have so enthusiastically noted: much of the content that flows across the screens of these "ordinary" users are texts, images, and videos generated by other "ordinary" users. In 1960, when the production of almost all media was still centralized, an economic (if not cultural) elite produced the content for the large class of consumers. But even then, television and the rock music world did suggest a new kind of performer who was not as remote or different from the audience as the classical musician or even the film star of the past. McLuhan ([1964] 2013)

remarked that the "cool" medium of television was promoting new figures, such as *Tonight Show* host Jack Paar, who were successful precisely because they seemed casual and approachable (288–289). Although the rock figures of the 1950s and 1960s were certainly not ordinary, their success often depended on the fact that teenage audiences could see idealized versions of themselves. The musicians were themselves teenagers or young adults who shared their audiences' origins and their life stores. Even the Beatles were depicted, at least early in their career, as unpretentious lads from industrial Liverpool.

At the same time, television and rock music expanded the audience of passive consumers, and so the gulf between the producing elite and the consuming masses remained. Even the classic counterculture festival of the 1960s, Woodstock, illustrated that gulf: approximately thirty-two groups performed in front of a sea of more than four hundred thousand listeners. This was not user-generated culture. Today, we are constantly reminded of the relative ease with which a YouTube celebrity or blog writer can emerge to command a large audience, significantly diminishing the difference between producing and consuming. If stars from the traditional media (e.g., George, Brad, and Angelina) may seem as remote from everyday life as their counterparts did in 1960 or 1930, Internet celebrities (e.g., PewDiePie or HolaSoyGerman) seem to be just like their millions of followers, only slightly cleverer or more telegenic. At the same time, much of what people read and view on their social media pages is created by their friends and peers. This wealth of user-generated materials (tweets, blog posts, status reports, images, and videos) is needed to maintain the flow experience for the hundreds of millions of users monitoring each other. Our time traveler—still used to thinking that media broadcasts are something special and should contain significant content—would be surprised that people so willingly publish and read online material that is so intimate and so ordinary.

The current fascination with a flow of user-generated content thus illustrates an ambivalence that has been a key feature of popular modernism since the 1960s. User-generated content represents a rejection of elitism in the realms of art and creativity. User-generated sites and services suggest that everyone can be part of the expanding text, image, and video plenitude. The hierarchical control of publishing and broadcasting is undermined (though not eliminated) on the web, as the creative materials offered

by publishing houses and production studios now compete with what users can write and read for free on Facebook pages, blogs, and Twitter feeds. On the one hand, this wave of user-generated content has suggested to digital media authors like Clay Shirky in *Here Comes Everybody* (2008) and *Cognitive Surplus* (2010a) that a new kind of "collective intelligence" is replacing individual genius in our culture. On the other hand, instead of digital communism, the ease of publishing on the Internet also suggests to many a digital version of the entrepreneurial American dream, in which individuals can become famous and possibly rich through their own effort and originality rather than their connections to elite standards of the past (in music, theater, literature). PewDiePie reportedly makes $12–$15 million dollars a year by playing video games online. Anyone who has enough money to buy a computer and connect to the Internet has in theory the opportunity to establish a successful YouTube channel or blog.

The Spectrum of Catharsis and Flow

The dichotomy between catharsis and flow is not a straightforward contrast between traditional media (film) and new media (video games), between older television audiences and younger Twitter users, or between older and newer conceptions of human identity and social engagement. In our media plenitude, these contrasts can only be approximations. For one thing, both flow and catharsis can be found in different genres within the same medium. While television drama is cathartic, many programs (shopping channels and infomercials, the weather channel, the morning shows, and late-night shows) offer predominantly flow experiences. Flow and catharsis can blend in the same experience, as they clearly do in forms of popular and even traditional music. Contemporary film blends these aesthetics as well. Action-adventure films often include game-like action sequences, which continue for minutes at one tense emotional register. Such scenes recall, if not they do not entirely recreate, the flow of action games and seek to appeal to much the same audience as video games. At the same time, video games based on film recall—if they do not always evoke—the catharsis of film. The contemporary media industry combines the two aesthetics in transmedia franchises. If the *Matrix* or *Star Wars* films are primarily cathartic, the *Matrix* or *Star Wars* video games are primarily flow experiences. Most of the games' players probably also watch the films,

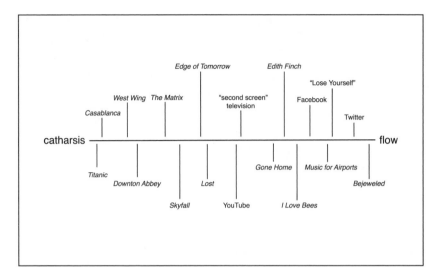

Figure 5.2
Flow and catharsis.

which suggests that the same viewer/player can appreciate both aesthetics. And although the audience for films and television series may tend to be older than the player base for action-adventure games, the success of *Titanic* or the *Harry Potter* books and films indicates that young audiences can still be won over to traditional narrative forms, as we noted in chapter 4.

We can envision a scale with catharsis at one end and flow at the other. Most films, video games, music, and social media sites provide some combination of cathartic and flow experiences. If we put a film like the Hollywood classic *Casablanca* (1942), directed by Michael Curtiz, at the catharsis end of the scale, and the puzzle game *Bejeweled* at the flow end, there is a wide range in between for both traditional and contemporary media forms (figure 5.2).

The Popular Avant-Garde

The world of video games is vast, a plenitude in itself, and it even includes applications that violate the most basic rules of gameplay, including flow. In 2002, Cory Arcangel hacked *Super Mario Bros.*, one of the most successful series of platform games originally designed for the Nintendo game console, to produce *Super Mario Clouds*. In the original game, the player

Figure 5.3
Cory Arcangel, *Super Mario Clouds* (2002–ongoing). Handmade hacked Super Mario
Bros. Cartridge, Nintendo NES video game system. Screenshot. © Cory Arcangel.
Image courtesy of Cory Arcangel.

manipulates the diminutive Mario so that he hops over obstacles from
surface to surface collecting coins along the way. Arcangel's hack removed
almost all the graphics. All that remained was a background consisting of a
few white clouds rolling across the blue sky. The flow of the original game
was completely disrupted, because there was nothing left to engage the
player (figure 5.3).

For many, perhaps most, in the mainstream game community, *Super
Mario Clouds* was not a video game at all. In *Avant-garde Videogames*, how-
ever, Brian Schrank (2014) described numerous examples of games that, like
Super Mario Clouds, violate the expectations of the player. *Untitled Game*,
created by a pair of internet artists under the collective name of JODI, is a
series of mods (modifications) of the *Quake* game engine (Schrank 2014, 53).
The original *Quake* (1996) was a classic fully 3-D, first-person shooter, and
JODI's mods deconstruct the flow of the original. One mod, for example,

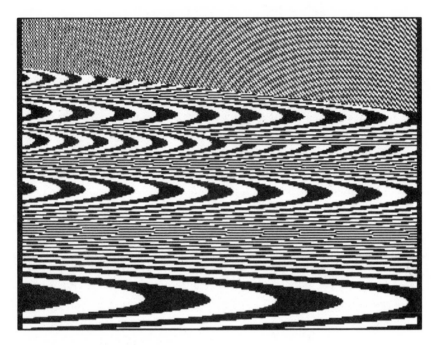

Figure 5.4
JODI, *Untitled Game*, screenshot. Reprinted with permission.

transforms *Quake*'s graphics into what look like the snow and distorted patterns on a black-and-white television screen (figure 5.4).

Jeff Minter's *Space Giraffe* (2007) is almost impossible to play because the player is overwhelmed by extraneous graphics, which Schrank (2014) describes as "fire flowers and 'sparkling grunts'" (50), to the point that the player cannot achieve any of the ostensible goals. Some video games, such as Adam Cadre's "text adventure" *Photopia* (1998), present stunted or disrupted stories that do not obey cause and effect (Schrank 2014, 179). Jason Rohrer's *Passage* (2007) works the opposite kind of disruption: "The player can walk any path in *Passage*, but she will always die in five minutes, in a gentle, morose irony" (Schrank 2014, 193).

Schrank's point is that there are video game designers today who are extending the work of the modernist avant-garde of the twentieth century. We can add that their ambiguous position in relation to the world of video games today resembles that of avant-garde artists in the twentieth-century world of art. They constitute a minority, and many in the mainstream game

community (those who work in studios like Electronic Arts and produce games for millions of players) deny that this avant-garde is making games at all. Sometimes these game-like artifacts are exhibited in galleries, and their creators want to be accepted by the art community. They may or may not succeed, by the way. The art world is still skeptical of digital art in general and certainly digital art deriving from the popular medium of games. However, MoMA has a video game collection in Applied Design, and the game designer Porpentine has had her game *With Those We Love Alive* on display at the Whitney Biennial 2017. Some makers of "art games" want to maintain their position within the games community. Jason Rohrer sees himself as a game designer who is also an artist, not as an artist who makes games. A *New York Times* article entitled "An Exhibition That Proves Video Games Can Be Art" notes that Rohrer became the first video game creator to have a solo show at a significant museum (Reese 2016). In any case, the video games that Schrank describes have different effects on their audience than mainstream games do. They do not conduct the player into the flow zone between anxiety and boredom, nor do they allow the player to lose herself in a storyworld. Instead, as Schrank put it, they move the player to ask herself what a video game is and what it means to play one. Such games suggest that we need to consider the experience of "reflection" as a third term along with catharsis and flow. Ironically, and this too was Schrank's point, video games that are reflective share this goal with the elite art of the twentieth century.

In the twentieth century, both flow and catharsis were generally associated with popular entertainment, not art. The aesthetics of catharsis and flow are different approaches to seizing and holding the viewer's attention. Csikszentmihalyi regarded complete engagement as the definition of a true flow experience, and even the low-intensity flow experiences offered by social media or channel surfing are exercises in the economy of attention. Catharsis too is engagement—for example, when a filmgoer is absorbed in following out the fate of the main character with whom she identifies. We recognize the aesthetics of immersion in popular film, television, and fiction: the movie that the audience does not want to end (but it must end), the page-turner that the reader cannot put down, and the addictive television series. Immersion in compelling narrative forms has been a characteristic of popular twentieth-century forms, and for that very reason it was generally rejected by experimental and elite art throughout the twentieth century.

We can take this as one definition of "modern art" in the twentieth century: that it rejects transparency and the immersion of the viewer in a storyworld. Avant-garde painting rejected immersion and in some cases representation itself. Early in the twentieth century, most of the important artists and styles (Cubism, Abstract Expressionism, Surrealism, and so on) were already deconstructing the illusion of three-dimensional space. By the midcentury, Abstract Expressionists such as Pollock and Rothko were offering canvasses in which there were no recognizable figures or representations at all. This was art, Clement Greenberg (1960) stated in "Modernist Painting," that "call[s] attention to art." Elite literature was inventing ways of telling stories that were reflective and called attention to their own medium—Joyce's *Ulysses* and *Finnegan's Wake*, for example. We have already mentioned how Bertolt Brecht rejected what he called the popular theater of his day, which aimed at catharsis. Almost all experimental theater of the twentieth century followed Brecht in this rejection. It was the same with avant-garde filmmakers, from Buñuel and Man Ray in the 1920s to Stan Brakhage and Hollis Frampton at midcentury. Throughout the period, elite art was supposed to call on the viewer to be reflective rather than fall into the play's, story's, or painting's immersive embrace.

In the era of high modernism, reflective art was understood in opposition to the aesthetics and politics of mainstream culture. For Greenberg (1939) a work was either avant-garde or kitsch, which in practice meant that serious art was difficult and appealed to an elite, while popular entertainment appealed to the masses because it was easily understood and sentimental. But in today's media culture, these oppositions make little sense. Immersion remains a goal of many Hollywood films and television dramas, but other films and television series are also reflective: they call attention to themselves as part of a genre (noir, romance, horror) or as part of our complex media culture. This is especially true of comedies. Live-action or even animated comedies are often filled with references to earlier films, to television, to pop music, or to political or celebrity figures. There is nothing elitist about Pixar's wildly successful animated films from *Toy Story* (1995) to the present. They manage to appeal to adults with sophisticated allusions, while providing young children with immersive experiences. The *Scary Movie* series, which began in 2000 and has grossed close to a billion dollars, began as a parody of other horror franchises, such as *Scream* and *I Know What You Did Last Summer*. In the series (up to *Scary Movie 5* by 2013),

the network of references grew to encompass more and more films and pop-cultural phenomena and celebrities, including of course earlier films in the franchise. The practice of remix in hip-hop music, discussed in chapter 6, is reflective while at the same time providing a flow experience: listeners who are familiar with hip-hop music can recognize the various quoted tracks that are put together in a new whole always supported by the relentless rhythms that make the music flow. Music videos are another popular modernist form, because they often borrow film techniques that were once regarded as avant-garde. Such videos are reflective for their enormously large community today in the same way Man Ray's films were for his tiny avant-garde community in the 1920s.

 In all these cases, the avant-garde experience of reflection has become popular entertainment. For the makers of these popular films and music

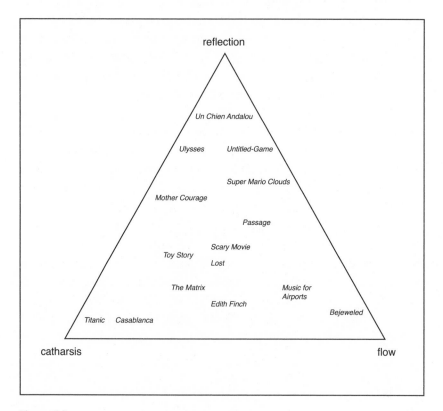

Figure 5.5
Three aesthetics: Flow, catharsis, and reflection.

remixes—and unlike the elite modernists of the past—aesthetic purity means little. They are popular modernists, not modernists. Hip-hop music flows. The *Toy Story* films are filled with in-jokes and references to earlier film and television genres, and yet they remain sentimental "buddy films" about the relationships among the personified toys. Even the *Scary Movie* films can sometimes achieve a passing cathartic thrill of horror.

To visualize this aspect of our media culture, we need to add a second dimension to the diagram and make a triangle, with flow, catharsis, and reflection as aesthetic ideals at the vertices (figure 5.5). In the digital plenitude today, almost any point in the interior of the triangle is occupied by some media form. Our current media culture creates hybrids easily and eagerly. The flourishing space in the interior of the triangle offers little evidence that the aesthetics of either catharsis or reflection will disappear. The only thing that is disappearing is the clear division between elite and popular forms.

Once again, the dichotomy of flow and catharsis is not adequate to describe our media plenitude. It is a starting point, a preliminary of sorting through the complex creativity of millions of media producers and consumers. The dichotomy becomes a spectrum, and the spectrum opens into a second dimension when we add reflection as a third pole. The dichotomies in the following chapters open up to become spectra in a similar way.

6 Remix and Originality

To understand remix in our contemporary media culture, we must begin with rap music and hip-hop culture. They have roots in vibrant but economically depressed African American cultures of North America in the 1960s and1970s (McLeod 2015). The African American inner cities, particularly in New York, put together the elements of MCing (the verbal rapping) with DJing (the "scratching" or sampling of vinyl records) to make this new musical form (Brewster and Broughton 2006, 226–288). Musicians/rappers from the 1970s to the 1990s created an enormous range of variations on this theme both by remixing different genres of popular music and by making use of increasingly sophisticated remix machines—analogue remixers that consisted of one, or often two, turntables, programmable drum machines, and digital samplers and synthesizers. The generations of rappers performing over these sound washes continued to change and expand their subject matter.

African American rappers perfected a form of self-aggrandizement in their raps, but also increasingly introduced political or social themes. Rap battles, in which two rappers compete against each other in producing clever rhymes that promote themselves and insult their opponents, became popular in the 1980s. JAY-Z's iconic 1998 song and video "Hard Knock Life" exemplified the highly personal nature of rap poetry. While the chorus (sampling from the Broadway musical *Annie*) is about the economic and social conditions of the inner city, JAY-Z's lyrics describe his own struggle for recognition and prominence as a rap singer. His generation of rappers seemed to be engaged in a rap battle even in solo songs. At least in this form and at this period, rap itself was a hard knock life, just like the economic community in which it emerged. Some well-known rap singers of the 1990s

(including the West Coast's Tupac Shakur and the East Coast's Notorious B.I.G.) succumbed to physical and not merely verbal violence. Hip-hop was defined by a struggle for dominance and hierarchy.

Ironically, while the rappers in the hip-hop community themselves engaged in a serious and sometimes dangerous struggle for dominance, the musical foundation of rap, that is, remix, has been anything but exclusive. By its very nature, remix was open to influence from other popular forms. Rappers were often "featured" in other rappers' songs, and rap combined with or was absorbed into other mainstream musical genres. As early as 1980, the punk group Blondie's "Rapture" incorporated rap elements. From 1995 on, the pop diva Mariah Carey began to work with hip-hop artists to remix songs such as "Fantasy." After about 2000, the distinctions between the reigning mainstream styles of R&B became increasingly difficult to separate from hip-hop. Pop singers and rappers collaborated, appeared in each other's songs, and changed their styles from record to record. Gangsta rap gradually gave way to less raw, controversial forms from performers such as Kanye West, who could more easily assimilate into the pop mainstream. Female singers such as Rihanna combined rap with pop and performed with dozens of other singers inside and outside the rap tradition. It became increasingly difficult to define either hip-hop or remix as isolated practices. The musical and legal marriage of JAY-Z and Beyoncé in 2008 symbolized the fusion of R&B and hip-hop.

Popular music today has not converged into one amorphous style; instead, remix has led to proliferation of subtly different styles and combinations. Wikipedia lists dozens of hip-hop genres, including crunk, electro hop, gangsta rap, hip house, political hip-hop, rap rave, and so on (Wikipedia contributors, "List of Hip Hop Genres"), and this list by no means exhausts the genre combinations with other forms that have or had their own communities of producers and listeners, such as soul, funk, and dance. Much of this music consists of highly repetitive rhythms and harmonies that come from electronic synthesis or sampling. It places less emphasis on melody than popular music did several decades earlier. Instead, the singing is often more chant-like, and the music feels as if it could go on indefinitely. In short, much popular music today prefers the aesthetic of flow rather than catharsis. That is a large part of rap's contribution to our musical plenitude.

In the last chapter, we saw how the game community uses the term "flow" to describe the player's ideal interaction with a video game. It turns

out that flow is also a term in rap music to describe the interplay of the rapper's rhyme and the beat. (JAY-Z uses the verb twice in "Hard Knock Life.") The expressive power of rap comes from its flow. When the rapper's lines and the underlying beat set by the DJ come together, the listeners experience a state of flow. Any mistakes, failures to rhyme, or breaks in the rhythm will disrupt that state for the audience. Rap music is flow music, and as its influence spread, flow became the most popular rhetoric in music today. We have only to look at the number of plays of JAY-Z's or Beyoncé's songs on Spotify or YouTube videos (both are in the hundreds of millions).

Remix Culture

Rap music was the earliest and most influential form of remix, but the practice of using digital technology to sample and recombine elements from earlier productions now extends to a variety of media (and multimedia) forms, including music, video, static images, and text (Navas 2012; Navas, Gallagher, and burrough 2015a). As Larry Lessig (2008) pointed out, remix—especially the mixing of borrowed video with recorded music—has now become a means of expression for a large population of (generally) young amateur digital producers. By now YouTube must contain millions of remixes, in which excerpts from animated and live-action films, news, and other broadcasts are combined or edited for humor, political comment, or simply as a show of skill. The easy availability of music and video editing software on Macs and PCs mean that, as Lessig (2007) has put it, "anybody with access to a $1500 computer … can take sounds and images from the culture around us and use it to say things differently." Hence, Lessig claims, we are living in a remix culture, and he is only one of many who hold that remix is the cultural dominant of our times. Already in 2005, *Wired* magazine claimed that ours was a remix planet (Wired Staff 2005).

It is certainly true that sampling, cutting and pasting, borrowing by various digital means, is part of communication and representation across a broad swath of professional and amateur activities—especially if we consider social media platforms as such Instagram, Pinterest, Facebook, and YouTube, where there are literally hundreds of millions of remixers (Manovich 2015). The social media remixers are generally limited to copying and pasting images, audio, and videos into their streams for their networked public. This is the amateur end of the creative scale. On the other

end of that scale, hip-hop grew long ago from a relatively amateur status to a highly professional and lucrative industry. JAY-Z and Beyoncé are together reputed to be worth over a billion dollars (Mclean 2017). There are obviously many levels of remix between the extremes of a teenager's remix of her favorite song with a favorite animated cartoon and the professional and subtle weaving of sounds and video cuts in "Drunk in Love" by Beyoncé and JAY-Z.

Video remix is often amateur in the etymological sense that it is done out of love of the craft. While recutting or remediating movie trailers (sometimes in radical ways) is a practice that predates YouTube (Dusi 2015), YouTube is now the standard repository for amateur remix. We cite here a few examples from this plenitude. One productive genre is the splicing together of film excerpts and trailers. Compilation videos of seemingly every Hollywood star (Tom Cruise running; Brad Pitt eating; Jennifer Lawrence being funny; Jennifer Lawrence, Angelina Jolie, Scarlett Johansson or virtually any A-list actress being "hot," and so on) or super cuts from popular, long-running television series (*Friends, The Walking Dead, Game of Thrones*) fill the datasphere on video-sharing sites. One practice is to transform a film from one genre to another—to make a trailer for, say, the classic romantic comedy *Sleepless in Seattle* into what appears to be a stalker film with the romantic lead Meg Ryan as the stalker (Lyall-Wilson 2006). In the same vein is *Pretty Woman* as a horror film (Jenkins 2010), and there are many others: for instance, Stanley Kubrick's horror film *The Shining* as a romantic family film with a happy ending (Yang 2008); or a trailer of *Spectre* cut so that Sean Connery, Roger Moore, or Pierce Brosnan is Bond instead of Daniel Craig (e.g., The Unusual Suspect 2015). Such videos are not typically meant to make a social comment (although some may, for example, implicitly critique the sexism of Bond films or the violence of action-adventure films). Most of these remixes are meant simply to impress the viewer with the inventiveness and skill they demonstrate in editing. To appreciate the remix properly, the viewer has to have a sense of the original films.

What all of these remixes have in common is that they reimagine some tiny portion of the vast world of Hollywood film. The remixer appropriates that portion—one film, one genre—and makes it her own. In this respect, remixes are like fan fiction, in which amateur writers extend the storyworlds of beloved films and series by taking their characters in fantasized directions. As we discussed in chapter 1, Henry Jenkins (1992, 2006b) has shown

how fans of certain popular series (of films, books, or television shows, such as the *Star Wars* or *Star Trek* franchises) passed easily from consumers to producers of media. Their fan fiction site, blogs, homage websites, and even films are important forms of appropriation. Such work is remix in the sense that it samples from characters, plots, and settings and reconfigures those samples into new stories. Fanfiction constitutes its own universe in which communities of fans write for one another. Similarly, video remixers fashion extensions or comic or ironic variations of Hollywood's canon of films. In fan fiction, the sampling is virtual or conceptual, whereas for video remix, digital sampling means that a universe of films is available for creative reimagination.

In 2004, a German film *Downfall* (2004) became part of the available film archive. A few years later, it became the source for hundreds of parodies, requiring less skill in editing than the trailer remix and a different kind of background knowledge for the audience. The parodies are based on a scene in which Hitler in his bunker screams at his generals for the failure of a German counteroffensive as the Russians close in on Berlin (Wikipedia contributors, "*Downfall* (2004 Film)"; Rohrer 2010). Each remix consists of the approximately four-minute scene with the original German dialogue; the remixer changes the subtitles so that Hitler is angry at something else. The humor comes from the anachronism and, often, from the relatively trivial character of what enrages Hitler. It might be the release of a version of the Apple iPod without a camera or that the soccer star Cristiano Rinaldo had been sold to Madrid. Political themes are now also common: Brexit or the nomination and election of Donald Trump, for example. There are self-referential versions in which Hitler complains about all the parodies of him that are being made. In 2010, Constantin Film, which owned the rights to the original movie, sought to have the parodies removed from YouTube for copyright violation. This effort led to videos in which Hitler complains about the attempted removal. The universe of parodies has spawned a self-conscious community who called themselves *Untergangers*.

The *Downfall* videos constitute a digital meme. Richard Dawkins came up with the notion of the meme in 1976 to describe well-defined cultural units that spread from person to person (Shifman 2014, 2). Decades later, the Internet has become an ideal mechanism for creating and distributing memes, and remix has become one of the key techniques for propagating memes. Each new instance of a digital meme is not an exact copy; it

is, instead, a variation on the theme. In the standard lolcat meme, each new version consists of a different image of a cat or a different caption, or both—the pasting together of new samples. In the *Downfall* meme, each video has a new sampled soundtrack. As Shifman (2014, 55) in *Memes in Digital Culture* points out, a meme is constituted by repetition and variation. A single video can go viral on the Internet, but it only becomes a meme when many videos are made in imitation. This act of imitation usually involves sampling and remixing.

Like most memes, The *Downfall* videos are casual products of remix culture in Lawrence Lessig's sense. The original *Downfall* remix, the source of the meme, is hard to trace; by 2010 there were thousands of such videos by hundreds of remixers. None of the remixers seemed to care who originated the idea. As remix culture matured and spread, however, those with an economic interest showed that they did care about the origin of visual, musical, and other ideas. Originality in our media culture remains as much an economic issue as an aesthetic one.

Good Musicians Copy; Great Musicians Remix

In 2000, the heavy metal band Metallica filed a lawsuit against Napster, the peer-to-peer file-sharing service. Napster struck terror into the music industry, which had failed to understand the implications of the Internet for its business model. Napster's decentralized technology made it possible for its users to upload and share files of all sorts. Most of these files were popular songs that were protected by copyright. One of these was Metallica's "I Disappear," leading the band to sue. Lars Ulrich, Metallica's drummer, appeared that year before the U.S. Senate Judiciary Committee to testify against this digital form of sharing. In an article published soon after, Ulrich (2000) appealed to a general sense of fairness, claiming that copying is stealing the band's product: "Just like a carpenter who crafts a table gets to decide whether to keep it, sell it or give it away, shouldn't we have the same options? My band authored the music which is Napster's lifeblood. We should decide what happens to it, not Napster—a company with no rights in our recordings, which never invested a penny in Metallica's music or had anything to do with its creation. The choice has been taken away from us." Ulrich (2000) cited a *New York Times* columnist, who argued that ownership is essential to creativity: "In closing, I'd like to [quote] the last

paragraph of a New York Times column by Edward Rothstein: "Information doesn't want to be free; only the transmission of information wants to be free. Information, like culture, is the result of labour and devotion, investment and risk; it has a value. And nothing will lead to a more deafening cultural silence than ignoring that value and celebrating ... [companies like] Napster running amok."

Formed around 1980, Metallica was a late representative of rock counterculture, and the irony was not lost on some fans that the band had gone from rock rebellion to representing the legal structure of the music industry. In fact, like so many in music, film, and television, Metallica was remaining true to popular modernist assumptions about art and creativity: the notion that the artist is the sole creator of his or her work and that the artist or the artist's agent (publishers, record, and film companies) should have the right to control that work.

Napster was not a remix site; instead, whole song files were being shared. But the essence of Napster was copying, and without copying there can be no sampling. We can see the changed definitions of "creativity" and "originality" in the much more recent "manifesto" of Right2Remix, a group of producers and artists: "We live in an age of remix. Creativity and culture have always drawn from previous works, but with the Internet and digital technologies, the creative re-use of works has been taken to a whole new level. More people are able to edit and share a greater range of works than ever before. More than ever, it has become clear that "everything is a remix!" (Right2Remix.org 2017). The manifesto takes the denial of originality as its aesthetic and legal foundation. It adds: "Since creative copying has become commonplace, the right to remix is a fundamental requirement for freedom of expression and free speech. a fundamental requirement for freedom of expression and free speech. (Right2Remix.org 2017; Sonvilla-Weiss 2015, 64)

Unlike Metallica, the Right2Remix group are not heavy metal rockers with millions of followers; the group consists of academics and lesser-known artists. But they do represent a shift in thinking among numerous communities of amateur remixers and (formerly) artistic elites. Remix evolved out of, and often sampled from, popular modernist traditions and styles in music and entertainment, yet it cannot help but undermine modernist assumptions about creativity and individuality.

In the music industry, each song (or even each performance) by a single artist or a small group is supposed to be unique and original. Rock music

subscribed to popular modernism beginning in the 1960s, and even after rock abandoned its single trajectory in the 1970s, music groups and solo performers with their well-rehearsed songs and meticulously planned stage shows retained the desire to be original. Like Metallica, many successful popular performers (or at least their record labels) remain strong defenders of laws protecting intellectual property. Because remix appropriates samples of music or video from others, creativity in remix cannot be measured by complete originality but by skillful or clever quotation, appropriation, editing, and reimagining. For the art world, pastiche, the practice of appropriating elements of previous styles, became a key distinction between modernism and postmodernism (Jameson 1991). The modern artist was supposed to create something new from first principles; postmodern artists instead would borrow and refashion. In the same way, borrowing and refashioning is exactly what characterizes the popular forms of remix.

In that sense we could call remix "popular postmodernism." But there is one important difference. Postmodernism was a development of and for artistic and academic communities, the former elites. Postmodern painters, installation and performance artists, architects, and writers were all in dialogue with the modernist art against which they were reacting. Remix musicians and video makers, in general, are not taking part in that dialogue. They work within their own creative communities—communities of hip-hop, dub, and dance music; of Hollywood film; of video games and game replays; of YouTube channels and their micro- or macro-celebrities. There are exceptions, of course: crossovers or at least remixers with some knowledge of elite modernist traditions. Take, for example, Cabaret Voltaire, an industrial band starting in the 1970s whose experimental music, and eventually videos, made them obviously avant-garde; their name is an explicit reference to the Dada movement in the 1910s.

Right2Remix is not so avant-garde that they abandon concern for legal issues. Their site is a demand not to abolish copyright but rather to grant musicians and videographers the legal right to fashion remixes out of existing copyrighted materials. They want to join the club, not abolish it. The legal scholar and activist Lawrence Lessig has made a similar case in two publications (released for free download with a Creative Commons license): *Free Culture* and *Remix: Making Art and Culture Thrive in the Hybrid Economy* (Lessing 2004, 2008). Lessig and others document how the music and film industries have continued to pursue a procrustean definition

of "copyright," taking the position that sampling even a few seconds of another song is infringement. In the early 1990s, the music industry was relatively successful in limiting sampling on commercially visible albums through a series of lawsuits, among them one against the rapper Biz Markie who had looped a phrase from a maudlin popular song "Alone Again (Naturally)" (McLeod 2015, 83). This wave of litigation resulted in the expectation that commercial musicians would license each sample, no matter how short. Major musicians might choose to do this or might simply limit their sampling to avoid the risk of lawsuits. The music industry may have believed that sampling clearance solved their problem and allowed them to remain "alone again (naturally)" with their intellectual property. But with the rise of amateur remix and the plenitude of recorded music online in the 2000s, there were now thousands or millions of remixers who were not part of the industry and did not feel compelled to obey the rules. Clearing their complex remixes would have been economically impossible in any case. In his film *RiP!: A Remix Manifesto* (2008), Brett Gaylor estimates if that Girl Talk were to license the hundreds of samples on one of his albums, the cost would be about $4,200,000.

There are two ways to look at remix: either it dissolves the notion of originality or it redefines originality as the mixing of materials. Even modernism had to confront the fact that artists drew from traditions. T. S. Eliot wrote famously that all poets borrow, great poets steal, and he was not the only modernist to whom that thought was credited. Picasso is supposed to have said, "Good artists copy; great artists steal" and Stravinsky said, "Lesser artists borrow; great artists steal" (Sonvilla-Weiss 2015, 57). At the same time, all of them were committed to the modernist passion for originality. Picasso and Stravinsky spent their long careers defining, changing, and refining styles that would make their painting and music unique contributions to their art. And if we look at Eliot's (1921) passage, we see his nuanced notion of theft: "Immature poets imitate; mature poets steal; bad poets deface what they take, and good poets make it into something better, or at least something different. The good poet welds his theft into a whole of feeling which is unique, utterly different than that from which it is torn; the bad poet throws it into something which has no cohesion. A good poet will usually borrow from authors remote in time, or alien in language, or diverse in interest." Eliot does not believe in "sampling" from recent hits. His idea of stealing is to draw allusions from the plenitude of earlier literary

traditions, and the result should itself be a unique work of art. Eliot, other elite modernists, and even some popular modernists saw no difficulty in distinguishing originality from mere copying.

Remix and Modernism

One of the great popular modernist anthems is John Lennon's song "Imagine," in which Lennon asks us to imagine a world where greed and want are eliminated and everything is held in common. The idea of sharing creative media is central to remix culture, and so it is appropriate that a mashup of Lennon's song exists. "Imagine This" was produced by Wax Audio and samples President George W. Bush's words so that he speaks Lennon's lyrics over the chords of the original song with a beat background. A videographer named John Callahan (known as Cal TV) then found the video of Bush's words and created a video mashup with the Audio Wax remix as background (Krieger 2015). The complex layering (made even more complex because another Beatles song, "Give Peace a Chance," and other materials are mixed in) refashions Lennon's original. Lennon's song could hardly be simpler: a few chords and a repetitive chant-like melody. In chapter 2, we noted that the creative impulses of John Lennon and Paul McCartney mirrored the difference between the political and the formal avant-gardes: John is political, Paul a formalist. By the time he wrote "Imagine" (after the break-up of the Beatles) Lennon had entirely rejected the formal innovations that George Martin and Paul McCartney had added to later Beatles songs, such as "Strawberry Fields." Lennon's popular avant-garde was entirely political, not formal. But the remix can only make its political point through the formal manipulation of numerous samples of Bush's speeches. And because remixes can be generative when shared, there are dozens, perhaps hundreds of versions of the "Imagine" remix, some of which depend on "Imagine This" and some of which rely on Lennon's original.

Many genres of remix videos have overt or implied political intent. Some mock government policies, elected officials, or political figures. Some on the left address what they view as the dominant economic or social structures of capitalism or neoliberalism; some on the right critique what they in turn view as political correctness. Political remix videos thus form their own ramifying series of genres (Conti 2015), although they may have smaller audiences than popular YouTube phenomena such as the *Downfall* videos. But, once again, small is always a relative term in the digital plenitude. In

2008 Greenpeace did a clever mashup that consisted of a song set to a collage to show how Dove and its owner Nestlé were contributing to deforestation in the tropics by their techniques of harvesting palm trees for oil. Their video has about two million views on YouTube (Peverini 2015). A common political remix technique is to parody a commercial—for example, a parody of a successful MasterCard commercial in support of WikiLeaks and Julian Assange (WikiLeaks 2011). Another style of parody is redubbing the audio or altering video of an interview. A satirical group called the Yes Men created a series of interviews mocking the Davos World Economic Forum of 2010, in which, for example, the head of the agribusiness Archer Daniels Midland appears in a matter of fact way to explain how her company exploits agriculture in the developing world to satisfy the "greed of the ultra-wealthy" (Jenkins 2010). Not surprisingly, most of these remixes critique figures and institutions that constitute economic or political elites. The remixes are generally made by outsiders. The elites themselves (at Davos and elsewhere) do not need remixes to promote their messages.

This critical stance gives political remix a special place for authors writing about digital media, who want to group these kinds of remixes into a contemporary avant-garde (Sinnreich 2010; Navas, Gallagher, and burrough 2015a, 320–407). However, this is a tradition that even most political remixers are not likely to be aware of. Remix as a part of our media culture is historically about as far from the elite culture of the twentieth century, from modernism, as one can get. It arose from popular traditions, particularly in the music that became hip-hop, and it continues to be a vastly popular form, not interested in any of the qualities that defined modernism. Political remix constitutes one community, or rather a network of related communities, in the vast world of remix. Most of the movie trailer parodies and other kinds of amateur remixes are not political. They are celebrations of form.

There is a sense in which remix unselfconsciously recalls and even surpasses the achievements of the twentieth century's avant-garde. We can see this in the work of one of the most accomplished audio remixers, Gregg Gillis, who performs and records under the name Girl Talk (Borschke 2015, 105; Lessig 2008). Girl Talk has produced several albums, each of which contains hundreds of samples from contemporary popular music. His breakthrough *Night Ripper*, alone consists of between 200 and 250 samples from 167 contemporary popular musicians (Lessig 2008, 11). The next album, *Feed the Animals*, had over three hundred samples (Wattercutter 2008). These samples are layered together with consummate subtlety, but

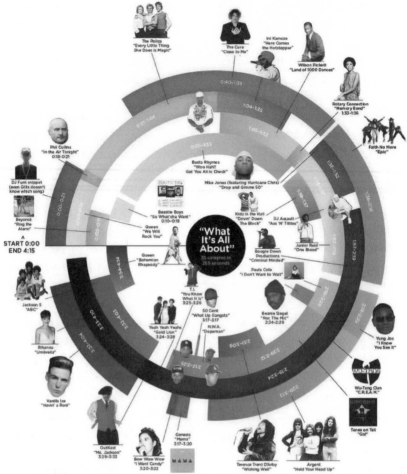

Correction: "C.R.E.A.M." is sampled from 2:29-3:12 and "Go!" from 2:19-3:24, not the other way around.

Figure 6.1
Mashup DJ Girl Talk Deconstructs Samples from "Feed The Animals": Angela Watercutter/Wired © Conde Nast.

it is always clear that this music is a pastiche (figure 6.1). The ideal listener is one who knows contemporary popular music well enough to recognize where these samples come from. Only such a listener can appreciate the sophistication of Girl Talk's mashups, and for that listener the tracks become a retrospective of popular music culture over the years. Because Gillis refuses to get permission for his samples (it would be virtually impossible in any case because of the sheer number), his music raises legal questions of

intellectual property. Lessig (2008, 12–13) offers Gillis as a cardinal example of the new creativity of remix culture. It is the copyright issue that gives Gillis's formal remix a political dimension, explored in detail in Gaylor's documentary *RiP!: A Remix Manifesto* (2008). Gaylor makes Gillis into a culture hero for remix culture, detailing how the recording and film industries have sought to lock up culture and free expression for their economic benefit. They represent the past, and Girl Talk and millions of other less talented remixers the future. At the same time, the interviews with Gillis, who was twenty-seven when the film was produced, show that he has no knowledge of or interest in the avant-garde tradition. He simply wants to make his kind of music and sees no ethical reasons why he should not be allowed to sample.

On the other hand, Gillis and other such remixers do achieve a crucial goal that eluded the historical avant-garde (as described by Bürger 1984): their music is integrated into the life of their numerous fans. Scenes in Gaylor's film, in which hundreds of fans at a Girl Talk concert sway and dance ecstatically, show the power of the musical experience he offers. The avant-garde of the 1910s and 1920s hoped to bring art out of the gallery and the museum and make it a part of the everyday life of the people. Where they failed, Girl Talk and other commercial and amateur remixers have succeeded. That is what the phrase "remix culture" means: the integration of the practice of remix into the lives of millions. Dub and hiphop, and other early manifestations of remix culture, were all authentically popular—the work of marginalized, often African American producers and musicians with their own musical and social concerns. The rise of remix is at least as striking an example of the breakdown of hierarchy as the earlier rise of rock and roll. Eduardo Navas (2012) writes that "principles of Remix in new media blur the line between high and low culture (the potential that photography initially offered), allowing average people and the elite to produce work with the very same tools" (31).

In *Mashed Up: Music, Technology, and the Rise of Configurable Culture*, Aram Sinnreich (2010) explains how what he calls configurable culture violates all the principles of the "modern framework." Sinnreich's "modern framework" describes the principles of artistic—but in particular musical—practice in the era of modernism. The modern framework made clear distinctions: that art is better than mere craft and that an original is obviously of a different and better order than a copy. In the modern framework, too, the distinction between artist and audience is well defined. According to

Sinnreich, in the new culture of configurability, these distinctions and others break down (68). And Sinnreich is right that remix producers not only ignored but were uninterested in these fundamental qualities, not only of music but of all the arts in the modern period. Within the elite art community, many artists in the second half of the twentieth century set out consciously to critique or defy the framework of modernism. African American DJs and hip-hop musicians generally were not in that conversation; their music reflects the concerns of their own musical and social communities in this period.

What about JAY-Z's rap and video *Picasso Baby: A Performance Art Film*, discussed in chapter 1? This is framed as a challenge to the hierarchy of elite and popular art by one of the most famous and successful rap musicians. But by this time (2013), JAY-Z was pushing against an open door. He claimed the status of an elite artist at a time when even the elite art community is no longer convinced that artistic hierarchy makes sense. And JAY-Z's laundry list of modern and postmodern artists to which he compares himself shows that he is not interested in critiquing the modern framework. Hip-hop and remix culture do have qualities that could be thought of as postmodern. That is, what the postmodern painting and performance are to modern elite art, remix music and video are to traditional popular music and film and television. Remix is in this sense indeed popular postmodernism. It is most like the historical avant-garde precisely when it is not trying to be. Girl Talk is more essentially avant-garde than JAY-Z.

Playing in the Plenitude

Remix is hard to place in the history of our media culture precisely because it is itself a mashup of many practices, forms of music, photography, film, and video. It is a popular and amateur practice of millions or hundreds of millions. It is also a technique used by professional musicians and video editors. It seems to continue the modernist and popular modernist traditions of the political and formal avant-garde, and yet it also seems to have nothing to do with those traditions. In other words, remix is a perfect reflection of the current media culture, about which every possible generalization is partly, but only partly, true.

Remix is about playing in the plenitude. It is perfectly at home in a media culture in which traditional hierarchies have broken down. If we have

a culture of fragments, then why not make a practice of piecing together fragments into new configurations? You can take samples from anywhere. As Navas (2012) points out, a skillful DJ could take samples from "uncool" mainstream traditions and make them work for a sophisticated audience (132). Two decades ago JAY-Z sampled from a Broadway musical to create a hip-hop classic. The fact that so much music and video material of all kinds is now available in digital form gives remixers more freedom than before. Digital formats, along with the connectivity of the Internet, expand the field of remix almost infinitely. Digital networking flattens out our media culture. The assertion of copyright is an attempt to maintain hierarchies, to fence off materials and remove them from the remixer's palette. Everything that counts as remix speaks to a rejection of notions of hierarchy, propriety, and ownership.

Just as flow and catharsis are creative opposites in our media culture today, we can see remix and originality as creative opposites as well, dividing and defining the practices of various communities of creators and consumers. Remix is original in its notion of derivation; it reimagines the very notion of originality (Navas, Gallagher, and burrough 2015b; Sonvilla-Weiss 2015; Campanelli 2015). In so doing, it reverses the modernist relationship between the individual and the tradition. Whereas modernism emphasized the individual artist's unique contribution to a well-defined tradition, remix emphasizes the wealth of the media traditions from which the individual musician or video editor draws. Samples are fragments from an inexhaustible reservoir of media. Remix can draw happily from numerous traditions without trying to make sense of any of them. In this respect, remix is more original than modernism or popular modernism, both of which were conscious of their place in the history of art or entertainment. Like elite modernism in the first half of the century, popular modernism in the 1960s was trying to move its art forward. The Beatles, Brian Wilson, and Frank Zappa were trying to take rock music further, to expand or redefine rock itself, just as elite painters from Picasso to Pollock were trying to develop the art of painting. Remix does not further a tradition; it plays in and with many traditions. Remix recalls some of the techniques of the avant-garde from the twentieth century, but it puts these techniques to a different use. Remix is playful no matter how serious some of its subject matter may be; the avant-gardes of the twentieth century were ultimately serious about redefining the place of art in our society no matter how playful they appeared to be.

A Girl Talk concert is highly participatory. The audience dances or moves rhythmically, hands raised, enveloped by the music and lights and surrounded by the bodies of fellow listeners. We have become used to this mass participation in rock and popular concerts, although certain genres of music, such as techno and dance remix, inspire particularly ecstatic participation. The participation is strongest when the music is repetitive, electronically produced or reproduced through sampling. The mechanical nature of the music seems to call out to the audience to respond with their own repetitive and often mechanical gestures—to lose themselves in the music and to become part of a music machine, just as Eminem advised in "Lose Yourself." The whole world of remix music, as hip-hop performers have long known, is flow music. The avant-garde dance music of Girl Talk, like all sampled dance music and like rap, could go on forever.

Remix culture is therefore flow culture. Remix is repetitive and iterative. The repetition occurs either within a single remix, as with rap music, or within a genre, such as the *Downfall* videos. Successful videos are generative: they become memes. There is always another Hitler *Downfall* video that can be made; always another movie trailer parody. And these videos are consumed on YouTube, where each one is linked to a half-dozen others and users turn watching into a flow experience. Digital media are essential to contemporary remix, and in digital media repetition is expressed through procedures. What we see in the concerts of Girl Talk and countless other DJs is the use of digitally encoded algorithms to play with samples in an inexhaustible variety of configurations. Remix today is procedural play, a celebration not only of the wealth of materials, but also of the procedural character of the digital technologies that make those materials available to be deployed.

7 Procedurality, History, and Simulation

Datafication

If she walked around an urban park or city street in the early morning, our time traveler from 1960 would no doubt be surprised at the number of people jogging by—not just trained athletes, but people of all ages and degrees of fitness, women as well as men. The first race in 1970 had 127 entrants (TCS New York City Marathon 2018). Now, about fifty thousand people finish the New York City Marathon each year. In 1960, aerobic training and bodybuilding were highly specialized activities, generally for professional or at least dedicated amateur athletes. Our time traveler might note the irony that jogging and other forms of exercise have become so widespread while at the same time obesity has reached epidemic proportions. From a 1960 perspective, fitness and fatness seem to form a cultural default line today.

Our time traveler would be surprised by another common feature of exercise culture today: its addiction to quantification. People wear trackers (Apple Watch or iPhone, Fitbit, Misfit, Garmin, Moov, and any of dozens of others) as they run, jog, or walk. In gyms, each machine is now often equipped with a small monitor and connected to a central server, so that users can record their daily routines of lifts, presses, and curls. Quantification has become so common that we may not appreciate how recent it is and how obsessive it would have seemed to our time traveler. Gary Wolf and Kevin Kelly of *Wired* magazine named this digital obsession the "Quantified Self" (Wolf 2009). They embraced the notion that recording and following data leads to a new degree of self-knowledge: "Numbers are making their way into the smallest crevices of our lives. We have pedometers in the

soles of our shoes and phones that can post our location as we move around town. We can tweet what we eat into a database and subscribe to Web services that track our finances. There are sites and programs for monitoring mood, pain, blood sugar, blood pressure, heart rate, cognitive alacrity, menstruation, and prayers."

Athletes, they noted, pioneered this "new culture of personal data." The quantified-self project has a website (http://quantifiedself.com) with the explicit purpose of creating a community with "international meetings, conferences and expositions, community forums, web content and services" and meetup groups in dozens of cities in the United States, but also in Europe, Asia, Latin America, and Australia. Contemporary media culture has willingly embraced the increasing importance of numbers. Wolf and Kelly's quantified selfers (selfies?) are responding to a larger social phenomenon (Lupton 2016).

In *Big Data: A Revolution That Will Transform How We Live, Work, and Think*, Mayer-Schönberger and Cukier (2013) called this phenomenon *datafication*. The subtitle indicated that the book subscribes to the popular modernist notion of technology-driven revolution (chapter 2): that our world is changing because digital technologies are giving us the ability to collect and explore data in quantities never before possible. The data are big in terms of sheer size, although the nature of the data is often trivial. In many cases, people generate these data without conscious effort, and companies and organizations aggregate, analyze, and seek to profit from the data. They might do so directly, in the form of targeted advertising, but also by selling information to other parties. For example, ReCaptcha manages to harness the free labor of users to disambiguate words in databases while they sign into sites (99).

It isn't just that companies like Google and Amazon are gathering data surreptitiously as we search and surf. Equally important are the ways in which we become actively aware and complicit in the process of data generation and feedback loops. During presidential election cycles, news audiences are bombarded with weekly, even daily, poll results. Insofar as the audience is addressed as "the American people," these polls have the quality of being collective political selfies—political preferences parsed out in painstaking detail. We learn not just who "we" will vote for, but also the intricacies of favorability and unfavorability ratings, trust ratings, ratings on which candidate is best for the economy, will keep "us" safe, has the

necessary qualifications to be president, and so on. The news for a full year or more before each presidential election has become a course in popular empirical sociology. Our media culture's attention to such polling is heightened during these elections, but in fact it is now ongoing, even outside election years. Every day the news, regardless of whether we consume it from print, television, blogs, or Twitter posts, presents us with polling and numerical data reported by organizations such as the Pew Center. And if you miss the latest Pew survey on the news, you can visit their extensive website (http://www.pewresearch.org) for polls and analyses of politics, media, social trends, religion, the Internet, technology, and science. Empirical techniques as a means of understanding social groups used to be the province of academic specialists, but they have become (admittedly in a highly simplified form) a general language for our media culture.

The same is true for economic data. The Dow Jones and Nasdaq stock reports, the Bureau of Labor Statistics monthly jobs report, and the fluctuations of the U.S. dollar are now all daily fare not just for economists, but also the millions of readers of newspapers and news websites. Business news has found its place in the general media landscape, and the news is often couched in numerical terms. It made headlines in 2012 when Apple surpassed Exxon as the corporation with the highest market capitalization (how many general readers fifty years ago even knew what market capitalization was?) and headlines again when Google's parent company Alphabet surpassed Apple in 2016. Even popular entertainment is datafied in this way: each week the news media now report the box office grosses of the top films. Along with the number of Oscars a film receives, films are now held up for having the largest gross in wide release over a three-day weekend (that would be as of this writing *Star Wars: The Force Awakens* over the weekend before Christmas 2015). Figures that were once only of interest to Hollywood executives are now part of the general discourse about media.

Box office receipts are by no means our media culture's only available sorting mechanism. We are offered endless lists to distinguish all sorts of media. Organizations produce such lists both to assert their own importance at the center of their community and to reassure members of their community that a hierarchy still exists. The American Film Institute devotes a whole section of its website to lists, each with a hundred entries, including the "100 Years … 100 Movies," "100 Years … 100 Movie Quotes," "100 Years … 100 Heroes and Villains," and so on. For rock music, *Rolling Stone*

offers among its lists "100 Greatest Artists" (http://www.rollingstone.com/lists). The *Rolling Stone* list is an example of a growing online genre, the listicle, which is a numbered list fleshed out with short prose explanations. The goal is to keep readers scrolling or clicking (and of course viewing ads) until they reach number one. In 1998, the Modern Library website offered two sets of what it called "best" novels, illustrating how different communities of readers understand the center of the universe differently. The Modern Library's Board (composed of well-known fiction and nonfiction writers) put *Ulysses, The Great Gatsby,* and *A Portrait of the Artist as a Young Man* at the top of its list. An online readers' poll taken in 1998 put two novels by Ayn Rand and one by L. Ron Hubbard at the top (Rich 1998). Today there are only elite "Top 100" lists on Modern Library's website: 100 Best Novels, and 100 Best Nonfiction (http://www.modernlibrary.com/top-100/). Our obsession with lists is just one indicator of our growing interest in classification, and that need to classify exists in more than just our entertainment and cultural genres.

Another is our willingness to participate in the processes of classification. Industrialization and the modern bureaucratic state, dating back to at least the eighteenth century, require that individual members of society be classified and tracked. In their landmark study of classification, *Sorting Things Out*, Bowker and Star (1999) pointed out that the late nineteenth century was already characterized by an information explosion: "the development of myriad systems of classification and standardization of modern industrial and scientific institutions" (16). They were concerned with how bureaucracies and institutions, over the past century, have classified members of society without their consent and often without their awareness. Such "standards and classifications, however imbricated in our lives, are ordinarily invisible" (2). These processes of invisible classification are certainly more wide ranging and detailed today than ever before (Mayer-Schönberger and Cukier 2013). Ours is the first generation whose every web page visited, every search term entered, every footstep taken—even the sequence of our DNA—can be tracked, classified, and stored. Digital technology not only changes the scale of data collection and classification. It also introduces new degrees of both automaticity and flexibility into the process.

Digital technology makes invisible classification far easier, but it can and often does make the classification process more visible. On a daily basis,

we update our own entries in myriad databases: banking and paying bills online, managing our credit cards, buying airline tickets, and interacting with government agencies all require that we create "accounts," a euphemism for entries in database management systems. In 2016, 71 percent of Americans were banking online (Federal Reserve 2016), and 79 percent of American adults had shopped online (Smith and Anderson 2016). Our bank accounts become tiny portals into an enormous economic network that in itself already constitutes a virtual world. In creating our accounts, we fill in our profile parameters and check preferences as if we were setting up avatars in a role-playing game. In examining our balances and paying bills, we manipulate the interface as in a simulation game. Such accounts, indeed the whole economy, has become a giant simulation. We can hardly help but think of William Gibson's ([1984] 2000) definition of "cyberspace," running on "the banks of every computer in the human system. Unthinkable complexity" (51). It was precisely the fact that the economy is an unthinkably complex simulation that encouraged the manipulation of monetary abstractions like "credit-default swaps" and "mortgage-backed securities" and very nearly crashed the whole system in 2008.

Beyond these commercial and institutional systems that millions of users accept because they value the benefits of online banking, shopping, and government, there is the more surprising fact that millions voluntarily participate in digital classification. They freely offer information about themselves on Facebook; rate services and products on Amazon, films on Rotten Tomatoes, and restaurants on Yelp; and in general put their parameterized lives online. Large portions of our population enter into datafication knowingly, and their knowing participation establishes the process as a cultural paradigm (Van Dijck 2014). The national and international indignation over the misuse of Facebook profiles and activity data during the 2016 election was certainly justified. The data, however, were either provided by the users or (usually) harvested in keeping with the terms of the user agreement, which users never bother to read. Even when the data collection was invisible, it was not really surreptitious.

As the response to the Facebook revelations suggests, our media culture is not uniformly consistent or enthusiastic about datification. Mayer-Schönberg and Cukier mention the movie *Moneyball* (2011) where "baseball scouts were upstaged by statisticians when gut instinct gave way to sophisticated analytics" (16). The movie (based on Michael Lewis's 2003

book of the same title) tells the story of the Oakland Athletics manager who built a winning team by using elaborate and (at the time) exotic statistics to acquire players who had been overlooked by other teams whose scouts relied on instinct and experience rather than OPS (On-base plus slugging) and WARP (Wins Above Replacement Players). Hollywood gave equal time to the other side in the datification debate in *Trouble with the Curve* (2012), which featured Clint Eastwood as an aged scout who rejects statistics and simply feels when a player is good (and is right in the crucial evaluation of a certain batter). That film reflected a tension in our media culture between traditional ways of understanding cultural complexity on one hand and datafication on the other.

This tension arises elsewhere, for example in the conflict between traditional political analysis and so-called data journalism. During and after the 2016 election, the media publicized and debated the value of polling data with more intensity than ever before. Listening to the podcasts and reading the articles by Nate Silver and his colleagues at the online site FiveThirty-Eight (www.fivethirtyeight.com) makes clear that these data journalists regard their methods of aggregating polls and their data models as new and appropriately scientific ways of understanding politics. They have little sympathy for the aging Clint Eastwoods even at prestigious papers such as the *New York Times*, who persist in believing that interviewing a few Trump supporters in Ohio can give them insight into this political phenomenon.

The literate elites who write and read the *New York Times* are not the only ones who are skeptical of datafication. Many, although by no means all, conservatives oppose the quantifying of society, and their revolt against quantification is precisely understood as a rejection of our contemporary knowledge culture. They see data as the enemy—climate data as well as the data generated by the social sciences. Congressional Republicans have repeatedly moved to restrict the federal government's gathering and publication of data, which they regard as ideologically tainted in support of liberal positions (e.g., Brady 2017). So, for example, Congress forbids the Center for Disease Control by law from gathering almost any data on gun violence (Kaplan 2018). Where the data journalists see their models as an empirically grounded form of research, these conservatives see an ideological intrusion that contradicts their lived experience. They prefer to trust their intuition or common sense that, for example, guns (in the right hands) reduce violence rather than encourage it. But enthusiasm for or the critique

of datafication does not divide neatly along political lines. The question is how are the data being used and by whom. On the one hand, conservatives usually want to restrict the government's collection of data, which they fear will be used for "social engineering." On the other hand, many conservatives support NSA surveillance in the name of national security (Savage and Peters 2014). They are also divided when it comes to private enterprise. Traditional Republicans may not object when businesses collect and sell data on their customers (Wheeler 2017), while some libertarians may join forces with liberals in defending an individual's right to the privacy against the data-collecting behemoths such as Facebook. As for direct political use of data, both major parties and all the presidential campaigns (especially since the Obama campaign of 2008) have kept databases of electronic profiles of potential supporters in order to target appeals for money and votes. The Trump campaign of 2016 was simply less scrupulous in how it collected the data and how it targeted voters, as their use of Facebook and the ensuing political scandal showed (Rosenberg, Confessore, and Cadwalladr 2018).

The Procedural and the Mechanical

Datafication is part of our contemporary reaction to the mechanization of our economy and society that dates back to the Industrial Revolution, and we cannot begin to catalogue here all the cultural responses to industrialization. Instead, we will focus on a few of the responses in the twentieth century, because they correlate with the rise of modernism and ultimately popular modernism. The cultural elites in the United States and Europe were often ambivalent, if not hostile, to mass production and consumption, and the avant-gardes of the twentieth century reacted violently to these same forces, but in contradictory ways. The Futurists embraced some aspects of industrialization—above all, technologies of power and war—while the Dadaists rejected the idea of technological progress. Popular culture, however, found that the new technologies afforded new forms of entertainment and social interaction: amateur photography, the phonograph, radio, and film. Beginning around 1890, for example, Kodak cameras, especially the Brownie introduced in 1900, initiated the tradition of family photography for American consumers, and the photo album become that period's equivalent of Instagram and Flickr today. And film became the mass popular entertainment of the first half of the twentieth century. If elites worried

Figure 7.1
Chaplin, starring in the film *Modern Times* (1936): The Tramp is devoured by the machine. Photo © Roy Export S.A.S.

that film was trivializing culture in comparison with the novel and the stage play, popular audiences had no such concerns.

In the 1920s and 1930s, both popular and avant-garde filmmakers addressed directly the theme of the human cost of mechanization. Chaplin's *Modern Times* (1936) is a famous example, and its most memorable scene is the one in which the Little Tramp becomes mesmerized by his repetitive work on the assembly line, falls onto the conveyor, and is devoured and then regurgitated by the giant gears of the machine (figure 7.1). In this case it was the popular filmmaker who revolted against the machine, while the avant-garde Fernand Léger in the abstract *Ballet Mécanique* (1924) seemed to be fascinated. Léger was gassed in the war and that experience caused him to fixate on the beauty and horror of the mechanical (Néret 1993, 66). The Bauhaus artist Oskar Schlemmer created his theater piece *Triadisches Ballet* (1922), in which human dancers dressed and performed like marionettes in twelve highly synchronized geometric pieces (Goldberg 2001, 111–113). Schlemmer too seemed intrigued, more than frightened, by the prospect of reducing his human dancers to movements that suggest the essence of the mechanical (figure 7.2). Finally, Fritz Lang's *Metropolis* (1927), somewhere

Figure 7.2
Oskar Schlemmer's *Triadic Ballet* (1922). Photographer: Ernst Schneider. Ullstein Bild
Dtl/Ullstein Bild/Getty Images.

between the popular and the avant-garde, sent a mixed message of fasci-
nation with and horror at a mechanized utopia, in which workers are fed
to the giant M-Machine. At the end of the film, the working and the elite
classes are reconciled, suggesting that technology can in fact accommo-
date human needs. The theme of the robot in film and theater from this
period (from Karel Čapek's original robots, to Chaplin's robotically mesmer-
ized Tramp, Schlemmer's mechanical dancers, and finally Lang's seductive
female robot, Maria) shows the range of reactions to this new age of the
machine in the 1920s. Chaplin's and Lang's films at least spoke to and for
a large popular audience.

Robots appear in science fiction films throughout the second half of the
twentieth century, posing but also subtly changing the same question: what
does it mean to be human in an age of mechanization? We need only think
of the most compelling robot from that whole period, HAL in *2001: A Space
Odyssey* (1968), whose body is reduced to an ominous and all-seeing eye, to
realize the extent to which the cultural understanding of the mechanical

had changed. Between Maria in 1927 and HAL in 1968, the fully electronic computer had been developed and provided a new metaphor for mechanization. The physical, often geometric representations of robotic movement were replaced by a fascination with artificial intelligence as a kind of mechanization of the mind. Gears were replaced by algorithms. The computer program is still a mechanism, but it is characterized by a flexibility that metal gears cannot achieve. When the astronaut enters the machine room in *2001* in order to switch HAL off, the depths of this machine are nothing like the one that swallows the Tramp in *Modern Times*. HAL consists of gleaming, symmetric rows of CPU and memory modules; what matters, what threatens the astronaut and kills all the rest of his crew, is the invisible, complex program that is racing around inside the physical circuits.

The computer is so different from the traditional industrial machine that a name has been coined to describe its operation: *procedurality* rather than mechanization. Media theorist Ian Bogost (2007) wrote that "Procedurality is the principal value of the computer, which creates meaning through the interaction of algorithms. ... This ability to execute a series of rules fundamentally separates computers from other media" (4). Bogost spoke of media rather than machines in general here, because the computer now delivers a new set of media forms for our culture.

Earlier media apparatuses like other mechanical devices could execute a series of rules, but a physical mechanism embodied these rules, making them difficult and time consuming to change. A photographic camera executed the rules for taking one picture after another by opening its shutter, allowing focused light to fall on the film, and then closing again. Although that series of rules was all that a simple box camera could execute, an expensive analogue camera from the twentieth century allowed for a large number of minor adjustments (to the aperture and the shutter speed, for example). Today's digital cameras are programmable, highly specialized computers themselves.

As computer specialists and popular writers have been pointing out since the 1950s, a fully programmable digital computer is capable of becoming infinitely many different "machines." If we looked at the development of calculating machines from Hollerith's punch-card tabulators around 1900 to the UNIVAC and other electronic computers of the 1950s, we would see stages in the transition from mechanism to procedure. Whereas the tabulators that made IBM a major company in the 1930s and 1940s were fully mechanical, by 1944, the IBM Automatic Sequence Controlled Calculator

or Mark 1 was an electromechanical system of switches and relays. By the late 1940s, computing machines had become fully electronic, representing numbers and performing operations through the use of (still rather unreliable) vacuum tubes (Moreau 1984).

Just as we can identify a series of machines that mark the development from mechanical calculators to the first electronic computers and then to the powerful computers of today, we could also identify steps in the increasing proceduralization of human beings in twentieth-century society. The process of perfecting mass bureaucracy gave us both the welfare state and its evil parodies, such as the meticulous National Socialist bookkeeping of the Holocaust and the bureaucracy of the Soviet gulag. This process involved assigning people to categories and applying increasingly sophisticated sets of rules to their social lives. The demands of the database and complexity of the rules eventually required computers for their management. The U.S. Social Security system, for example, computerized in the mid-1950s, converting its mountains of punched cards and microfilm into magnetic tape processed by computer (Cronin 1985). If proceduralization was an ongoing trend throughout the century, it is hard to imagine that it could have penetrated so deeply into the grain of contemporary society without digital technology.

In *The Shallows*, Nicholas Carr (2010), critic of digital culture, equated the digital project of Google today to the industrial project of Frederick Winslow Taylor in the heyday of mechanization: "By breaking down every job into a sequence of small, discrete steps and then testing different ways of performing each one, Taylor created a set of precise instructions—an 'algorithm,' we might say today—for how each worker should work. ... Taylor's system is still very much with us; it remains the ethic of industrial manufacturing. ... Google, says its chief executive, Eric Schmidt, is 'a company that's founded around the science of measurement,' and it is striving to 'systematize everything' it does. ... What Taylor did for the work of the hand, Google is doing for the work of the mind" (loc. 2550 of 4856, Kindle). But Carr ignored important differences between the mechanization of physical labor and contemporary procedurality. Procedurality is characterized by a new definition of "the machine" and by a changed relationship between the human and the mechanical. Programmability allows computers and digital devices to be reconfigured for a variety of tasks without changes in the hardware. Computers are physical embodiments of the information

processor that Alan Turing imagined in the 1930s: they are approximations of the *Turing machine*, which means that they become a different information processor with each new program loaded into memory. Today, each program not only reconfigures the machine, it also reconfigures its human users, offering them a new interface with new modes of interaction. In order to use any digital device, the user must become part of the procedure. This is as true of digital entertainments such as video games as it is of the programs used by engineers or scientists. Indeed, video games offer some of the most sophisticated and meticulously designed interfaces of all digital applications. Video games are defining examples of the procedurality of contemporary digital media.

Video Games: Procedures to Save the World

Video games are procedural: their look and feel and their game mechanics are the visible expression of specific sequences of programmed instructions (redraw the graphics, play sounds, tally points, and so on). This is as true of MMORPGs such as *World of Warcraft* as it is of the augmented-reality scavenger game *Pokemon Go*. Apparently far removed from the Tolkien fantasies of *World of Warcraft* are puzzle games such as *Bejeweled* and its derivative *Candy Crush Saga*. But these too are procedural: the sets of programmed rules are visualized as falling blocks or candies that the player manipulates. The player of *Candy Crush Saga* works against a move counter to get the candies in the right places, like Chaplin's Tramp at the assembly line in *Modern Times*, except that in the case of *Candy Crush Saga* the activity is experienced as play rather than alienating labor.

In all these games, said to be *interactive* or *participatory*, the interaction or participation necessarily happens on the computer's procedural terms. In games where players assume roles or take control of active figures, such as *World of Warcraft*, their ability to act and the results of their actions are represented by a set of parameters. Discrete values indicate what kind of character you are playing (mage, warrior, priest, and so on) and how powerful, healthy, or skilled you are. If you use certain abilities, your attack values rise. If in the course of combat, your health points dwindle to 0, you die. Even in many puzzle games, the player plays against the clock, trying to amass points before time runs out. Parameterization is the video game

version of the datafication and classification that, as enthusiasts and critics both agree, have become a general feature of our digital world.

A second element, the *event loop*, is basic to the procedural architecture not only of video games, but of interactive applications in general. The system loops through a series of actions, repeatedly checking to see whether the user has "generated an event"—that is, clicked the mouse, pressed a key, typed a phrase, or moved the joystick. If the user clicks the mouse over a particular object on the screen, the system might highlight that object. If the user types a word on the keyboard, the system might place those letters into a text box on the screen. Applications built around such event loops are interactive in the sense that they invite or require the human user to intervene or interact. As we noted in chapter 5, games are flow experiences, because they promote a flowing or even addictive relationship between the player and the action. The key to evoking flow is to insert the player so seamlessly into the event loop that she feels herself to be part of the procedure itself and, as a result, wants the loop to continue indefinitely.

Although not everyone plays video games, video games do educate large segments of our digital media culture to this new paradigm of parameterization and event loops. As early as 2006, popular media writer Steven Johnson (2006) argued: "It's not what you're thinking about when you're playing a game, it's the way you're thinking that matters.... Games force you to decide, to choose, to prioritize" (40–41). The procedurality of video games is what stimulates the decision-making. Procedures set up situations that require the player's decisions, and the decisions themselves are expressed as inputs that are processed in loops. Video games do have a specific educational function: they train us to take part in the procedural structures of contemporary computer systems.

Participation in today's digital economy is more intricate, but not essentially different from the demands of twentieth-century economic and bureaucratic life. But our relationship to technology is now subtler and more intimate than in the age of mass industrialization. Along with our economic activities, social life is becoming increasingly proceduralized, and many users of all ages seem now to enjoy the proceduralization of entertainment and forms of social communication. Apple's iTunes is a paradigm of proceduralized entertainment, an application whose hundreds of millions of users purchase and organize songs, movies, and television shows in increasingly

elaborate ways (Dediu 2016). iTunes invites us to parameterize and program our playlists or use the Genius feature to create them automatically. Millions of users share their lists and preferences on Facebook and other social networking sites, so that entertainment and social communication flow easily into one another. The point of iTunes, YouTube, Spotify, Facebook, Twitter, and numerous other such procedural systems is to keep us flowing along: moving from listening to watching, sharing, and adjusting our parameters.

The purpose of interaction design for these systems is to conduct the user subtly and effortlessly into and through the event loops. Steve Jobs and his design team at Apple were noted for artifacts that present the procedural as "magic"—an aesthetic in which the underlying code remained invisible beneath a seamless user interface. During Jobs's tenure (during both periods in fact, but particularly the second one from 1997 until his death in 2011), Apple practiced a kind of popular modernist design in which form followed function and yet managed to make the function seem playful and surprising. Apple's iPhones and iPads would in fact only appear magical to a highly technologically literate audience that already regarded procedurality as natural. Good digital design today encourages users to proceduralize their behavior in order to enter into the interactions, and a large portion of those in the developed countries have now accepted this as the path to participation in digital media culture.

Game designer and author Jane McGonigal (2011) published a book entitled *Reality Is Broken*, in which she argued earnestly that playing collaborative video games could "change the world": "Very big games represent the future of collaboration. They are, quite simply, the best hope we have for solving the most complex problems of our time. They are giving more people than ever before in human history the opportunity to do work that really matters, and to participate directly in changing the whole world" (loc. 5662 of 7154, Kindle). The conviction that video games can change the world makes McGonigal, quite obviously, a popular modernist. Video games are for her and her community what avant-garde art was to the modernists of the twentieth century: they are salvational. McGonigal's community generally believes that video games are a new form of art. For the Dadaists, art could be integrated into life; for the games community, video games today can be integrated into and change lives. Millions of people play video games on a daily basis, after all, while the avant-garde was always the tiniest fraction of the whole population.

How can video games help us "solv[e] the most complex problems of our time"? McGonigal points specifically to ARGs of the kind she had a hand in pioneering. Alternate reality games first appeared around 2000, and early examples, such as *The Beast* and *I Love Bees*, were elaborate multimedia conspiracy games, designed to promote upcoming movies and video games, in this case the film *A.I. Artificial Intelligence* (2001) and the game *Halo 2*, respectively. The public was invited surreptitiously into the ARGs through clues scattered in websites or movie trailers. The players' actions were relatively restricted: they could not create new material, but they were encouraged to comb the web as well as physical locations to find clues and solve puzzles. The players worked in groups, and their performance consisted of the collective reading of a story written both online and in the physical world. McGonigal's later games (including *World Without Oil* and *Superstruct*) expanded the field of performance for their players. In *World Without Oil* (2007), there was no mystery to uncover, but rather an evolving economic and social scenario to respond to. In the game's scenario, an oil shortage was causing drastic and repeated price shocks, and the players were to respond by describing in blogs and videos the impact on their community. Some players chose to perform their responses in the world—by bicycling to work or adjusting other activities as if gasoline was actually in short supply. McGonigal offers such ARGs as examples of a new style of activism that can effect social change, in which the procedurality of video games can facilitate a "collective intelligence." The notion of collective intelligence was originally advanced by the French media philosopher Pierre Lévy (1997). In McGonigal's vision these large collective games can simulate world problems. Players solve such problems in the games and these solutions apply to the real world, making it possible to repair the reality that is broken. As she claims in her TED talk, the success of her project depends on the willingness of hundreds of millions of people to spend billions of hours playing various forms of collaborative video games. Hers is a vision in which procedurality triumphs as a cultural practice.

The case of collaborative video games as a new form of the popular modernist's life-as-art is also made, ironically, in Christopher Nolan's film *The Dark Knight* (2009). Nolan makes Batman's nemesis, the Joker, into a perverse avant-garde artist. His popular modernist art form is the ARG. Not only does he make his lethal practical jokes into a perverse ARG for Batman and the police; a real promotional ARG entitled "Why So Serious?" preceded the

release of the film by fourteen months. The game's seed was an email sent to thousands of potential players, inviting them to visit a website, which in turn led them to a bakery and a cake containing a cell phone. Following a series of clues brought persistent players in several cities to secret screenings of the film's first few minutes. The screenings suggested that, through their actions in solving the puzzles, the ARG players had become accomplices to the Joker's crime (Rose 2011). By staging this ARG, which was in the end an elaborate mechanism for drawing a select audience to a preview, Nolan and his collaborators made *The Dark Knight* into a transmedia project. The film itself emphasizes our culture's fascination with, and at the same time its ambivalence toward, the procedural.

History and Simulation

Sid Meier's Civilization (1991), based on an earlier board game, was a strategy game in which the player builds a crazy-quilt civilization beginning with a simple agricultural or pre-agricultural stage and continuing to the present (Edwards 2007). The game was remarkably successful and initiated a whole series up to *Civilization VI* at the present, as well as expansions and spinoffs (Wikipedia contributors, "*Civilization* series"). By one estimate (Nunnely 2016) there are thirty-three million owned copies of the series. Each new installment in the franchise of course had improved graphics and gameplay, but the premise remained the same throughout. You play a game of proceduralized empire building. You can choose to lead a civilization with one of a variety of familiar names (such as the Russian, British, Aztec, Zulu, and Mongolian civilizations), build cities, invest in various technologies, expand into new districts, and fight wars with other nascent civilizations, as time marches on from 4000 BC to the near future (figure 7.3). You win by taking over the world, absorbing all the other civilizations, or "on points" by surpassing other civilizations in science and culture. There are vague nods to the historical details of technology and social development. In the preindustrial period, your civilization has appropriate tools and its citizens fight with spears and horses. In the modern era, you can research weapons like tanks and missile cruisers. But in other ways, the depiction is a (popular postmodern) patchwork of historical elements. If you are the Chinese civilization, you may choose to build the Eiffel Tower in Beijing, which could be located on the Isthmus of Panama.

Figure 7.3
Sid Meier, *Civilization IV*: history as simulation. Take2 Interactive.

The *Civilization* series is an early and ongoing contribution to a vast genre of strategy and simulation games, many of which aim for more historical accuracy. A similar, influential series are the *SimCity* games, in which the player founds and develops a city by deciding on the placement of various buildings and services for the citizens. Developed around the same time as the first *Civilization* game, *SimCity* demonstrated how a video game could "gamify" urban planning. Other city or civilization building games from the 1990s and 2000s include the *Anno* series, *Outpost*, and *Cities XL*. And there are related genres, such as social simulation and construction and management simulation (Wikipedia contributors, "List of Simulation Games"). Some of these may give the player some smattering of historical facts. *SimCity* may, for example, teach the player the rudiments of urban planning, but that is not the point of such games. The point is to inscribe the player into a challenging procedural loop. We remember Steven Johnson's (2006) observation that in playing a video game "it's the way you're thinking that matters" (40–41). Simulation games invite their players into a mode of procedural thinking.

In chapter 2 we quoted the games scholar Espen Aarseth (2004): "The computer game is the art of simulation. A subgenre of simulation, in other words. Strategy games are sometimes misleadingly called 'simulation' games,

but all computer games are simulations" (52). It is clear that the digital gaming community considers simulation a defining quality. For physicists, meteorologists, and economists, a simulation is a mathematical model of some phenomenon in the physical or social world, a model expressed as an algorithm and embodied in a computer program. By running the program, usually over a series of time cycles, a researcher can determine how well a model describes or predicts the state of the world. But video games are seldom faithful models of anything in the physical or social world. They are fictional, playful versions of things as they might be. Even *SimCity* teaches the player little beyond the crucial idea itself that cities can be planned according to procedures. And the famous *Grand Theft Auto* (GTA) series, whose titles play out in thinly distinguished versions of Miami, New York, and other American cities, does not aim to teach the player anything but instead revels in the vast dimensions and therefore the playability of the so-called "open world."

Video games take over the scientific notion of simulation and remove the necessary connection to embodying a theory about the world. They are not simulations so much as what the postmodern philosopher Jean Baudrillard called "simulacra"—imitations that have no original, have lost their connection to the original, or (like the fictions of novels and films) are their own originals (Baudrillard 1994). The pleasures they generate are the ones described by Janet Murray (1997) in *Hamlet on the Holodeck*: the pleasure of the Holodeck is precisely that it is a hermetically sealed universe that does not have to correspond to the world outside.

Film and novels are also detached from our world: they can reflect elements of the world or ignore them at will. But, as game scholars are fond of pointing out, video games are not novels or films. One of the key differences is replayability. Films and novels must come to an end. Books can only have so many pages. Films, at least when they were printed on celluloid, could only play for so many minutes, and even in the age of digital projection, no commercially successful film lasts more than a few hours. In all but the resolutely avant-garde novels and films, the story itself follows the form in having a beginning and a resolution. Video games usually have an end as well, in the sense that the player wins or loses and has to start over. And that is the point: in all but a few avant-garde video games, the player is able to start over. Murray (2004) has called replay "one of the most pleasurable and characteristic structures of computer-based gaming

in particular, which is usually accomplished by saving the game state at regular intervals" (6).

In this one important sense, video games are indeed like scientific simulations. Simulations can be rerun, and rerunning them with different inputs produces a new experience and potentially a new outcome. A model of climate change can be run with various numerical assumptions about our society's use of fossil fuels in order to chart the possible rise or fall of carbon dioxide levels. In the reality of the next hundred years, of course, our society will only be able to make one set of choices. The world will get only one run and we must live with the results. All simulations are playful in this sense, and, in video games, playfulness is the essence.

This is a defining difference between playing a video game (or running a scientific simulation) and reading (or living) history, at least in our traditional understanding of history. In *The 18th Brumaire of Louis Bonaparte*, Marx ([1852] 2008) noted famously that great historical events occur twice: once as tragedy (Napoleon) and then as farce (his nephew). But the very fact that the first event was a tragedy and the second a farce shows that history was in fact *not* repeating itself. Some ancient cultures had cyclical views of history, but Western views, certainly since the eighteenth century, have assumed that the political and social worlds develop and change in one direction. Even today, and even if many no longer believe that the world is getting better, we know that political and social events proceed in one direction and cannot be called back. But video games, even when they are about history, give the players a very different sense. Murray (2004) notes: "A replay story world allows the interactor [player] to experience all the possibilities of a moment, without privileging any one of them as the single choice" (7). The *Civilization* games ostensibly enforce a rigorous and obvious kind of progressive history. Your civilization progresses, grows, and triumphs or withers in the course of time. When the game ends (generally in 2050 or 2100 AD), you win if you have bested the other civilizations. This is a story that you can review at the end of the game, as you step through a synopsis of your wars with other civilizations. But *Civilization* also allows you to do something that never happens in geopolitics. You can replay the game as the same civilization or a different one; you can make other choices and experience a different outcome.

The political vision suggested by video game simulations is fundamentally playful; political strategy becomes a matter of adjusting parameters

and trying again. Video games ask the same question as Christopher Nolan's Joker: "Why so serious?" But history has been viewed as serious and irrevocable since the eighteenth century. In the United States, relatively few people have a deep interest in or knowledge of history. It sometimes seems as if the only two historical moments of reference in American political culture are the Munich Conference of 1938 and 9/11. Surveys of historical and cultural knowledge confirm American ignorance of history (Shenkman 2009, 20). Yet there seems to remain a broad, if shallow, belief in a progressive view of history when it comes to the country itself: that the United States can or should progress continuously through the decades and centuries; that the country's destiny is to become ever greater, and if it is not getting better, it must be the fault of our political, economic, or social leaders. Video game players progress, sometimes in straight lines to victory, sometimes in loops. But they can always start over. They can halt or reverse the arrow of time, as in the game *Life Is Strange*. In this sense any moment in their own history of the game can become present again. Video game players live in a perpetual present whose future can be reimagined. This presentness is what McGonigal depends on for her enthusiastic and naive belief that the collective intelligence of an eclectic community of gamers can address world hunger, global climate change, or a host of other challenges that are as much political problems as technical ones. She is offering an alternative paradigm to historicism—an alternative that seems increasingly plausible to communities that embrace digital procedurality.

The claim that Americans have lost of a sense of history is of course nothing new, and the growing cultural importance of video games and digital media is not the cause of Americans' diminished interest in or knowledge of politics and history. In *The Culture of Narcissism*, Christopher Lasch (1978) lamented that "Americans seem to wish to forget not only the sixties ... but their entire collective past. ... We are fast losing the sense of historical continuity, the sense of belonging to a succession [of] generations originating in the past and stretching into the future" (4). Lasch, along with many others, was describing a breakdown in the hierarchy of knowledge and political order that occurred during the 1960s. For him, this breakdown evidenced a decline in American culture that led to a litany of the now-standard conservative complaints about contemporary culture: the rejection of different roles for men and women, the decline of the traditional American family, the absence of any values higher than one's own pleasure, and so on. We do

not have to agree with Lasch's critique of contemporary culture, but we can acknowledge that he was witnessing in the 1970s a waning historical consciousness. With the rise of video games in the 1990s and 2000, we have an alternate paradigm that can compete with the "sense of history" that Lasch refers to. The paradigm of simulation, exemplified by the video game, now exists alongside the historical sensibility in our media culture. The celebrity inventor Elon Musk has (apparently seriously) suggested that our world is itself a computer game of an advanced civilization (Klein 2016). If so, our history would just be a much more elaborate version of *Civilization*.

Strong and Weak Narratives

This is not to say that games cannot be political or ideological. Ian Bogost (2006) has also written that "all simulations are subjective representations that communicate ideology" (180). Video games in particular can embody what he has called "procedural rhetoric" as a new way of making arguments through processes themselves (Bogost 2007, chap. 1). What does this look like? In 2003 game designer Gonzalo Frasca created a video game entitled *September 12* (figure 7.4). It was a simple Flash game, which depicts a small, stereotypical town in the Middle East. The inhabitants walk mechanically up and down among buildings on the gridded streets, and among them are a few terrorist figures with white headdresses and rifles. As the player, you direct missile strikes on the terrorists. The problem is that your missiles kill civilians as well, and these deaths anger other civilians and turn them into terrorists. You can never eliminate the terrorists because the collateral damage always ends up generating more than you kill. The starting screen message makes it clear that the game is overtly political: "This is a simple model you can use to explore some aspects of the war on terror." In fact *September 12* explores only one aspect of the war on terror: the futility of a traditional approach to so-called asymmetrical war. It makes this point procedurally, by having you as the player enact the futile attempt to eliminate violence through violence.

This is procedural rhetoric, and it is practiced in a growing number of political games, such as the ones that Bogost (2007, chap. 2) describes: *A Force More Powerful, Antiwargame, New York Defender, Kabul Kaboom, Darfur Is Dying, Madrid,* and others. And geopolitics is not the only sphere for procedural rhetoric: there are games to persuade the player to live sustainably,

Figure 7.4
Gonzalo Frasca and Sofia Battegazzore, *September 12*, a video game with a political message. Reprinted by permission.

eat healthier foods, exercise more often, or monitor her medical conditions. Although the overwhelming majority of games have no rhetorical purpose, some do. The diversity and popularity of video games have produced whole genres and communities devoted to "serious games," whose procedural rhetoric aims for political, social, or personal improvement. Games for Change (www.gamesforchange.org) is an organization that promotes such games. If you can think of some perceived social issue, personal problem, or even historical controversy, there is a good chance that a video game (or five) has been created to address it. The Iranian Revolution? There is *1979 Revolution: Black Friday*. Famine in war-ravaged areas of the world? Play the Facebook game entitled *Food Force* from the United Nations World Food Programme. Dyscalculia (difficulty in learning basic mathematics)? The online game *Meister Cody* can teach you (www.meistercody.com/en/talasia). The Israeli-Palestinian conflict? Numerous video games deal with this politically volatile subject. *Global Conflict Palestine* attempts to acquaint players

with the complexity of the issues. *PeaceMaker: Israeli Palestine Conflict* gives the player a chance to effect a mutually agreeable settlement of the conflict. *The Liberation of Palestine*, in contrast, is completely and violently partisan. Such partisan games seek to evoke strong responses in their players; theirs is the rhetoric of a swift punch, not an elaborately reasoned argument.

That video games can sometimes provoke strong emotional responses does not mean that they do so in the Hollywood style. The game scholar Espen Aarseth (2004) has written: "Simulation is the hermeneutic Other of narrative, the alternative mode of discourse, bottom up and emergent where stories are top-down and preplanned. In simulations, knowledge and experience [are] created by the player's actions and strategies, rather than recreated by a writer or moviemaker" (52). Video games are different from films and novels. Many have no story to tell: puzzle games are not stories about anything, and even games of skill that feature human or animal figures usually are not narrative. Is there really a story to platform games such as the *Super Mario* series? Other first-person shooter or action adventure games do have storylines or back stories, but these are often told in cinematic "cut scenes," while the bulk of the interactive game involves killing enemies. Some games (*Gone Home*, *What Remains of Edith Finch*, and others discussed in chapter 4) embody narratives of the kind that we expect in Hollywood films or for that matter European or Indian films. But games more often aim for flow experiences that can go on for as long as possible. Conventional novels and films move instead to a defined and cathartic ending.

We can put this another way. Conventional novels and films are *strong narratives*—stories of conflict that move confidently towards a resolution. *Weak narratives* lack the qualities of traditional Hollywood films or popular novels. The conflict may be clear, but it is not clear where it leads except to repetition. Weak narratives have been associated with postmodern fiction, which is to say fiction that speaks to a sophisticated and relatively small community of authors and readers who used to be understood as our culture's literary elite (McHale 2001). When they have narrative at all, then, video games are usually weak narratives, as are other forms of expressive digital media (Engberg 2011). The very form of the video game (its procedurality, interactivity, and replayability) offers the player other pleasures than the experience of watching a film.

There are cultural and even political implications to the growing importance of weak narrative in our media culture. Political thinking of the

nineteenth and twentieth centuries was characterized by strong narratives: Marxism, fascism, American liberalism. These political ideologies all had simple, coherent stories to tell in which history moves forward to the triumph of a particular class or people—stories that are marked by a sense of historical inevitability. It is possible to simulate the workers revolution, perhaps, but it would not make a very good game. There are video games that are strongly partisan if not ideological (e.g., *The Liberation of Palestine*), but there is a sense in which this is working against the form. Game cultures today may be strongly ideological: for example, the Gamergate controversy unmasked (as if it needed unmasking) the strong sexism of gamer culture (Parkin 2014). But the ideological positions they represent are seldom coherent, not like the great political narratives of the past two centuries. (In the case of Gamergate, the vulgar attacks on female game makers and critics did not rise as narrative even to the level of the conspiracy theories of neo-Nazis. There was no historical vision there, not even a perverted one.) For video game cultures, simulation replaces history, and the individual's sense of being caught up in history is replaced by a feeling of a simulated present and future in which everything is possible.

The Procedural Divide

One of the great fault lines in the vast space of our media culture today, then, is summed up in the keywords: datafication, procedurality, and simulation. On one side of the divide are those communities that are still committed to a view of the individual human as part of a historical process—communities that connect themselves to the past through coherent narratives. These communities will likely prefer media such as print fiction and traditional film that support the telling of those stories, even if they choose to read their fiction in the form of ebooks or watch their films on tablets. They will prefer political parties that align themselves with traditional strong narratives such as liberal democracy, socialism, extreme nationalism, and perhaps even fascism.

On the other side will be those communities that favor procedural interfaces for social interaction and procedural media for entertainment—video games instead of movies or movies that reflect and draw on the procedurality of video games. For these communities, as we have said, simulation replaces history, and in the extreme form they live in an infinitely repayable

present. They prefer the weak narratives of contemporary political movements (such as libertarianism), which deemphasize or ignore history altogether. To believe with McGonigal that video games as simulations can solve major societal problems is to believe that the historical and therefore traditionally political dimension of these problems can simply be left out of the procedural equation. We will discuss in the next chapter some political implications of this new world view.

8 Social Media and the Politics of Flow

If we ask where digital technologies have offered the greatest opportunity for participation, the answer is: Facebook, WhatsApp, Tumblr, Instagram, Snapchat, Twitter, and the other social media platforms that now give literally billions of people the opportunity to express themselves and to communicate with friends, coworkers, and the public online. Social media are the most visible manifestation of plenitude in our media culture today. The level of participation guarantees a high degree of diversity. Communities small, large, and enormous have formed in and through the channels offered by social networking, image sharing, and microblogging sites. You can argue whether these sites promote democracy in any positive sense, but it is clear that they work against elitism in the dissemination of ideas. Just a couple of decades ago, economic and cultural elites controlled publication and broadcasting venues in all their forms (print, television, film), and they are still guarding these traditional venues as best they can. But social media applications have enabled virtually everyone in the developed countries to circumvent traditional media and publish thoughts, images, even videos.

What do they publish? Anything and everything in the collective imagination of billions of individuals: political views, reviews of movies, television and video games, lolcat memes, pornography, DIY videos on every possible topic from how to cook a steak to how to use the latest version of every software upgrade on the market, and on and on. But most people simply publish themselves: tweets about what they are doing at the moment, things that happen to them, images and videos of what they see around them—bits of their lives. The fact that social media are identity media has infuriated conservative critics. In *The Cult of the Amateur*, the first

in a series of critical monographs, Andrew Keen (2007) wrote: "What the Web 2.0 revolution is really delivering is superficial analysis, shrill opinion rather than considered judgement. The information business is being transformed by the Internet into the sheer noise of a hundred million bloggers all simultaneously talking about themselves" (16). Keen did not use the term "amateur" in any positive sense. For him the lack of professional barriers to publication was a cultural disaster. For Jaron Lanier, ironically a technologist who helped to develop virtual reality in the 1980s and 1990s, social media and remix have been both a cultural and personal human disaster. Lanier (2010) was relatively happy with the digital revolution of the 1990s, sometimes called in hindsight *Web 1.0*, when websites were still relatively hard to develop so that the technology itself created barriers to mass participation. However: "Something started to go wrong with the digital revolution around the turn of the twenty-first century.... Anonymous blog comments, vapid video pranks, and lightweight mashups may seem trivial and harmless, but as a whole, this widespread practice of fragmentary, impersonal communication has demeaned interpersonal interaction.... A new generation has come of age with a reduced expectation of what a person can be, and of who each person might become" (3).What started to go wrong was the advent of social networking sites (first Friendster, then MySpace, then Facebook), easy to use blogging software, and microblogging sites like Twitter.

But what Keen (2007), Bauerlein (2008), Lanier (2010), Carr (2010), Turkle (2011), Timberg (2015), Foer (2017), and many others regard as a social or cultural disaster, digital enthusiasts have interpreted as liberation for all those who never had the opportunity to broadcast or publish themselves. *The Digital Divide* (Bauerlein 2011) offers articles from authors on both sides. For better or worse, social media give their millions of users new techniques and opportunities for defining and projecting their identity, and these opportunities add to the ones that have been available to the middle class and, to some extent, even the working classes since the rise of consumer society: choice of clothing, home decoration, entertainment, and so on. In the affluent 1950s and 1960s, everyone with disposable income was able to make choices about what music to listen to or how to cut their hair, and this concept of personal style became increasingly important when hierarchical definitions of appropriate dress, entertainment, and more, were breaking down (Judt 2005, 395). But only a tiny elite (authors, filmmakers, performers) could extend this

process of self-definition to what they published or broadcast during that time. Today social media makes everyone who chooses to participate into an author or celebrity who must style their persona.

Flow and the Not So New Narcissism

> We are now—in the Me Decade—seeing the upward roll (and not yet the crest, by any means) of the third great religious wave in American history, one that historians will very likely term the Third Great Awakening.... Where the Third Great Awakening will lead—who can presume to say? One only knows that the great religious waves have a momentum all their own. And this one has the mightiest, holiest roll of all, the beat that goes ... Me ... Me ... Me ... Me ...
> —Tom Wolfe (1976, 25, 28)

For conservative social critics, ours is the age of "the New Narcissism." According to Arthur C. Brooks, the head of the American Enterprise Institute, psychologists are telling us that "narcissism has increased as quickly as obesity has since the 1980s" (Brooks 2016). And critics are likely to regard Facebook and YouTube as the cause of this epidemic. "Is Social Media to Blame for the Rise in Narcissism?" asks a writer in *Psychology Today* (Firestone 2012). But the new narcissism is not that new: concern over the rise of narcissistic self-absorption dates back to a time before social media or even the personal computer. Writing in the 1976, Tom Wolfe had already labelled the 1970s the "Me Decade," and ever since, young people in America (or all Americans) have been characterized as far more concerned about their individual well-being rather than any collective good. For Wolfe the 1970s saw the rise of a quasi-religious commitment to self: this was an era of New Age spirituality, health fads, LSD and meditation (left over from the 1960s). The point was not money itself, although material prosperity provided the leisure time and the resources for the new spirituality (and the drugs). It was rather the "Third Great Awakening" in American history. In *The Culture of Narcissism*, Christopher Lasch (1978) agreed with Wolfe regarding the rise in narcissism but would not grant this phenomenon a religious foundation: "the contemporary climate is therapeutic, not religious" (6). And as we noted in chapter 7, Lasch complained about the waning of a sense of history that accompanied this turning inward, a turning from "politics to self-examination."

When Lasch and Wolfe were writing, the baby boomers were in their twenties and thirties. By the 1990s and 2000s, critics did not even see a veneer of spirituality in Generation X and millennials; the complaint became that these young people were not even interested in self-fulfillment, but simply in amassing wealth. This was the era of investment banking, when young traders made and lost staggering fortunes overnight (Lewis 2010). On the one hand, in the wake of the Great Recession and the Trump election, some might argue that the millennials and Generation Z are again becoming less narcissistic and more politically engaged, as the opportunities for wealth in banking and corporate law, and for economic mobility in general, diminish. Some joined the Occupy Wall Street movement in 2011; more "felt the Bern" (the Bernie Sanders presidential campaign) in 2016; far more have protested the Trump presidency. On the other hand, the rise of identity politics during recent decades could be a kind of collective narcissism, in which each group is encouraged to interpret the political and social universe as a reflection of its own identity.

Lasch was describing the social consequences of the breakdown of traditional hierarchies that we also discussed in chapter 7, and he could understand the change only as decline. It was also in the 1970s that Csikszentmihalyi defined "flow" as "a state in which people are so involved in an activity that nothing else seems to matter." They pursue the activity "for the sheer sake of doing it" (Csikszentmihalyi 1991, 4). Csikszentmihalyi's flow is a secularized version of the ecstatic spirituality pursued by Wolfe's Me generation. And what Csikszentmihalyi regarded as a valuable facet of human experience, Lasch would certainly have seen as further evidence of narcissistic self-absorption. The experience that Csikszentmihalyi identified was not new to the 1970s per se. But by suggesting that flow helps to make life fulfilling, Csikszentmihalyi was promoting this form of experience at precisely the time when cultural critics like Lasch were lashing out. Csikszentmihalyi thought of flow as a kind of therapy, as self-regeneration, exactly what Lasch condemned in the new spirituality. Flow was a therapy for the individual who found herself in a society without universally agreed values: each individual had to find her own path toward fulfillment.

As we discussed in chapter 5, the advent of computer games and later social media have also helped to make flow into a media aesthetic that rivals the traditional catharsis of film and dramatic television. Flow and catharsis constitute a spectrum in today's media culture. Genres of television shows and films, music, novels, video games, board games, social media, and

a dozen other entertainment and communication forms can be placed at various points on that spectrum—some delivering experiences that are pure flow or pure catharsis, many others delivering a combination of the two. We have also noted that in the case of film, television series, plays, and novels, it is a coherent story that delivers cathartic experience—an experience in which the reader or viewer comes to identify with a main character as the story unfolds. Strong narrative is associated with catharsis, just as weak narrative is associated with media that flow.

These two interrelated dichotomies—catharsis/flow and strong/weak narrative—mark significant fault lines in our current media culture. They extend beyond what we think of as entertainment into the realms of social and political engagement. They help us chart current attitudes, particularly among gamers and users of social media (in other words, hundreds of millions), toward individual identity and collective action. Once again, these are endpoints along a spectrum. Some media and some social practices vacillate between weaker and strong narratives. Weak narratives are not in any absolute sense worse than strong ones, but they do shape a different kind of identity and a different kind of politics.

The Performance of Identity

The social media researcher dana boyd believes that the conventional wisdom is wrong: constant texting and image sharing on their smartphones do not isolate teenagers from personal relationships. In her book *It's Complicated*, boyd (2014) told the story of attending a football game in 2010 at the high school she had attended in the 1990s. In 2010, of course, almost every student had a smartphone, as did the parents who were also attending the game. But the two groups were using their phones differently:

> The teens were not directing most of their attention to their devices. When they did look at their phones, they were often sharing the screen with the person sitting next to them, reading or viewing something together.
>
> The parents in the stands were paying much more attention to their devices. ... Many adults were staring into their devices intently, barely looking up when a touchdown was scored. And unlike the teens, they weren't sharing their devices with others or taking photos of the event. (boyd 2014, loc. 118 of 5300, Kindle)

The stereotype is that social media isolate young people, keeping them from face-to-face contact. The reality is more complex. Boyd argued that

teenagers integrate texting and social networking into their social lives; their cell phones and computers become ways to extend their social life into times and places when they cannot be with their friends. Sherry Turkle (2011) in *Alone Together* took a darker view. She suggested that these digital media are responsible for "new state(s) of the self," in which our networked selves compete with our traditional roles in our social world. She wrote: "The narrative of *Alone Together* describes an arc: we expect more from technology and less from each other.... Overwhelmed, we have been drawn to connections that seem low risk and always at hand: Facebook friends, avatars, IRC chat partners" (295).

But it is not clear that the risks of social networking sites such as Facebook are all that low. Each Facebook page is a constantly accessible channel in which regular users call attention to themselves by writing posts, posting images, looking for responses in the form of likes, and commenting on friends' posts. To participate in Facebook is to present a face to your networked audience, an identity defined both by your profile and by the sum of the posts and comments you make. Even setting aside the very rare cases of teenagers who commit suicide because of harassment on Facebook, each user faces stress and potential humiliation from posts and cross-posts. But such risks do not deter hundreds of millions of users from offering themselves up online.

People have often critiqued the use of the word "friend" to describe their Facebook connections. But Facebook does not adulterate the word so much as redefine it to fit its vast media community. According to boyd (2014), users of social networking sites such as Facebook, especially teenagers, do in fact mostly connect with their friends or acquaintances in the physical world. There are other genres of networking sites for other kinds of digital/physical sharing or liaisons (e.g., Snapchat for ephemeral messages; Reddit for information; Instagram and Pinterest for images; Tinder, Grindr, Spoonr for intimate contacts). On Facebook, friendship means more than anything else a willingness to listen (and to like): it is a site where you tell your story to your friends and listen to theirs in return. And the story that you tell is an accumulation of fragments that trickle into your friends' newsfeed over days, weeks, years.

If you look at a Facebook page, what is immediately striking is how busy and confusing it is—how hard for a newcomer read. (And there are still newcomers, about fifty-four million in the last quarter of 2017, for example, according to Statista 2018b.) Steve Jobs would never have approved: this is

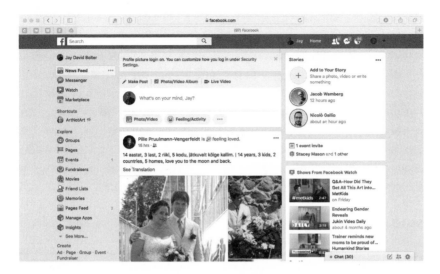

Figure 8.1
The confused and illegible design of a typical Facebook page.

certainly not a page of popular modernist graphic design (figure 8.1). The screen is so full of links and buttons that it seems hard to click anywhere without launching a new page. The newsfeed (posts from yourself and friends) runs in the column down the center, itself bristling with links and images. Columns on the left and right offer long lists of links to favorites, pages, groups, apps, games, friends, and of course ads. The page is a portal into the digital plenitude, and you connect yourself through your own posts and photos. The identity you construct for your Facebook audience is built out of nuggets intersecting with and linked to your friends. You become a series of texts, images, and videos for your friends and, if you choose, the public to see. This is identity as remix: to the samples that you find on the Internet and those contributed by your friends, you add some of your own. Who you are at any moment depends on the flow of these small and often unrelated elements, some of which may be intended for different communities that you belong to. Boyd (2014) discusses how difficult it can be to keep your story straight with one audience (your friends) when another may be reading (your parents). She also tells about a youth from South Central Los Angeles who applied in 2005 to an Ivy League university with an excellent application essay depicting, it seemed, exactly the kind of identity that the university was looking for. But when the admissions officer looked

up the youth's MySpace page, he found it filled with gang symbolism. For the purposes of helping the boy get into college, boyd pointed out to the officer that the two identities served different audiences. The boy designed his MySpace page, she argued, to facilitate his survival in his local environment (boyd 2014, loc. 523 of 5300, Kindle); it was not who he really was. But the point of her story could also be that he was not "really" either the person in the essay or the one on the MySpace page. While the written essay allowed him to construct a coherent story of identity, the social media page constructed a fluid identity that adapted to the moment, the circumstances, or indeed multiple identities for multiple audiences.

Social Media and Weak Stories

When I visited my own home page one day in August 2016, I happened to have in the advertising column a link to a site offering a master class by Aaron Sorkin on screenwriting. Sorkin, of course, is the master of cathartic storytelling on film and television. We are now well aware that Facebook builds profiles of each of its users in order to target advertising, but I am not sure how Facebook's algorithms could know that I was writing a book about catharsis. The skills Sorkin's course offers are not useful on Facebook itself. However, Hollywood filmmakers are interested in Facebook as a subject. Sorkin himself wrote *The Social Network* (2010) about Facebook's inventor, Mark Zuckerberg, and the film was an excellent example of contemporary Hollywood narrative style. Sorkin explains the rise of social media in Hollywood terms—not by focusing on the technology or the new interactions it mediates, but by focusing instead on Zuckerberg's complicated and flawed humanity. Sorkin's Zuckerberg is a more complicated and compelling character than the real-life billionaire programmer, and this is how Hollywood explains Silicon Valley in its (Hollywood's) own terms.

Being on Facebook requires a kind of storytelling very different from that of a Hollywood film. As the Facebook site explains: "The stories that show in your News Feed are influenced by your connections and activity on Facebook. This helps you to see more stories that interest you from friends you interact with the most" (Facebook Help Center 2018a). These intertwined stories cannot have the narrative arc of a Hollywood movie. Instead, they constitute weak narratives: repetitive, fragmentary and without a sense of an ending. Weak narratives are a feature of many video games, but the

narratives of social media are weaker still. This is not to say that they are lacking in emotion or even that they cannot be momentarily coherent and strong. NGOs (Amnesty International, Help Syrian Refugees, Doctors Without Borders) publish Facebook pages about refugees and victims of war, famine, and poverty; individuals tell about their struggles with illness. Any Facebook user's status updates may reflect emotional extremes. The news feed may contain links to current media news stories. They may be extreme and absurd stories that make up fake news. More often, the "news" is a bit of Internet flotsam that has caught the attention of one of your friends. Taken together, such elements make up your life in and through Facebook. They flow along, moving from the bottom to the top of the screen as quickly as you and your friends send them.

Facebook is self-centered, almost inevitably self-aggrandizing. With your Facebook page you are always calling attention to yourself, seeking an audience. To this extent the cultural critics are right: Facebook *is* narcissistic in a popular, though not a clinical, sense. But Facebook is not alone. Most social media platforms and sites are narcissistic, as each one in its own way invites users to tell their own stories. Each tweet on your Twitter account, no matter what the subject matter, assumes that you have something your followers should attend to. On Instagram your story is a series of photographs with comments, often selfies or photos of you taken by others. Even if the photo has another subject, you make it part of your story by choosing to post it. On YouTube, you can be just a viewer, but if you post a video or create a channel, you are "broadcasting yourself" and can become a microcelebrity or even go viral (Marwick and boyd 2010). These differences determine the kind of story you tell, but it will always be a story of yourself. Much has been written about the selfie as a phenomenon (Rettberg 2014), and Lev Manovich and his colleagues have even created a site (selfiecity.net) dedicated to "investigating the style of self-portraits (*selfies*) in five cities across the world." In a sense, the entire social media network is a vast selfie, a constantly flowing and updating exploration of self by two billion users.

The experience of social networking is predominantly one of flow punctuated occasionally by catharsis. Each person goes on adding posts indefinitely, and you read your friends' posts and feeds indefinitely. Your participation is never meant to end. Facebook now provides for deleting your account, but the deletion process requires a special contact request. The Facebook site notes that "it may take up to 90 days from the beginning

of the deletion process to delete all of the things you've posted, like your photos, status updates or other data stored in backup systems" (Facebook Help Center 2018b). Even death may not end the flow. Facebook provides for memorializing the account of someone who has died and allows friends to share posts on the timeline.

Twitter, too, is a flow technology and an ideal medium for weak narrative, whether you are performing your identity or transmitting political points for what Marwick and boyd (2010) called your "network audience." While many authors use their Twitter stream to present a flow of links to longer articles, the vast majority of Twitter streams, like the vast majority of Facebook pages, are individuals presenting themselves to friends, 280 (formerly 140) characters at a time. In the extreme, self-presentation can indeed become narcissism. For obvious confirmation we can simply turn to the endless tweets of President Donald Trump. No matter what the ostensible topic of his tweet, the subject is always really himself, his perceived struggles and triumphs. The flow of tweets permits the constant reaffirmation of self that he needs. What is Trump's essential identity? How can we know? Twitter suits him perfectly for that reason.

Digital Identity and Identity Politics

Trump's unexpected success in the 2016 election suggests that Twitter can be a forum for a new kind of politics. This media celebrity has shown how the presentation of self and politics can merge in digital media as easily as on television, which has dominated American politics for decades. Trump has perfected a form of identity politics different in important ways from what the left thinks of as identity politics. For the left, identity politics is a variation on traditional politics. It is based on a particular reading of history—notably the history of race and gender and the ways in which women or people of color have been systematically oppressed or marginalized. This politics of identity is a collection of stories of tragedy or injustice with an expected future of triumph. It is highly cathartic, demanding that we find our place in that collection. A more nuanced version of identity politics is provided by the idea of intersectionality (Crenshaw 1991). Individuals may be more aptly identified through the intersection of race, gender, and other categories: women of color face forms of discrimination different from those of black men and white women; disabled black men

face different obstacles than disabled whites and able-bodied blacks. Thus, the stories of any individual may be a shifting interplay of different classifications, different identities, although they are still ultimately stories of the struggle for social justice.

Trump's identity politics is quite different. His is not the alt-right's narrative, which is in fact an inversion of the crudest form of the left's identity politics. The alt-right simply (and implausibly) flips the roles, so that in their story white males are being marginalized and must reassert their position as the champions of Western culture. This story is relatively coherent and can be quite elaborate, as it updates fascist narratives of the first half of the twentieth century. It can spin out a reading of the whole history of the West as one of encounters with other (inferior) cultures and races in order to define white, Western (and ultimately American) identity. The white-nationalist site www.stormfront.org, for example, employs conventions of more benign social networking sites (forums, FAQs, calendars, links to other nationalist sites) to build and sustain a community around a narrative of white identity (Statzel 2008). In fact, it is not just fascists in the twentieth century or the alt-right today who have practiced white identity politics; it has been a thread of mainstream American politics for many decades (Lopez 2017). But the current radical version has certainly been emboldened by Trump's populist victory.

In an important sense, however, Trump's own identity politics does not center explicitly on race or history, but rather on the individual, and indeed one individual, himself. He is not only the Twitter president, but the Facebook president (his page has over twenty-four million total likes), showing by his own example how a political persona (the decisive businessman who is at the same time champion of the working class) can be generated out of the same process of self-definition that has made Facebook so popular for two billion individuals. Trump has succeeded in uniting the personal and political dimensions of social media in himself. In this respect, of course, Trump is simply following the lead of autocrats and demagogues throughout history. On a humbler scale, American media figures (such as talk radio hosts Rush Limbaugh and Sean Hannity) have been uniting the personal and political for decades. Trump has transferred the formula from radio and cable television to Twitter. In doing so, he has made apparent what was perhaps always latent in social media. For any user of Facebook and Twitter, social, political, and personal identity can easily merge. All these forms

of identity in social media are composed of potential fragments, texts and images, likes and often strong dislikes.

The ways in which social media such as Facebook, together with search engines such as Google, define their users' online identities and target them accordingly have facilitated Trump's task. These services did not develop targeting techniques for political purposes but for advertising. Facebook, Google, and other digital services, after all, exist to make money, and user profiles enable them to direct ads to groups of users most likely to buy something. Users themselves initiate these profiles: the profile is essential to the procedural identity that each user creates, for example, for her Facebook account. Algorithms that track users' online activities vastly expand and enhance the profiles. How well these techniques work may be open for debate, but it is clear that the business community is willing to pay to have their ads delivered to target groups, contributing to the vast wealth of Facebook and Google.

Digital profiling and targeting are not only about money, however. They are also an important expression of the proceduralization of culture (discussed in chapter 7) in which hundreds of millions of users now willingly participate. They are the techniques that have evolved for participating in the media plenitude. Users clearly need and want ways to navigate and manage all the available material. They want filters—both ones that they establish themselves and ones that algorithms provide for them. The filters include the websites they choose to visit, the social media platforms they join, the people they connect to on these services, and obviously, the voluntary digital filters, such as email spam filters. All such choices help to define the communities they belong to. The algorithmic filters function surreptitiously to reinforce and modify these choices. All these techniques, but particularly the surreptitious ones, have led to concern about filter bubbles.

Media critic Eli Pariser articulated this concern several years ago in a TED talk (2011a) and subsequent book in 2011 (2011b). Pariser was troubled specifically by information coming from Facebook's newsfeed and Google searches, tailored to user profiles. He realized, for example, that Facebook was editing out all the posts from conservative friends, making his newsfeed into a liberal filter bubble. During and after the 2016 election, Facebook faced growing criticism for the naive ways in which it treated the political dimension of its service, failing to understand how many of its users

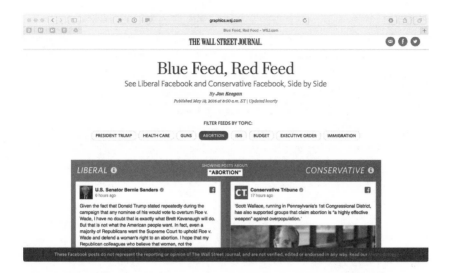

Figure 8.2
"Blue Feed Red Feed": A site that illustrates the polarization of American political life (http://graphics.wsj.com/blue-feed-red-feed/#/guns).

were getting their news solely or predominantly from this social media site (Thompson and Vogelstein 2018). *Wall Street Journal* reporter Jon Keegan demonstrated how radically filtered Facebook's newsfeed could become in a web page entitled "Blue Feed, Red Feed" (Fowler and Keegan 2016). With literal buttons for each of a number of "hot button" topics such as abortion and guns, the page shows in two columns how users could inhabit completely different political worlds. As of 2018, the site was still active, documenting a flow of political stories that are always changing and always the same (figure 8.2).

Zuckerberg and his team thought of their algorithms as facilitating the perfect flow of information that his Facebook users would want. To them, it made perfect sense that your online profile should define both the communities you aspire to belong to and the information that would sustain your participation in those communities. They did not realize that this mechanism was perfectly suited to the politics of flow, in which some of these siloed communities would receive a diet of conspiracy theories and misinformation. But if they were naive, it would be equally naive to assume that their digital technologies brought about the siloing of American political life. Even before the rise of the Internet, America was never a perfect public

sphere in which various points of view were debated in newspapers, radio, and television. We have to acknowledge that people were always choosing among various information channels. In the heyday of newspapers in the nineteenth century and first half of the twentieth century, there were several papers available, at least in the large cities, and each paper might favor the outlook of a political party or meet the needs of different economic classes. Digital media today intensify and encourage a trend toward separate information communities that has always existed.

Our media plenitude is vastly larger and more ramified than in the era of newspapers and earlier electric media. Its size and complexity make the need for filtering more important, as does the way in which digital identity is being used to define communities. In this environment, identity can always be mobilized for a kind of identity politics by the Trump political organization, by Russian hackers, and by many other groups with political agendas. The seeming apolitical acts of filling out your Facebook profile, visiting a website, or making online purchases can engage you in the new politics of flow.

Social Media and Collective Action

For twenty years now there have been significant political uses for the communication channels afforded by mobile as well as social media. Twitter is grounded in the format of the SMS, and even in the 1990s (years before Twitter, Facebook, or YouTube) texting could be aggregated to turn personal messages into collective action. One of the early realizations of collective messaging was the *flash mob*—a phenomenon beginning in the early 2000s and continuing, although with less popularity, today. A flash mob was an ad hoc gathering of participants, perhaps a dozen or a couple of hundred, to create a short, apparently spontaneous event. The participants were reached through text messages or viral email and instructed to assemble at a given location, usually to perform a bizarre unmotivated action: lie down in a public space, freeze in place for a couple of minutes, dance spontaneously, and so on. Flash mobs were often briefly disruptive. They were performances rather than traditional political demonstrations; or rather they were political in the avant-garde sense, spiritual heirs to performances from Dada early in the century to Fluxus and the Situationists in the 1950s and 1960s. They were popular modernist performances.

They were also celebrations of the power of a new technology to gather and focus people to a particular goal. Howard Rheingold (2002) coined the term "smart mob" to describe the more overtly political version of the flash mob. This involved using text messaging to constitute and direct the action of a crowd in protest, for example, helping to organize protests such as those in the Philippines in January 2001 to oust then-President Joseph Estrada. Like flash mobs, smart mobs were temporary and provisional: they came together for a specific protest and then dissolved. This model of political action has continued in recent years through social media sites such as Facebook and Twitter along with other text messaging and chat platforms.

Blogs, Twitter, and Facebook were credited with playing an important role in the uprisings in Egypt and Tunisia during the unfortunately named Arab Spring of 2011. A common view has been that social media served as catalysts for the popular rejection of authoritarian governments (Howard and Hussain 2013; Kirkpatrick and Sanger 2011; Huang 2011). A contemporary BBC documentary (BBC Two 2011) confirmed this (popular modernist) notion in its very title: *How Facebook Changed the World: The Arab Spring*. Beyond the Arab Spring, there were the various actions by the Occupy movement, in Wall Street; Oakland, CA; Washington, DC; London; and so on. Whether social media in fact played a decisive role in the Arab Spring and other political protests, it is significant that the repressive governments themselves believed in and feared the power of social media. Tunisia blocked certain sites and routes; Egypt repeatedly tried to block Facebook and Twitter and eventually moved to shut down Internet access to the country as a whole (Stepadova 2011, 2). The so-called great Chinese Firewall, the elaborate system of technical and legal regulations of Internet access in that country, especially for social media and search services, is evidence of the belief on the part of autocratic leaders that these technologies can promote political democracy.

Media analyst Clay Shirky argued that Facebook and other social media enable new forms of grassroots political action. In a TED talk he told the story of Ushahidi, a web service that aggregates and maps reports from many sources for "crisis management." First used to map violence in Kenya in the aftermath of an election, the web service was used throughout the world to map reports of civil violence and natural disasters (Shirky 2010b). Shirky characterized these kinds of social media applications as the "marriage of technology and human generosity" In *Here Comes Everybody*,

he wrote: "Our electronic networks are enabling novel forms of collective action, enabling the creation of collaborative groups that are larger and more distributed than at any other time in history. The scope of work that can be done by noninstitutional groups is a profound challenge to the status quo" (Shirky 2008, loc. 115 of 758, Ibook).

This combination of technology and human generosity is not so much a marriage as a temporary liaison. Most of these experiments in collective intelligence forge communities whose time is limited. The same is true by design in the case of Jane McGonigal's social-political ARGs, which we discussed in chapter 7. The game *World Without Oil* lasted thirty-two days (Wikipedia contributors, "World Without Oil"); *Superstruct* ran from September to November 2008 (Kirchner 2010). The ARGS and collective social websites and apps certainly represent a kind of political and social engagement, and they are grounded in stories or generate stories in the process of playing. But the narratives are often either fragmented or temporally limited. Characteristic of other digital media interventions too is a style of political engagement that may be intense but is often short-lived. People are brought together around specific acts of injustice or to achieve immediate goals, and their narratives are specific and simple. "The government is trying to take away our guns" or "Wall Street is against Main Street." Most do not have the lasting effect of the longer and more elaborate political narratives of the twentieth century. This is not to say that all movements in twentieth-century politics were sustained or that all contemporary movements must necessarily flame out quickly. Just as there is a spectrum of catharsis and flow in entertainment forms today, there is also a spectrum in forms of political and social engagement. The women's movement, which has deep roots going back to the nineteenth century, will not disappear or abate; nor will the movement to combat climate change. But even in these cases particular social media expressions (for example, the #MeToo hashtag) are likely to appear and then fade, replaced by other expressions, perhaps uniting a different Venn diagram of communities. Some of these political actions become memes and spring up repeatedly with variations: Occupy Wall Street in 2011 repeated itself in various other places (Occupy Berlin, Occupy Canada, Occupy Melbourne, and so on). But even memes eventually lose their effectiveness.

In short, various forms of social media are suited for both individual identity construction (telling your own story) and political or social engagement

(telling a collective story), and social media bring the same characteristics of weak narrative and flow to both these domains. The distinction between the individual and the group becomes less and less clear. The Me generation can become the Us generation, but any individual "me" can opt in and out of any community. The history of the Anonymous international collective of hacktivists provides a good example of the complexity of motives and the confusion of narratives in this new form of political engagement.

Anonymous

4chan is one of the best-known *imageboards* (www.4chan.org). Like ARGs, this curious anonymous website was founded with no ostensible political agenda—in this case by a fan (whose handle was "moot") of manga comics for a community whose members wanted to share images that were not available in the West. Partly to avoid being identified as copyright infringers, the founder of the site and his contributors adopted a policy of anonymity. 4chan gradually developed into a series of boards that distributed various genres of images. A typical post on one of these boards consists of an "image macro," the image itself together with a comment, often inane and so compact that it is difficult to understand as a form of traditional communication. The most popular board entitled /b/ is for random images that mix the sentimental and the pornographic. Even more obviously than Facebook, 4chan is a flow experience; the experience is also the weakest of possible narratives. One macro will spawn others in response and others will quickly replace it. On /b/, macros are added almost every second, so that whenever the visitor refreshes her window the ones at the top have been pushed down and replaced by new pictures of cats or naked women (figure 8.3). The famous lolcats macro alone appears in constant variation and sameness (Wikipedia contributors, "4chan").

4chan shares with Facebook a complete lack of visual design sense, but otherwise it is a form of digital self-expression in a mode opposite to that of Facebook. Because contributors remain anonymous, they cannot use the site to define and broadcast their identities to friends or a general audience. 4chan has become an everyday pastime for thousands of young people, most of whom have no training in art or connection to the art community. It is another expression of popular modernism, where art has dissolved into everyday life. The creation of endless variations of lolcats and

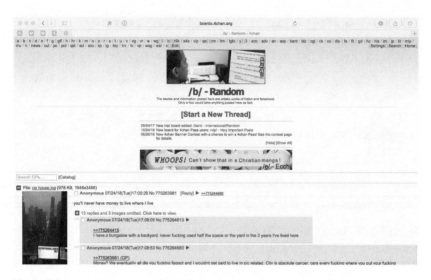

Figure 8.3
The 4Chan /b/ board: a site for anonymous self-expression.

the propagation of other memes are simply art as nonsense; they are crude, playful, silly, meaningless, or insulting.

4chan was also the springboard for the loose collective known as Anonymous (Schrank 2014). No longer satisfied with just posting images and texts, some contributors began to work pranks and hacks on other Internet sites. Such pranks had long predated 4chan, but a sense of solidarity forged by this site catalyzed a few of its members to collective action. When in early 2008 the Church of Scientology insisted that YouTube take down an embarrassing interview of the religion's poster-child, Tom Cruise, the hackers who became known as Anonymous began Project Chanology, a campaign against the Church's website (Olson 2012; Coleman 2014). Their method was the distributed denial of service (DDOS) attack, in which users launch bots or automatic programs that flood a website with requests for pages. If a large enough number of human users or bots all request service, they overwhelm the site, slowing its response time or stopping it altogether. The Scientologists subscribe to a strong quasi-religious narrative based on the fantasies of science fiction writer L. Ron Hubbard. Thus, Scientologists and Anonymous were perfect foils for each other on the fringes of the American political landscape. While the Scientologists have legalistic and secretive belief structures, Anonymous stood for the denial of such

structures and of hidden knowledge. Anonymous has by its very nature no official spokesperson, no creed, and a fluid definition of membership in the group.

The nature of the attacks, the publicity they generated, and the anonymity of Anonymous made it seem as if the collective was large and well organized. In fact, Olson reports (2012, loc. 1733 of 7001, Kindle) that some of their most famous attacks were the work of relatively few young people armed with software that co-opted computers around the Internet. Success led to larger, physical demonstrations, as when on February 10, 2009, hundreds of protesters in cities around the world demonstrated in front of Church of Scientology offices, many wearing Guy Fawkes masks, which became a symbol of the group (loc. 102 of 7001, Kindle). Other actions followed in the coming years. In 2010 Julian Assange and his WikiLeaks site faced attempts to thwart their release of confidential government information. Anonymous then conducted DDOS attacks on credit card companies that refused to process contributions to WikiLeaks. Soon thereafter, the security company HBGary and the emails of its executives were hacked because of their plans to launch cyber counterattacks against Anonymous. In 2011, in the most conventionally political of their interventions, Anonymous also supported the Arab Spring movements in Tunisia and Egypt by hacking government sites and helping protesters get around Internet stoppages imposed by the struggling authorities.

The motivations of the Anonymous participants in all these actions were complex. Communicating through IRC (Internet Relay Chat) channels, these young men (and a few women) hung out—forming groups and splinter groups, discussing and arguing about targets, and then haphazardly deciding on raids. The difference between pranking and sustained political action was at first difficult to discern. Interviews with some of the principals in Brian Kippenberger's documentary *We Are Legion: The Story of the Hacktivists* (2012) make clear that they transitioned almost inadvertently from 4chan meme creators to hacktivists. They were teenagers and young adults playing around online and had no political program. They had in that sense little in common with the generations of students throughout the twentieth century who sat in European cafes discussing Marx or Mao and then in some cases took to the streets. At first and above all, members of Anonymous were offended that anyone would seek to disturb the endless flow of digital information to which they were themselves addicted. Later,

some seemed to pick up fragments of more traditional political ideologies opportunistically, when they supported free access to government information (WikiLeaks) or the democratic rights of the people (Arab Spring). The cult film *V for Vendetta* (2006) provided them with a compelling metaphor, although the film itself is not a serious work of political art. It is the story of a lone masked figure opposing a future (British) Orwellian government with an increasingly effective series of deadly pranks. At the end of the movie, thousands of masked followers constitute a legion that resists and overthrows the government.

The exploits of Anonymous illustrate the politics of flow, just as 4chan itself reflects flow as an entertainment or aesthetic experience. It is appropriate that the defining technique of Anonymous hacktivists is the DDOS, which is the perfect instrument for a politics of flow, because its point is to deny access to an organization that (in the attackers' view) has itself sought to deny the flow of information to others. The motto of Anonymous, taken from the Internet community that spawned the open source movement of the 1980s, is that "information wants to be free." This ultimately is a popular modernist claim that, by its very nature as a medium, the Internet demands unfettered access to information, the absence of proprietary ownership of software, text, images, videos, and anything else that flows through its routers and fibers. Other hacktivist movements have had more articulate political agendas, for example the Tactical Media movement, as described by Lovink and Garcia (1997) and Raley (2009). In the end, if members of Anonymous developed a political ideology at all, it was opposition to any and all statism—a position shared historically by political anarchists on the left and the right. Anarchism itself has perhaps always been a weak political narrative in response to the stronger narratives of liberal democracy and Marxism in the nineteenth century.

WikiLeaks itself is not anonymous, but rather has an internationally recognizable persona in Julian Assange, who has promoted himself vigorously as a champion of the flow of information. Active since 2006, WikiLeaks became famous in 2010 for releasing thousands of confidential documents on the war in Afghanistan as well as thousands of U.S. diplomatic cables. The group has gone on to release documents of all kinds, including files of the U.S. government on the Guantanamo prison and the war in Iraq, from the governments of Syria and Brazil, from banks regarding questionable financial transactions, and so on.

Shortly after the WikiLeaks site went public, Julian Assange offered a rambling manifesto to justify its activities. Assange invoked elementary graph theory to argue that exposing secrets will sever the links of the network of official conspiracies in the world, which will in turn disrupt the flow of information that is essential to maintaining the conspiracies. There was no theory of political revolution. Christian Caryl (2010), a contributing editor at *Foreign Policy*, reviewed some of Assange's interviews and writings as well as the Manifesto and remarked that Assange offered "a patently contradictory agenda; I'm not sure how we're supposed to make sense of it. In practical terms it seems to boil down to a policy of disclosure for disclosure's sake. This is what the technology allows, and Assange has merely followed its lead." As a traditional political journalist, Caryl sought to interpret the actions of governments and individuals as coherent narratives. He was justifiably baffled by a "policy of disclosure for disclosure's sake"—baffled, that is, by the politics of flow.

We have seen that flow is the aesthetic principle of social media, as well as the political principle of this new form of hacktivism. For WikiLeaks under Assange as for Anonymous, the line between the personal and the political easily blurred. The Anonymous hackers took personal offense that individuals (such as Aaron Barr) or organizations (such as the Church of Scientology) would identify them as a menace, and they retaliated accordingly. In 2016, WikiLeaks released emails hacked from the servers of the Democratic National Committee and a Democratic political operative, John Podesta. The release was timed to damage the Democratic nominee, Hillary Clinton. Although he does not hide behind a Vendetta mask, Assange released the emails in an apparent personal vendetta against Clinton. Like Trump, Assange was also practicing a form of identity politics.

Weak Narrative and American Politics

American politics today is characterized today by a struggle between an older style of narrative politics and a politics of flow. In one sense the rise of digital media (from the 1980s on) has coincided with a move toward greater ideological coherence. The Republicans led the way in insisting on an ideology of free market economics combined with coercive governmental promotion of traditional religious values and an interventionist foreign policy. The Democrats responded with a more "progressive" agenda, calling

for more government regulation and control of the economy. As is well known, both parties, but especially the Republicans, have now cleansed themselves of elements that disagree with their story, with the result that practically every congressional member of the Republican Party has a more conservative voting record than any congressional member of the Democratic Party. This polarization in Congress comports with a polarization in the electorate (Pew Research Center 2012, 2014): America is now largely divided into red and blue electorates and their respective legislators. These divisions separate not only or even principally state from state, but also county from county and especially urban from rural counties.

But the polarization does not necessarily mean that the current narratives on either side are historically grounded or even consistent. The traditional and digital media (cable television, talk radio, and blogs and Twitter) have offered highly emotional but fragmented narrative lines for both sides, but particularly Red America. For example, Tea Party Republicans of a few years ago affected to hate the federal government, and yet they saw Social Security and Medicare as justified entitlements, ignoring that these are federal government programs (Skocpol and Williamson 2012). In *Strangers in Their Own Land: Anger and Mourning on the American Right*, sociologist Arlie Russell Hochschild (2016) described the confused political positions of the community she studied in Calcasieu Parish in Louisiana. She offered what she called a "deep story" (which is really a myth of identity) to explain how inhabitants of an area polluted for decades by chemical and oil companies were convinced that the problem was too much government regulation. The Democrats have their own emotional and not always consistent narratives around core issues of racial and sexual equality. The intense nature of the discourse should not obscure the fact that the storylines are less consistent than they were earlier in the twentieth century.

The 2016 presidential campaign of Donald Trump exposed the increasing weakness in both narratives. Political pundits interpreted Trump as a realignment of the traditional stories of left and right. In fact Trump showed how easy it was to break both narratives into a series of puzzle pieces that could be reshuffled into a variety of combinations. It was easy because much of the American electorate no longer seemed able to judge the coherence of any political rhetoric. Trump rearranged the pieces almost from week to week as he responded to questions from the press, attacks from his opponents, or external events (such as terrorist attacks in Europe). Again, Trump

showed that a weak narrative does not mean one devoid of emotion. In place of an overarching story, he offered highly emotional story fragments. It is no coincidence that Twitter became his favored communication channel. He could fire off tweets immediately in response to what he saw on the morning news shows, and in some cases the show would close the loop, reporting his tweet just after it appeared. Twitter requires very short communicative bullets, which fit Trump's mode of thinking perfectly. At his rallies, Trump spoke in much the same fragmented style that he used in the 140-character tweets.

The campaign between Trump and Clinton thus became a contest between flow and coherent, cathartic narrative and (to some extent) between digital media and more traditional media. The Clinton campaign machine was a procedural masterpiece, carefully organized in every detail. Each night of the Democratic Convention in July was designed around a different message; the speeches were organized as a series of crescendos, and the whole four nights aimed at a cumulative effect. It offered a number of highly cathartic moments in which the audience was invited to identify with the stories told by the speaker on stage: a mother and father of a fallen Muslim American soldier offered the most effective of these moments, but by no means the only one. The Republican Convention was less successful at sustaining narrative and less interested in cathartic identification. The character of their candidate did not invite his audience to identify with him, but rather to follow him. Both campaigns used social and traditional media, although Clinton spent much more heavily on television advertising (Pearce 2016). The Trump campaign's use of Facebook and Twitter was more effective at reaching and motivating targeted segments of voters (Bump 2018).

It remains to be seen whether Trump is an aberration or a pioneer for a new political order. It does seem clear that Trump benefited from the two epochal developments that we have been exploring. Trump is the latest in a line of populist presidential candidates since the rise of popular culture in the mid-twentieth century and specifically Republican pseudo-candidates in recent election cycles (Sarah Palin, Herman Cain, and Ben Carson), who have in traditional terms few or no qualifications whatsoever for office. The appearance of such candidates is the political version of the earlier breakdown of elitism in art and culture. You no longer have to be trained in the elite communities of art or music to be an artist or a musician. Likewise, you no longer have to be part of the political elite to be a politician. Trump

could never have been president at any time in the past, when it was gener-ally accepted that you needed training and expertise (years of political or at least military experience) to be president. It also seems unlikely that Trump could have been elected president prior to the rise of social media and the conservative blogosphere, which broke down the controlling structures for disseminating news and political opinion. The rise of fake news sites and the use of Facebook and Twitter to spread such stories to millions of users, who regard blogs and social media as the equivalent of printed newspapers and television networks, attest to the way in which digital media provide a matrix for the politics of flow.

Conclusion

At several points in this book, we have imagined a time machine that could pluck a person from 1960 and bring her to the present. If we had such a machine, we would of course be tempted to use it to transport ourselves into the future, to see what our media culture would look like in a few decades. And the fact that there are no time machines has not deterred writers and industry experts from imagining that future. For many of them, it is one in which one or a few media technologies reconfigure and dominate our media landscape: virtual reality, augmented reality, the Internet of Things, artificial intelligence, robots, the AI singularity, and so on. Others have forecast a future determined by one of the prominent media practices, such as social media, remix, or video games. All these predictions owe a debt to McLuhan and his popular modernist view of the succession of media. We used to live in "print culture," and soon we will live in "remix culture" or "a culture of social media" or "a VR or AR world."

There may or may not have been such a dominant constellation of media in the past. Perhaps it is appropriate to speak of an "age of print" from the fifteenth century to the twentieth, in the sense that the printing press was the major technology for recording authorized knowledge, although even in the age of print there was a wealth of other culturally important media (painting, sculpture drama, music) that constituted their own communities. From 1850 to 1950, the technologies of photography, film, and sound recording were already challenging the dominance of print and beginning to chip away at the hierarchy of knowledge validated by print publication. In any case, the role that digital media play today is very different from the role of the printing press in earlier centuries, and our cultural assumptions have changed.

catharsis	flow
originality	remix
organic/spontaneous	procedurality/datafication
history	simulation

Figure 9.1
Dichotomies of our media culture.

Let's return to the dichotomies laid out in chapter 3 and discussed in chapters 4–8 (figure 9.1). As we have seen, each of these dichotomies represent endpoints with a spectrum of possibilities in between. Some video games are pure flow experience; others incorporate elements of storytelling and catharsis. Many films, especially Hollywood action-adventures, have sequences that seek to put the audience into a flow state, like a video game. The same musical piece can have elements of flow and catharsis. Some audio and video remixes incorporate original tracks along with the samples. Not all tweets or YouTube videos follow the memes; many are original and surprising, breaking the mold. Procedurality and spontaneity can coexist in the same social media practice. A compelling media form or practice can occupy almost any point on any of these spectra, adding to the multiplicity of our current media culture.

We have seen that the column on the right represents new practices, preferences, or aesthetics that are particularly at home in born-digital media, such as video games, social networking, and microblogging sites. But in most cases, the aesthetics or preferences on the left are not disappearing. Cathartic film and television are flourishing. Traditional single-authored books continue to be published and read (on paper and as ebooks). Our datafied society is really a half-datafied society in which millions of people still do *not* track their likes on Facebook or their steps on a Fitbit or Apple Watch. Digital media have come to constitute an ideal environment for supporting diverse preferences and multiple communities—ideal for fostering all the fragments of the deflated cultural hierarchies of twentieth century.

This multiplicity is our future. It is hard to see how we could possibly return to a situation in which one set of values in arts and culture prevails, so that everyone agrees on what good music is and whether video games are art. In fact there never was such a "golden age," at least since the

Industrial Revolution. It was rather that the dominant cultural and economic classes agreed on standards, and the tastes of other classes, with their limited access to cultural institutions and media technologies, were largely ignored—a situation described by the French sociologist Pierre Bourdieu (1984). Today the cultural and economic elites have parted company, the former cultural elites have become special communities (e.g., the art community, the literary community), practically everyone in the developed world has access to all forms of media, and millions are able to produce media as well as consume it. Our media plenitude opens up opportunities for hundreds of millions of people to express themselves and to share their self-expression with others. This wealth of opportunity seems (to me at least) to more than compensate for the loss of a single cultural center and a set of universally shared standards.

It may upset a group of critics that JAY-Z is equated to Picasso or that universities have programs in games studies or that PewDiePie has fifty million YouTube viewers. The critics of any of these or hundreds of other mass media phenomena can join communities that still assert traditional standards in music, art, film, and so on, and the Internet allows those communities to coexist alongside the larger ones that prefer rap music, video games, and YouTube celebrities. The plenitude of our media culture is vast and can accommodate all such communities. Diversity in entertainment, art, and cultural expression should not be a cause for concern.

The breakdown of hierarchy in arts and culture does not pose a danger to our society. But there is a danger, as suggested in chapter 8, in the social and political arenas, where the same forces have been at work since at least the middle of the twentieth century. The rise of popular culture undermined the notion that education and status in the elite arts communities made you an artist, or a better artist. In the same way, there has been an erosion of the assumption that the political and technical elites, typically educated in the best universities, should run the government. Populism has long been a feature of American politics, but it is stronger now than perhaps ever before, because millions of Americans no longer believe that education, expertise, or prior experience are necessary qualifications for governing. Donald Trump is the expression, not the cause, of this profound change.

The formerly elite media and traditional political figures complain today of the loss of standards in public discourse and conduct. They fear that the behavior of politicians like Trump will become "the new normal." This is the

political equivalent of the complaint by critics such as Keen and Carr that remix and video games are devaluing our culture. But the political situation is different in this crucial respect. When it comes to music, art, films, and video games, we can each retreat to our corner of the media plenitude. In the political realm, we cannot simply agree to disagree, because decisions must be made collectively. Our democratic systems are founded on the assumption that all the members of the society agree on the purpose and function of political discourse. The United States and Western Europe (at least) operate on political systems grounded in what I have called the politics of catharsis. Not all the members of the society believe the same story (liberalism, socialism, Burkean conservatism), but they all believe that there is a story—that the political life of the nation makes sense over time. The rise of the politics of flow threatens that foundational assumption, and it is not clear how this new politics could function under constitutional systems that were developed over the past two centuries. The answer to that question might be the most compelling reason to wish for the ability to time travel into the future.

References

Aarseth, E. 2004. "Genre Trouble: Narrativism and the Art of Simulation." In *First Person: New Media as Story, Performance, and Game*, ed. N. Wardrip-Fruin and P. Harrigan, 45–55. Cambridge, MA: MIT Press.

Adgate, B. 2015. "What 'Mad Men' Was and Wasn't." *Forbes*, May 17. https://www.forbes.com/sites/bradadgate/2015/05/17/what-mad-men-was-and-wasnt/#8375aa4655f0.

Alter, A. 2012. "The Weird World of Fan Fiction." *Wall Street Journal*, June 14. http://online.wsj.com/article/SB10001424052702303734204577464411825970488.html.

American Alliance of Museums. 2017. "Museum Facts & Data." https://www.aam-us.org/programs/about-museums/museum-facts-data/.

Arnold, M. 2004. *Selections from the Prose Works of Matthew Arnold*. Project Gutenberg eBooks. http://www.gutenberg.org/ebooks/12628.

Barstow, D. 2000. "'Sensation' Closes as It Opened, to Cheers and Criticism." *New York Times*, January 10.

Baudrillard, J. 1994. *Simulacra and Simulation*. Ann Arbor: University of Michigan Press.

Bauerlein, M. 2008. *The Dumbest Generation: How the Digital Age Stupefies Young Americans and Jeopardizes Our Future (Or, Don't Trust Anyone Under 30)*. New York: Penguin Group.

Bauerlein, M., ed. 2011. *The Digital Divide: Arguments For and Against Facebook, Google, Texting, and the Age of Social Networking*. New York: Penguin.

BBC Two. 2011. *How Facebook Changed the World: The Arab Spring*. Episode 1. https://www.youtube.com/watch?v=VCdIOch2970.

Beatles. 2013. The Beatles Ultimate Experience. Beatles interviews database. http://www.beatlesinterviews.org/db1969.1219.beatles.html.

Boal, A. 1979. *Theater of the Oppressed*. New York: Urizen Books.

Bogost, I. 2006. *Unit Operations: An Approach to Videogame Criticism*. Cambridge, MA: MIT Press.

Bogost, I. 2007. *Persuasive Games: The Expressive Power of Videogames*. Cambridge, MA: MIT Press.

Bogost, I. 2017. "Video Games Are Better without Stories." *The Atlantic*. April 25. https://www.theatlantic.com/technology/archive/2017/04/video-games-stories/524148/.

Bolter, J. D. 2014. "Marshall McLuhan and the Legacy of Popular Modernism." *Journal of Visual Culture* 13: 23–25. doi:10.1177/1470412913509454.

Boone, A. R. 1941. "Mickey Mouse Goes Classical." *Popular Science* 138 (1): 65–67.

Bourdieu, P. 1984. *Distinction: A Social Critique of the Judgement of Taste*. Trans. R. Nice. London and New York: Routledge.

Bowker, G. C., and S. L. Star. 1999. *Sorting Things Out: Classification and Its Consequences*. Cambridge, MA: MIT Press.

Boyd, B. 2009. *On the Origin of Stories: Evaluation, Cognition, and Fiction*. Cambridge, MA: Belknap Press of Harvard University Press.

boyd, d. 2014. *It's Complicated: The Social Life of Networked Teens*. New Haven, CT: Yale University Press.

Brady, M. 2017. "House Votes to Restrict EPA's Use of Scientific Studies." *U.S. News and World Report*. March 29. https://www.usnews.com/news/national-news/articles/2017-03-29/house-votes-to-restrict-epas-use-of-scientific-studies.

Brenson, M. 1989. "Andres Serrano: Provocation and Spirituality." *New York Times*, December 8, C1, C28.

Brewster, B., and F. Broughton. 2006. *Last Night a DJ Saved My Life: The History of the Disc Jockey*. New York: Grove Press.

Brooks, A. C. 2016. "Narcissism Is Increasing. So You're Not So Special." *New York Times*, http://www.nytimes.com/2016/02/14/opinion/narcissism-is-increasing-so-youre-not-so-special.html.

Bruner, J. 1985. *Actual Minds, Possible Worlds*. Cambridge, MA: Harvard University Press.

Bruner, J. 2004. "Life as Narrative." *Social Research* 71 (3): 691–710.

Bull, M. 2013. "iPod Use: An Urban Aesthetics of Sonic Ubiquity." *Continuum: Journal of Media & Cultural Studies* 27 (4): 495–504. doi:10.1080/10304312.2013.803300.

Bump, P. 2018. "All the Ways Trump's Campaign Was Aided by Facebook, Ranked by Importance." *Washington Post*. March 22. https://www.washingtonpost.com/news/politics/wp/2018/03/22/all-the-ways-trumps-campaign-was-aided-by-facebook-ranked-by-importance/?noredirect=on&utm_term=.e1fb2d75665f.

Bureau of Labor Statistics. 2017. *Occupational Outlook Handbook*. https://www.bls.gov/ooh/arts-and-design/craft-and-fine-artists.htm.

Bürger, P. 1984. *Theory of the Avant-Garde*. Trans. M. Shaw. Minneapolis: University of Minnesota Press.

Campanelli, V. 2015. "Toward a Remix Culture: An Existential Perspective." In *The Routledge Companion to Remix Studies*, ed. E. Navas, O. Gallagher, and x. burrough, 68–82. New York: Routledge.

Carr, D. 2014. "Barely Keeping Up in TV's New Golden Age." *New York Times*, March 9. https://www.nytimes.com/2014/03/10/business/media/fenced-in-by-televisions-excess-of-excellence.html.

Carr, N. 2010. *The Shallows: What the Internet Is Doing to Our Brains*. New York: W. W. Norton and Company.

Carrier, L. M., L. D. Rosen, and J. N. Rokkum. 2018. "Productivity in Peril: Higher and Higher Rates of Technology Multitasking." *Behavioral Scientist*, January 8. http://behavioralscientist.org/productivity-peril-higher-higher-rates-technology-multitasking/.

Caryl, C. 2010. "WikiLeaks in the Moral Void." *The New York Review of Books*. https://www.nybooks.com/daily/2010/12/07/wikileaks-moral-void/.

Chen, J. 2007. "Flow in Games (and Everything Else)." *Communications of the ACM* 50 (4): 31–34.

Cohen, P. 2014. *Family Diversity Is the New Normal for America's Children*. Council on Contemporary Families. https://contemporaryfamilies.org/the-new-normal/.

Cole, Robert. 2010. "Apple 1984 Super Bowl Commercial Introducing Macintosh Computer (HD)." YouTube Video, 1:03, June 25. https://www.youtube.com/watch?v=2zfqw8nhUwA.

Coleman, G. 2014. *Hacker, Hoaxer, Whistleblower, Spy: The Many Faces of Anonymous*. New York: Verso.

Conti, O. 2015. "Political Remix Videos as a Vernacular Discourse." In *The Routledge Companion to Remix Studies*, ed. E. Navas, O. Gallagher, and x. burrough, 345–357. New York: Routledge.

Cooke, M. 2008. *A History of Film Music*. New York: Cambridge University Press.

Correspondents of the New York Times. 2005. *Class Matters*. New York: Henry Holt and Company.

Crenshaw, K. 1991. "Mapping the Margins: Intersectionality, Identity Politics, and Violence against Women of Color." *Stanford Law Review* 43 (6): 1241–1299.

Cronin, M. A. 1985. "Fifty Years of Operations in the Social Security Administration." *Social Security Bulletin* 48 (6). https://www.ssa.gov/history/cronin.html.

Csikszentmihalyi, M. 1991. *Flow: The Psychology of Optimal Experience.* New York: HarperPerennial.

Curran, A. 2001. "Brecht's Criticisms of Aristotle's Aesthetics of Tragedy." *Journal of Aesthetics and Art Criticism* 59 (2): 167–184.

Cut, The. 2016. "A New Film Proves That Knitting Is an Art Form." *The Cut* (blog), *New York Magazine,* June 23. https://www.thecut.com/2016/06/yarn-movie-clip.html.

D'Anastasio, C. 2017. "Students Show Which Video Game Genres Women Play Most." *Kotaku,* January 20. https://kotaku.com/study-shows-which-video-game-genres-women-play-most-1791435415.

Daniel, D. 2009. "7 Technologies that Changed the World." *PC World,* February 19.

Danto, A. C. 1997. *After the End of Art: Contemporary Art and the Pale of History.* Princeton, NJ: Princeton University Press.

Darnton, R. 2011. "Six Reasons Google Books Failed." *NYR Daily,* March 28. https://www.nybooks.com/daily/2011/03/28/six-reasons-google-books-failed/.

DeCarlo, T. 1999. "Landscapes by the Carload: Art or Kitsch?" *New York Times,* November 7. http://www.nytimes.com/1999/11/07/arts/art-architecture-landscapes-by-the-carload-art-or-kitsch.html?rref=collection%2Fsectioncollection%2Farts.

Decker, D. 1998. *Anatomy of a Screenplay.* Chicago: Dan Decker Books.

Dediu, H. 2016. "Counting Apple's Customers." Asymco, August 16. http://www.asymco.com/2016/08/18/counting-apples-customers/.

Dennett, D. 1988. "Why Everyone Is a Novelist." *Times Literary Supplement* 4459 (September 16–22): 1016, 1028–1029.

deviantART. 2018. "What Is deviantART?" https://welcome.deviantart.com/.

Documenta 13. 2013. Documenta 13. https://www.documenta.de/en/retrospective/documenta_13.

Dusi, N. M. 2015. "Remixing Movies and Trailers Before and After the Digital Age." In *The Routledge Companion to Remix Studies,* ed. E. Navas, O. Gallagher, and x. burrough, 153–165. New York: Routledge.

Dutton, D. 2009. *The Art Instinct: Beauty, Pleasure, and Human Evolution.* New York: Bloomsbury Press.

Ebert, R. 2010. "Video Games Can Never Be Art," April 16. https://www.rogerebert .com/rogers-journal/video-games-can-never-be-art.

Edwards, B. 2007. "The History of Civilization." Gamasutra, July 18. http://www .gamasutra.com/view/feature/1523/the_history_of_civilization.php?page=2.

Eliot, T. S. 1921. "Phillip Massinger." In *The Sacred Wood: Essays on Poetry and Criticism*. New York: Knopf. www.bartleby.com/200/sw11.html.

Engberg, M. 2011. "Writing on the World: Augmented Reading Environments." *Sprache und Literatur* 108 (2): 67–78.

Engberg, M. 2014. "Polyaesthetic Sights and Sounds: Analyzing the Aesthetics of *The Fantastic Flying Books of Mr. Morris Lessmore, Upgrade Soul*, and *The Vampyre of Time and Memory*." *SoundEffects* 4 (1): 22–40.

Engberg, M., and J. Bolter. 2017. "Mobile Cinematics." In *Compact Cinematics: The Moving Image in the Age of Bit-Sized Media*, ed. M. Poulaki and P. Hesselberth, 165–173. New York: Bloomsbury Press.

Ennis, P. H. 1992. *The Seventh Stream: The Emergence of Rocknroll in American Popular Music*. Middletown, CT: Wesleyan University Press.

Entertainment Software Association. 2017. "Sales, Demographic and Usage Data." http://www.theesa.com/wp-content/uploads/2017/09/EF2017_Design_FinalDigital .pdf.

Facebook Help Center. 2018a. "How News Feed Works." https://www.facebook.com/ help/327131014036297/.

Facebook Help Center. 2018b. "How Do I Permanently Delete My Facebook Account?" https://www.facebook.com/help/224562897555674.

Federal Reserve. 2016. *Consumers and Mobile Financial Services 2016*. Washington, DC: https://www.federalreserve.gov/econresdata/consumers-and-mobile-financial -services-report-201603.pdf.

Field, S. 1984. *Screenplay: The Foundations of Screenwriting*. New York: Delta Trade Paperbacks.

Firestone, L. 2012. "Is Social Media to Blame for the Rise In Narcissism?" *Psychology Today*, November 29. https://www.psychologytoday.com/blog/compassion -matters/201211/is-social-media-blame-the-rise-in-narcissism.

Fjellestad, D., and M. Engberg. 2013. "From Madonna to Lady Gaga, or Toward a Concept of Post-Postmodernism." *Reconstruction* 12 (4). (Site closed December 31, 2013.)

Flegenheimer, M. 2012. "Thomas Kinkade, Artist to Mass Market, Dies at 54." *New York Times*, April 8, A20. http://www.nytimes.com/2012/04/08/arts/design/thomas -kinkade-artist-to-mass-market-dies-at-54.html.

Flomenbaum, A. 2015. "Accenture Report: 87% of Consumers Use Second Screen Device While Watching TV." *Adweek*, April 20. http://www.adweek.com/lostremote/accenture-report-87-of-consumers-use-second-screen-device-while-watching-tv/51698.

Foer, F. 2017. *World Without Mind: The Existential Threat of Big Tech*. New York: Penguin.

Fowler, G. A., and J. Keegan. 2016. "Blue Feed, Red Feed." *Wall Street Journal*, May 19. https://www.wsj.com/video/red-feed-blue-feed-liberal-vs-conservative-facebook/0678AF47-7C53-4CDF-8457-F6A16A46CDAF.html.

Frank, T. 1997. *The Conquest of Cool: Buiness Culture, Counterculture, and the Rise of Hip Consumerism*. Chicago and London: University of Chicago Press.

Gee, J. P. 2007. *What Video Games Have to Teach Us About Learning and Literacy*. Rev. and updated ed. New York: Palgrave Macmillan.

Gennari, J. 2006. *Blowin' Hot and Cool: Jazz and Its Critics*. Chicago: University of Chicago Press.

Gibson, W. (1984) 2000. *Neuromancer*. New York: Ace Books.

Glaister, D. 2012. "Thomas Kinkade: The Strange Life and Secret Death of Art's King of Twee." *The Guardian*, May 10. http://www.guardian.co.uk/artanddesign/2012/may/09/thomas-kinkade-dark-death-painter.

Goldberg, R. 2001. *Performance Art: From Futurism to the Present*. London: Thames and Hudson.

Greenberg, C. 1939. "Avante-Garde and Kitsch." *Partisan Review* 6 (5): 34–49.

Greenberg, C. 1960. "Modernist Painting." *Forum Lectures*. Washington, DC: Voice of America.

Greene, D. 2016. *Rock, Counterculture and the Avant-Garde, 1966/1970: How the Beatles, Frank Zappa and the Velvet Underground Defined an Era*. Jefferson, NC: McFarland & Company, Inc., Publishers.

Heffernan, V. 2018. "A Short History of Technology Worship." *Wired*, February 26. https://www.wired.com/story/a-short-history-of-technology-worship/.

Hilbert, M. 2015. *Quantifying the Data Deluge and the Data Drought*. https://ssrn.com/abstract=2984851.

Hirsch, E. D., J. F. Kett, and J. S. Trefil. 1987. *Cultural Literacy: What Every American Needs to Know*. Boston: Houghton Mifflin.

Hochschild, A. R. 2016. *Strangers in Their Own Land: Anger and Mourning on the American Right*. New York: The New Press.

Holtzman, S. 1997. *Digital Mosaics: The Aesthetics of Cyberspace*. New York: Simon & Schuster.

Howard, P. N., and M. M. Hussain. 2011. *Democracy's Fourth Wave?: Digital Media and the Arab Spring*. Oxford: Oxford University Press.

Huang, C. 2011. "Facebook and Twitter Key to Arab Spring Uprisings: Report." *The National*, June 6. http://www.thenational.ae/news/uae-news/facebook-and-twitter -key-to-arab-spring-uprisings-report.

Huyssen, A. 1986. *After the Great Divide: Modernism, Mass Culture, Postmodernism*. Bloomington: Indiana University Press.

Internet World Stats. 2017. Internet World Stats. https://www.internetworldstats.com/ stats.htm.

Isaacson, W. 2011. *Steve Jobs*. New York: Simon and Schuster.

Jameson, F. 1991. *Postmodernism, or the Cultural Logic of Late Capitalism*. Durham, NC: Duke University Press.

JAY-Z. 2013. *Picasso Baby: A Performance Art Film*. http://youtu.be/xMG2oNqBy-Y.

Jenkins, H. 1992. *Textual Poachers: Television Fans & Participatory Culture*. New York: Routledge.

Jenkins, H. 2006a. *Convergence Culture: Where Old and New Media Collide*. New York: New York University Press.

Jenkins, H. 2006b. *Fans, Bloggers, and Gamers: Exploring Participatory Culture*. New York: New York University Press.

Jenkins, H. 2010. *DIY Video 2010: Political Remix (Part One)*. http://henryjenkins .org/2010/11/political_remix_video_can_empo.html.

Jobs, S. 2007. Complete Transcript of Steve Jobs, Macworld Conference and Expo, January 9. genius. https://genius.com/Steve-jobs-complete-transcript-of-steve-jobs -macworld-conference-and-expo-january-9-2007-annotated.

Johnson, E. 2015. "Virtual Reality Is 'The Last Medium,' Says Filmmaker and Vrse CEO Chris Milk (Q&A)." *recode*, October 1. https://www.recode.net/2015/10/1/11619088/ virtual-reality-is-the-last-medium-says-filmmaker-and-vrse-ceo-chris.

Johnson, S. 2006. *Everything Bad Is Good for You: How Today's Popular Culture Is Actually Making Us Smarter*. New York: Riverhead Books.

Jones, R. 2016. *The End of White Christian America*. New York: Simon and Schuster.

Judt, T. 2005. *Postwar: A History of Europe since 1945*. New York: Penguin Press.

Kaplan, S. 2018. "Congress Quashed Research into Gun Violence. Since Then, 600,000 People Have Been Shot." *New York Times*, March 12. https://www.nytimes .com/2018/03/12/health/gun-violence-research-cdc.html.

Keen, A. 2007. *The Cult of the Amateur: How Blogs, MySpace, YouTube, and the Rest of Today's User-generated Media Are Destroying Our Economy, Our Culture, and Our Values.* New York: Doubleday.

Kirchner, M. 2010. "Explore the World of Superstruct," *Future Now: The IFTF Blog,* September 24. http://www.iftf.org/future-now/article-detail/explore-the-world-of -superstruct.

Kirkpatrick, D., and D. Sanger. 2011. "A Tunisian-Egyptian Link That Shook Arab History." *New York Times,* February 13. http://www.nytimes.com/2011/02/14/world/ middleeast/14egypt-tunisia-protests.html?_r=1&.

Klein, E. 2016. "Elon Musk Believes We Are Probably Characters in Some Advanced Civilization's Video Game." *Vox,* June 2. https://www.vox.com/2016/6/2/11837608/ elon-musk-simulation-argument.

Koster, R. 2005. *A Theory of Fun for Game Design.* Scottsdale, AZ: Paraglyph Press.

Kozinin, A. 2011. "Don't Scowl, Beethoven, You're Loved." *New York Times,* December 18. https://www.nytimes.com/2011/12/19/books/beethoven-in-america-by-michael -broyles-review.html.

kreftovich1. 2010. "Apple's Think Different Advertising Campaign: 1997–2002." YouTube Video, 1:09, August 21. https://www.youtube.com/watch?v=cFEarBzelBs.

Krieger, J. M. 2015. "The Politics of John Lennon's 'Imagine': Contextualizing the Roles of Mashups and New Media in Political Protest." In *The Routledge Companion to Remix Studies,* ed. E. Navas, O. Gallagher, and x. burrough, 373–385. New York: Routledge.

Kurzweil, R. 2005. *The Singularity Is Near.* London: Duckworth Publishers.

Lanier, J. 2010. *You Are Not a Gadget: A Manifesto.* New York: Knopf.

Lasch, C. 1978. *The Culture of Narcissism: American Life in an Age of Diminishing Expectations.* 1st ed. New York: W. W. Norton and Company.

Lessig, L. 2004. *Free Culture: How Big Media Uses Technology and the Law to Lock Down Culture and Control Creativity.* New York: Penguin Press.

Lessig, L. 2007. "Laws That Choke Creativity." TED talk. http://www.ted.com/talks/ larry_lessig_says_the_law_is_strangling_creativity.html.

Lessig, L. 2008. *Remix: Making Art and Commerce Thrive in the Hybrid Economy.* New York: Penguin Press.

Levine, L. 1988. *Highbrow/Lowbrow: The Emergence of Cultural Hierarchy in America.* Cambridge, MA: Harvard University Press.

Lévy, P. 1997. *Collective Intelligence: Man's Emerging World in Cyberspace.* New York: Plenum Trade.

Levy, S. 2011. *In the Plex: How Google Thinks, Works, and Shapes Our Lives.* 1st ed. New York: Simon & Schuster.

Lewis, M. 2003. *Moneyball: The Art of Winning an Unfair Game.* 1st ed. New York: W. W. Norton and Company.

Lewis, M. 2010. *The Big Short.* New York: W. W. Norton and Company.

Longley, M., L. Silverstein, and S. Tower. 1960. *America's Taste: The Cultural Events of a Century Reported by Contemporary Observers in the Pages of the* New York Times. New York: Simon and Schuster.

Lopez, G. 2017. "The Battle over Identity Politics, Explained." *Vox*, August 17. https://www.vox.com/identities/2016/12/2/13718770/identity-politics.

Los Angeles Times. 2012. "PBS Reveals Who's Really Watching 'Downton Abbey.'" *Show Tracker* (blog). March 28. http://latimesblogs.latimes.com/showtracker/2012/03/pbs-reveals-whos-really-watching-downton-abbey-.html.

Lovink, G., and R. Garcia. 1997. "The ABC of Tactical Media." https://www.nettime.org/Lists-Archives/nettime-l-9705/msg00096.html.

Lunday, E. 2013. *The Modern Art Invasion: Picasso, Duchamp, and the 1913 Armory Show That Scandalized America.* Guilford, CT: Lyons Press.

Lupton, D. 2016. *The Quantified Self: A Sociology of Self-Tracking.* Cambridge, UK: Polity Press.

Lyall-Wilson, D. 2006. *Sleepless in Seattle: Recut as a Horror Movie.* https://m.youtube.com/watch?v=frUPnZMxr08&feature=related.

MacCormick, J. 2012. *Nine Algorithms That Changed the Future.* Princeton, NJ: Princeton University Press.

MacDonald, D. 2011. *Masscult and Midcult: Essays Against the American Grain.* New York: New York Review Books Classics.

MacDonald, H. 2013. "How Graphic Novels Became the Hottest Section in the Library." *Publishers Weekly*, May 3. https://www.publishersweekly.com/pw/by-topic/industry-news/libraries/article/57093-how-graphic-novels-became-the-hottest-section-in-the-library.html.

Manovich, L. 2001. *The Language of New Media.* Cambridge, MA: MIT Press.

Manovich, L. 2013. *Software Takes Command.* New York: Bloomsbury Academic.

Manovich, L. 2015. "Remix Strategies in Social Media." In *The Routledge Companion to Remix Studies*, ed. E. Navas, O. Gallagher, and x. burrough, 135–152. New York: Routledge.

Marwick, A. E., and d. boyd. 2010. "I Tweet Honestly, I Tweet Passionately: Twitter Users, Context Collapse, and the Imagined Audience." *New Media and Society* 13 (1): 114–133.

Marx, K. (1852) 2008. *The 18th Brumaire of Louis Bonaparte*. Cabin John, MD: Wildside Press LLC.

Mayer-Schönberger, V., and K. Cukier. 2013. *Big Data: A Revolution That Will Transform How We Live, Work, and Think*. Boston: Houghton Mifflin Harcourt.

McGonigal, J. 2011. *Reality Is Broken: Why Games Make Us Better and How They Can Change the World*. New York: Penguin Press.

McGonigal, J. 2017. "Gaming Can Make a Better World." TED talk. https://www.ted .com/talks/jane_mcgonigal_gaming_can_make_a_better_world.

McHale, B. 2001. "Weak Narrativity: The Case of Avant-Garde Narrative Poetry." *Narrative* 9 (2): 161–167.

Mclean, R. 2017. "Jay Z and Beyoncé Are Worth More Than $1 Billion. *CNNMedia*, May 17. http://money.cnn.com/2017/05/17/media/jay-z-beyonce-billion/index.html.

McLeod, K. 2015. "An Oral History of Sampling: From Turntables to Mashups." In *The Routledge Companion to Remix Studies*, ed. E. Nasa, O. Gallagher, and x. burrough, 83–95. New York: Routledge.

McLuhan, M. 1962. *The Gutenberg Galaxy: The Making of Typographic Man*. Toronto: University of Toronto Press.

McLuhan, M. (1964) 2013. *Understanding Media: The Extensions of Man*. Berkeley, CA: Gingko Press.

Miles, B. 1997. *Paul McCartney: Many Years from Now*. New York: Henry Holt and Co.

Milk, C. 2015a. *Clouds Over Sidra*. http://dragons.org/creators/chris-milk/work/the -united-nations-clouds-over-sidra/.

Milk, C. 2015b. "How Virtual Reality Can Create the Ultimate Empathy Machines." TED talk. https://www.ted.com/talks/chris_milk_how_virtual_reality_can_create_the _ultimate_empathy_machine.

Moreau, R. 1984. *The Computer Comes of Age: The People, the Hardware, and the Software*. Trans. J. Howlett. Cambridge, MA: MIT Press.

Morganti, E. 2013. "Gone Home (review)." Adventure Gamers, August 16. http:// www.adventuregamers.com/articles/view/25075.

Moriarty, C. (Producer). 2013. "*The Last of Us* (review)." *IGN Gamereview*. https:// www.youtube.com/watch?v=-GBXuE6jcl4.

Morris, C. 2016. "Level Up! Video Game Industry Revenues Soar in 2015." *Fortune*, February 16. http://fortune.com/2016/02/16/video-game-industry-revenues-2015.

Murray, J. 1997. *Hamlet on the Holodeck*. Cambridge, MA: MIT Press.

Murray, J. 2004. "From Game-story to Cyberdrama." In *First Person: New Media as Story, Performance, and Game*, ed. N. Wardrip-Fruin and P. Harrigan, 2–11. Cambridge, MA: MIT Press.

National Endowment for the Arts. 2012. *2012 Guide*. Washington, DC: Office of Public Affairs, National Endowment for the Arts.

National Endowment for the Arts. 2018. "Media Arts." https://www.arts.gov/artistic -fields/media-arts.

National Film Registry. 2013. National Film Registry, Library of Congress. https:// www.loc.gov/programs/national-film-preservation-board/film-registry/complete -national-film-registry-listing/.

Navas, E. 2012. *Remix Theory: The Aesthetics of Sampling*. Vienna: New York: Springer.

Navas, E., O. Gallagher, and x. burrough, eds. 2015a. *The Routledge Companion to Remix Studies*. New York: Routledge.

Navas, E., O. Gallagher, O., and x. burrough. 2015b. Introduction. In *The Routledge Companion to Remix Studies*, ed. E. Navas, O. Gallagher, and x. burrough, 1–12. New York: Routledge.

Néret, G. 1993. *Fernand Léger*. Trans. Susan D. Resnick. New York: BDD Illustrated Books.

Norman, P. 2008. *John Lennon: The Life*. New York: HarperCollins.

Nunnely, S. 2016. "The Civilization Series Has Sold 33 Million Copies Since It Debuted in 1991." VG24/7, February 19. https://www.vg247.com/2016/02/19/the -civilization-series-has-sold-33-million-copies-since-it-debuted-in-1991/.

Olson, P. 2012. *We Are Anonymous: Inside the Hacker World of Lulzsec, Anonymous, and the Global Cyber Insurgency*. 1st ed. New York: Little, Brown and Co.

Pariser, E. 2011a. "Beware Online "Filter Bubbles." TED talk. https://www.ted.com/ talks/eli_pariser_beware_online_filter_bubbles#t-515332.

Pariser, E. 2011b. *The Filter Bubble: How the New Personalized Web Is Changing What We Read and How We Think*. London: Penguin Books.

Parker, L. 2012. "How Video Games Changed the World." *Gamespot*. https://www .gamespot.com/articles/how-video-games-changed-the-world/1100-6388544/.

Parkin, S. 2014. "Gamergate: A Scandal Erupts in the Video-Game Community." *The New Yorker*, October 17. http://www.newyorker.com/tech/elements/gamergate -scandal-erupts-video-game-community.

Pearce, A. 2016. "Trump Has Spent a Fraction of What Clinton Has on Ads." *New York Times*, October 21. https://www.nytimes.com/interactive/2016/10/21/us/ elections/television-ads.html.

Peverini, P. 2015. "Remix Practices and Activism: A Semiotic Analysis of Creative Dissent." In *The Routledge Companion to Remix Studies*, ed. E. Navas, O. Gallagher, and x. burrough, 332–345. New York: Routledge.

Pew Research Center. 2012. "The Polarized Congress of Today Has Its Roots in the 1970s." *FactTank: News in the Numbers*. http://www.pewresearch.org/fact-tank/2014/ 06/12/polarized-politics-in-congress-began-in-the-1970s-and-has-been-getting -worse-ever-since/.

Pew Research Center. 2014. "Political Polarization." *FactTank: News in the Numbers*. http://www.pewresearch.org/packages/political-polarization/.

Pinker, S. 1995. *The Language Instinct*. New York: HarperPerennial.

Polaine, A. 2005. "The Flow Principle in Interactivity." Paper presented at the Second Australasian Conference on Interactive Entertainment, Sydney, November 23–25.

Postman, N. (1985) 2005. *Amusing Ourselves to Death: Public Discourse in the Age of Show Business*. New York: Penguin.

Raley, R. 2009. *Tactical Media*. Minneapolis: University of Minnesota Press.

Reese, N. 2016. "An Exhibition That Proves Video Games Can Be Art." *New York Times Style Magazine*, February 10. https://www.nytimes.com/2016/02/10/t-magazine/ art/jason-rohrer-video-games-exhibit-davis-museum.html.

Rettberg, J. W. 2014. *Seeing Ourselves Through Technology: How We Use Selfies, Blogs and Wearable Devices to See and Shape Ourselves*. New York: Palgrave Macmillan.

Rheingold, H. 2002. *Smart Mobs: The Next Social Revolution*. Cambridge, MA: Perseus Publishing.

Rich, F. 1998. "Who Chose 'The Magus'?" *New York Times*, August 8. https://www .nytimes.com/1998/08/08/opinion/journal-who-chose-the-magus.html.

Richter, H. 1978. *Dada, Art and Anti-Art*. New York: Oxford University Press.

Right2Remix.org. 2017. "Manifesto." https://right2remix.org/-01-manifest.

Rohrer, F. 2010. "The Rise, Rise, and Rise of the *Downfall* Hitler Parody." *BBC News Magazine*, April 13. http://news.bbc.co.uk/2/hi/uk_news/magazine/8617454.stm.

Rolling Stone. 2012a. "500 Greatest Albums of All Time." *Rolling Stone,* May 31. http://www.rollingstone.com/music/lists/500-greatest-albums-of-all-time-20120531/the-beatles-sgt-peppers-lonely-hearts-club-band-20120531.

Rolling Stone. 2012b. "Mitt and Ann Romney Name Their Favorite Musicians." *Rolling Stone,* August 24. http://www.rollingstone.com/music/news/mitt-and-ann-romney-name-their-favorite-musicians-20120824.

Rose, F. 2011. *The Art of Immersion: How the Digital Generation Is Remaking Hollywood, Madison Avenue, and the Way We Tell Stories.* New York: W. W. Norton and Company.

Rosenberg, M., M. Confessore, and C. Cadwalladr. 2018. "How Trump Consultants Exploited the Facebook Data of Millions." *New York Times,* March 17. https://www.nytimes.com/2018/03/17/us/politics/cambridge-analytica-trump-campaign.html.

Ryan, M. 2006. *Avatars of Story.* Minneapolis: University of Minnesota.

Savage, C., and J. W. Peters. 2014. "Bill to Restrict N.S.A. Data Collection Blocked in Vote by Senate Republicans." *New York Times,* November 9. https://www.nytimes.com/2014/11/19/us/nsa-phone-records.html.

Schell, J. 2008. *The Art of Game Design: A Book of Lenses.* Amsterdam; Boston: Elsevier/ Morgan Kaufmann.

Schrank, B. 2014. *Avant-Garde Videogames: Playing with Technoculture.* Cambridge, MA: MIT Press.

Shenkman, R. 2009. *Just How Stupid Are We? Facing the Truth about the American Voter.* New York: Basic Books.

Shifman, L. 2014. *Memes in Digital Culture.* Cambridge, MA: MIT Press.

Shiner, L. E. 2001. *The Invention of Art: A Cultural History.* Chicago: University of Chicago Press.

Shirky, C. 2008. *Here Comes Everybody: The Power of Organizing without Organizations.* New York: Penguin Press.

Shirky, C. 2010a. *Cognitive Surplus: Creativity and Generosity in a Connected Age.* New York: Penguin Press.

Shirky, C. 2010b. "How Cognitive Surplus Will Change the World." TED talk. June. https://www.ted.com/talks/clay_shirky_how_cognitive_surplus_will_change_the_world?language=en.

Siebenbrodt, M., and L. Schöbe. 2009. *Bauhaus: 1919–1933 Weimar-Dessau-Berlin.* New York: Parkstone Press.

Sinnreich, A. 2010. *Mashed Up: Music, Technology, and the Rise of Configurable Culture.* Amherst: University of Massachusetts Press.

Skocpol, T., and V. Williamson. 2012. *The Tea Party and the Remaking of Republican Conservatism.* Oxford: Oxford University Press.

Small, G., and G. Vorgan. 2008. "Your iBrain: How Technology Changes the Way We Think." *Scientific American Mind* 19 (5). https://www.scientificamerican.com/magazine/mind/2008/10-01/.

Smith, A., and M. Anderson. 2016. "Online Shopping and Purchasing Practices." *Pew Research Center: Internet & Technology*, December 16. http://www.pewinternet.org/2016/12/19/online-shopping-and-purchasing-preferences/.

Smith, A., and J. Brenner. 2012. "Twitter Use 2012." *Pew Research: Internet and Technology*, May 31. http://www.pewinternet.org/2012/05/31/twitter-use-2012/.

Smith, K. 2017. "45 Incredible and Interesting Twitter Statistics." *Brandwatch.* https://www.brandwatch.com/blog/44-twitter-stats/.

Sonvilla-Weiss, S. 2015. "Good Artists Copy; Great Artists Steal." In *The Routledge Companion to Remix Studies*, ed. E. Navas, O. Gallagher, and x. burrough, 54–67. New York: Routledge.

Statista. 2017. "Share of Adults Who Stream Netflix Daily in the United States in 2011 and 2017. Statista: The Statistics Portal. https://www.statista.com/statistics/258922/average-netflix-content-consumption-in-the-us/.

Statista. 2018a. "Prevalence of Second- or Dual-Screening Worldwide as of 1st Quarter 2014, by Generation." Statista: The Statistics Portal. https://www.statista.com/statistics/307088/prevalence-of-second-screen-usage-by-generation/.

Statista. 2018b. Number of Monthly Active Facebook Users Worldwide as of 4th Quarter 2017 (in Millions)." Statista: The Statistics Portal. https://www.statista.com/statistics/264810/number-of-monthly-active-facebook-users-worldwide/.

Statzel, R. S. 2008. "Cybersupremacy: The New Face and Form of White Supremacist Activism." In *Digital Media and Democracy*, ed. M. Boler, 405–428. Cambridge, MA: MIT Press.

Stepadova, E. 2011. "The Role of Information Communication Technologies in the 'Arab Spring.'" PONARS Eurasia Policy Memo, 1–6: Institute of World Economy and International Relations (IMEMO), Russian Academy of Sciences.

TCS New York City Marathon. 2018. "History of the New York City Marathon." https://www.tcsnycmarathon.org/about-the-race/history-of-the-new-york-city-marathon.

Telotte, J. P. 2008. *The Mouse Machine: Disney and Technology.* Chicago: University of Illinois Press.

Thompson, N., and F. Vogelstein. 2018. "Inside the Two Years That Shook Facebook—and the World." *Wired*, February 12. https://www.wired.com/story/inside-facebook-mark-zuckerberg-2-years-of-hell/.

Thompson, R. J. 1996. *Television's Second Golden Age: From Hill Street Blues to ER*. New York: Syracuse University Press.

Timberg, S. 2015. *Culture Crash: The Killing of the Creative Class*. New Haven: Yale University Press.

Trebay, G. 2013. "Jay-Z Is Rhyming Picasso and Rothko." *New York Times*, July 12. https://www.nytimes.com/2013/07/14/fashion/jay-z-is-rhyming-picasso-and-rothko .html.

Turing, A. M. 1950. "Computing Machinery and Intelligence." *Mind* 59 (236): 433–460.

Turkle, S. 2004. "How Computers Change the Way We Think." *Chronicle of Higher Education* 50 (21): B26.

Turkle, S. 2011. *Alone Together: Why We Expect More from Technology and Less from Each Other*. New York: Basic Books.

Ulrich, L. 2000. "Nobody Else Works for Free: Why Should Musicians?" *The Globe and Mail*. https://beta.theglobeandmail.com/arts/nobody-else-works-for-free-why-should -musicians/article25466956/?ref=https://www.theglobeandmail.com&.

Unusual Suspect, The. 2015. "What If 'Spectre' Starred Pierce Brosnan?" *YouTube. com*. https://www.youtube.com/watch?v=x6SiRA3lSuw.

van der Meulen, S. 2009. "The Problem of Media in Contemporary Art Theory 1960– 1990." PhD dissertation, Columbia University, ProQuest Dissertations Publishing. 3395147.

Van Dijck, J. 2014. "Datafication, Dataism and Dataveillance: Big Data between Scientific Paradigm and Ideology." *Surveillance and Society* 12 (2): 197–208.

Van Laar, T., and L. Diepeveen. 2013. *Artworld Prestige: Arguing Culture Value*. New York: Oxford University Press.

Vance, J. D. 2016. *Hillbilly Elegy: A Memoir of a Family and Culture in Crisis*. New York: HarperCollins.

Wakin, D. J. 2012. "A Loud Call for Cheering at Classical Concert Halls." *New York Times*, June 8, C1.

Watercutter, A. 2008. "Mashup DJ Girl Talk Deconstructs Samples from Feed the Animals." *Wired*, August 18. https://www.wired.com/2008/08/mashup-dj-girl-talk -deconstructs-samples-feed-animals/.

Watercutter, A. 2014. "*Edge of Tomorrow* Is the Best Videogame You Can't Play." *Wired*, June 6. https://www.wired.com/2014/06/edge-of-tomorrow-review/.

Webster, A. 2017. "*What Remains of Edith Finch* Is the Game Equivalent of a Haunting Short Story Collection." *The Verge*, April 25.

Wheeler, T. 2017. "How the Republicans Sold Your Privacy to Internet Providers." *New York Times*, March 29. https://www.nytimes.com/2017/03/29/opinion/how-the-republicans-sold-your-privacy-to-internet-providers.html.

Whitford, F. 1984. *Bauhaus*. London: Thames and Hudson.

WikiLeaks. 2011. WikiLeaks Mastercard Advert." *YouTube*. https://www.youtube.com/watch?v=2uk_jVuJD5w. Accessed on September 13, 2011.

Wikipedia contributors. "4chan." Wikipedia. https://en.wikipedia.org/wiki/4chan. Accessed on September 13, 2018.

Wikipedia contributors. "*Civilization* (series)." Wikipedia. https://en.wikipedia.org/wiki/Civilization_series. Accessed on September 13, 2018.

Wikipedia contributors. "*Downfall* (2004 Film)." Wikipedia. https://en.wikipedia.org/wiki/Downfall_(2004_film). Accessed on September 13, 2018.

Wikipedia contributors. "*Gone Home*." Wikipedia. https://en.wikipedia.org/wiki/Gone_Home. Accessed on September 13, 2018.

Wikipedia contributors. "List of Hip Hop Genres." Wikipedia. https://en.wikipedia.org/wiki/List_of_hip_hop_genres. Accessed on September 13, 2018.

Wikipedia contributors. "List of Rock Genres." Wikipedia. https://en.wikipedia.org/wiki/List_of_rock_genres. Accessed on September 13, 2018.

Wikipedia contributors. "List of Simulation Games." Wikipedia. https://en.wikipedia.org/wiki/List_of_simulation_video_games. Accessed on September 13, 2018.

Wikipedia contributors. "Nielsen Ratings." Wikipedia. https://en.wikipedia.org/wiki/Nielsen_ratings. Accessed on September 13, 2018.

Wikipedia contributors. "Video Game Genre." Wikipedia. http://en.wikipedia.org/wiki/Video_game_genres. Accessed on September 13, 2018.

Wikipedia contributors. "World Without Oil." Wikipedia. https://en.wikipedia.org/wiki/World_Without_Oil. Accessed on September 13, 2018.

Williams, R. 1974. *Television: Technology and Cultural Form*. London: Fontana.

Wired Staff. 2005. "Remix Planet." *Wired*, July 1. https://www.wired.com/2005/07/intro-3/.

Wolf, G. 2009. "Know Thyself: Tracking Every Facet of Life, from Sleep to Mood to Pain, 24/7/365." *Wired*, June 22. https://www.wired.com/2009/06/lbnp-knowthyself/.

Wolfe, T. 1976. "The 'Me' Decade and the Third Great Awakening." In *Mauve Gloves & Madmen, Clutter & Vine*, 126–167. New York: Farrar, Straus and Giroux.

Yang, R. 2008. *Shining Movie Trailer Parody*. https://www.youtube.com/watch?v=-e6d_gzaDgk.

YouTube. 2017a. VR Channel. https://www.youtube.com/channel/UCzuqhhs6 NWbgTzMuM09WKDQ.

YouTube 2017b. "YouTube by the Numbers." https://www.youtube.com/yt/about/ press/.

Index